P9-DFS-563

THE GREEK CONQUERORS

12⁵⁰

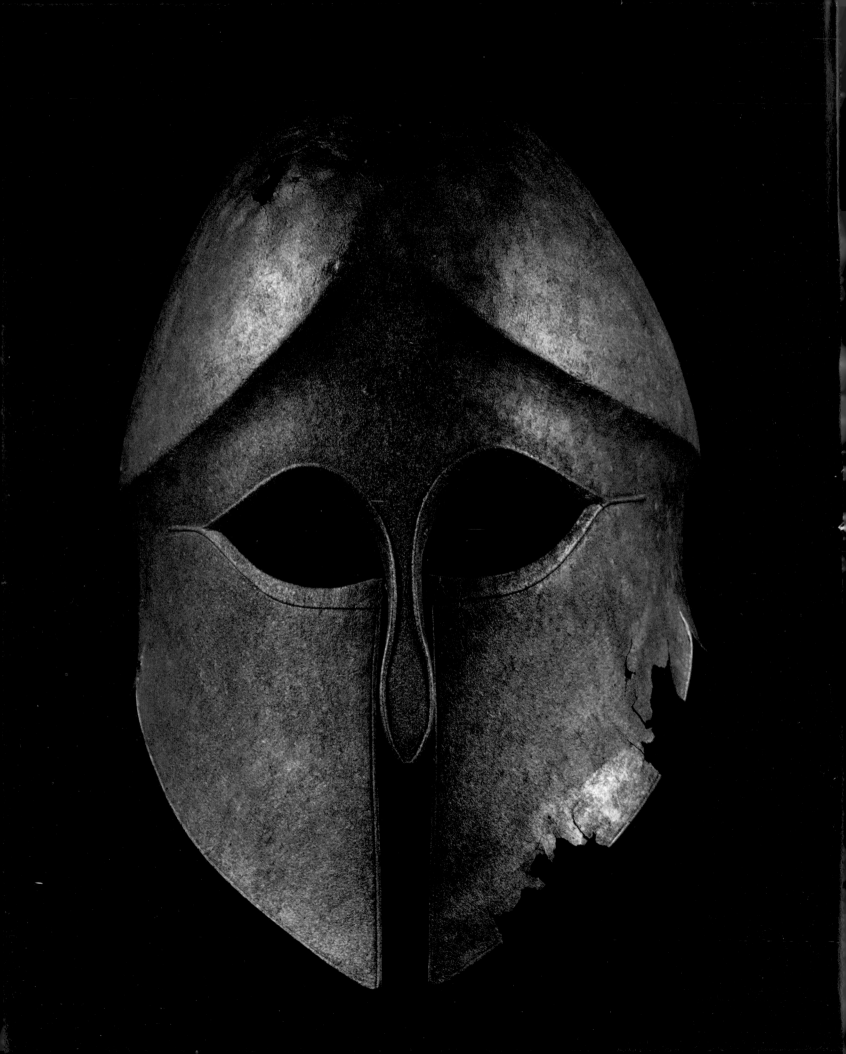

TREASURES OF THE WORLD

THE GREEK CONQUERORS

by

Lionel Casson

STONEHENGE

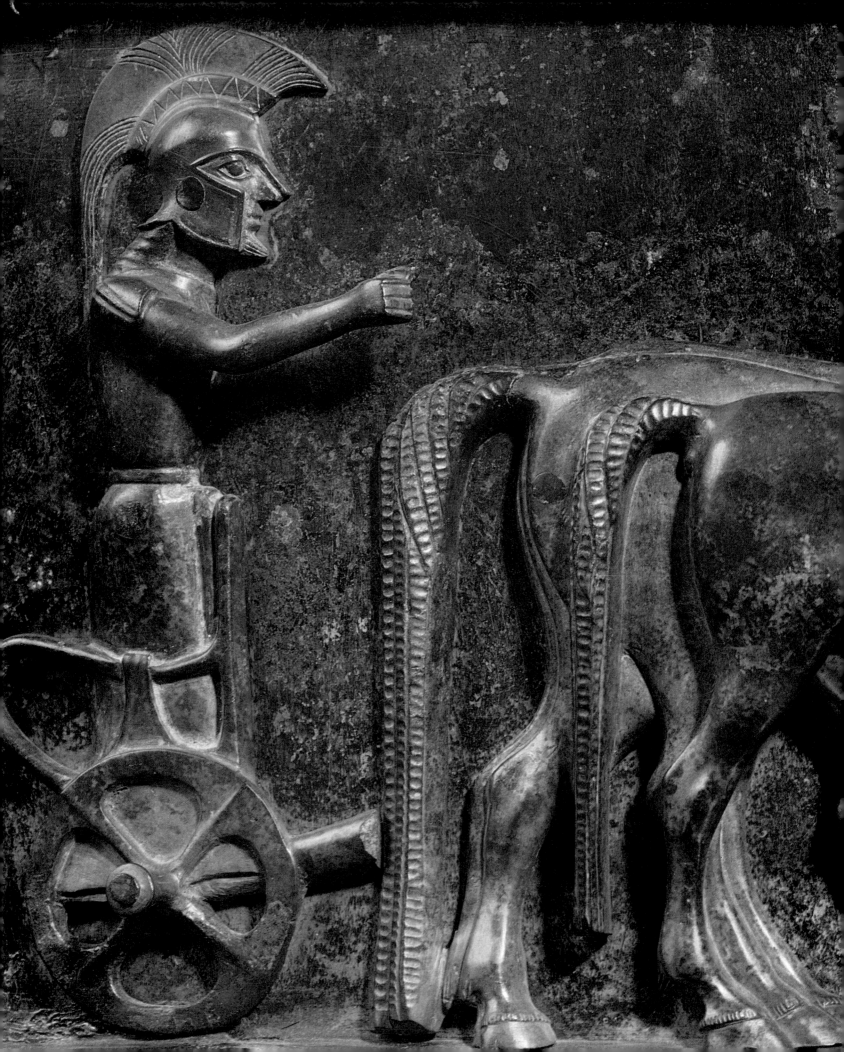

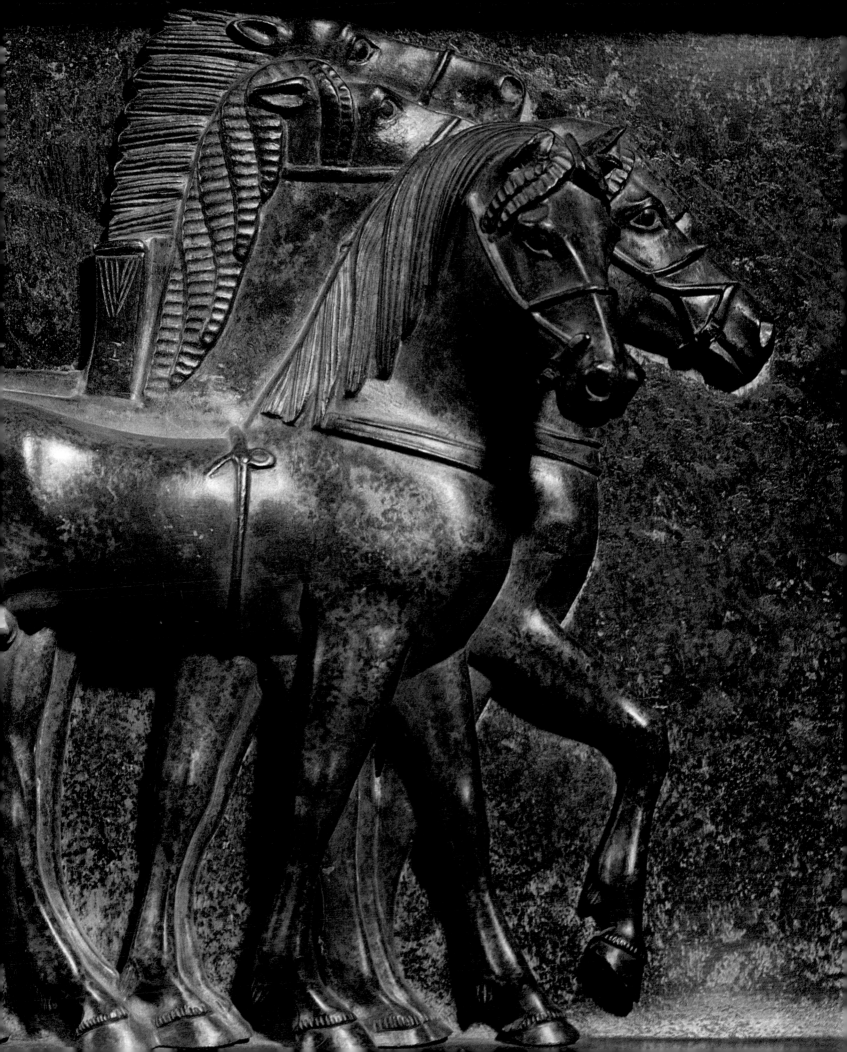

Treasures of the World was created and
produced by
TREE COMMUNICATIONS, INC.

PRESIDENT
Rodney Friedman
PUBLISHER
Bruce Michel
VICE PRESIDENTS
Ronald Gross
Paul Levin

EDITOR
Charles L. Mee, Jr.
EXECUTIVE EDITOR
Shirley Tomkievicz
ART DIRECTOR
Sara Burris
PICTURE EDITOR
Mary Zuazua Jenkins
ASSOCIATE EDITORS
Thomas Dickey Vance Muse Henry Wiencek
ASSISTANT ART DIRECTOR
Helen Namm
ASSISTANT PICTURE EDITORS
Carol Gaskin Charlie Holland
COPY EDITOR
Lilyan Glusker
ASSISTANT COPY EDITOR
Fredrica A. Harvey
EDITORIAL ASSISTANTS
Martha J. Brown Janet Sullivan
FOREIGN RESEARCHERS
Rosemary Burgis (London)
Mirka Gondicas (Athens)
Alice Jugie (Paris)
Dee Pattee (Munich)
Simonetta Toraldo (Rome)
CONSULTING EDITORS
Joseph J. Thorndike, Jr.
Dr. Ulrich Hiesinger

The series is published under the supervision of
STONEHENGE PRESS INC.

PUBLISHER
John Canova
EDITOR
Ezra Bowen
DEPUTY EDITOR
Carolyn Tasker

THE AUTHOR: Lionel Casson is Andrew W. Mellon Professor of Classical Studies at the American Academy in Rome, as well as professor of classics at New York University. He is the author of *The Ancient Mariners*, among other books, and of numerous articles for *Horizon* magazine.

© 1981 Stonehenge Press Inc. All rights reserved. No part of this book may be reproduced in any form or by any electronic or mechanical means, including information storage and retrieval devices or systems, without prior written permission from the publisher, except that brief passages may be quoted for reviews.
Second Printing. Revised 1982.
Published simultaneously in Canada.
Library of Congress catalogue card number 81-52542
ISBN 0-86706-001-8
STONEHENGE with its design is a registered trademark of Stonehenge Press Inc.
Printed in U.S.A. by R.R. Donnelley & Sons.
For information about any Stonehenge book, please write:
Reader Information
Stonehenge Press Inc.
303 East Ohio Street
Chicago, Illinois 60611

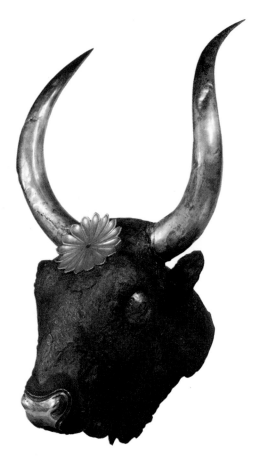

COVER: *On a gold earring of the fourth century* B.C., *a bearded Heracles wears a cap of lion skin.*

TITLE PAGE: *A sixth-century Greek armorer hammered this helmet out of a single sheet of bronze.*

OVERLEAF: *A soldier rides behind a team of horses on the decoration from a bronze bowl.*

ABOVE: *A royal Mycenaean grave held this silver and gold drinking vessel shaped like a bull's head.*

CONTENTS

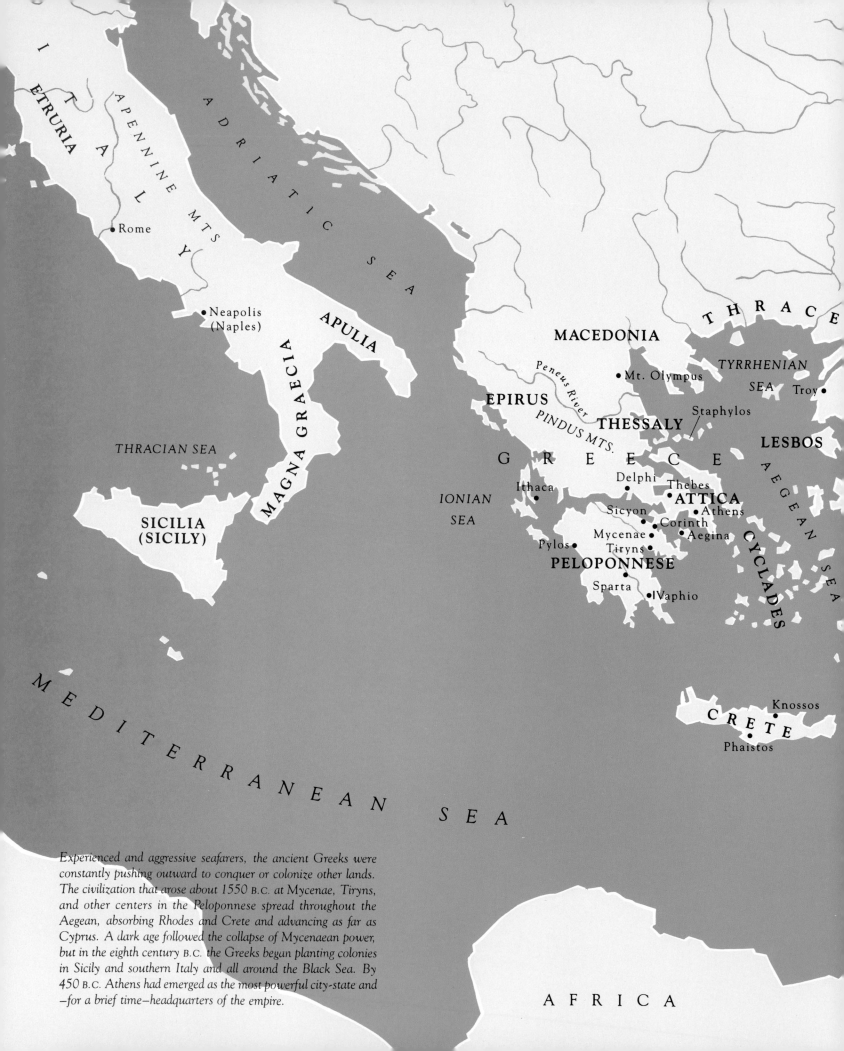

ETRURIA

I T A L Y

APENNINE MTS

Rome

A D R I A T I C S E A

THRACE

MACEDONIA

Neapolis
(Naples)

APULIA

Peneus River

Mt. Olympus

TYRRHENIAN
SEA

Troy

MAGNA GRAECIA

EPIRUS

PINDUS MTS.

THESSALY

Staphylos

THRACIAN SEA

GREECE

LESBOS

A
E
G
E
A
N

S
E
A

Delphi

SICILIA
(SICILY)

Ithaca

IONIAN
SEA

Thebes

ATTICA

Sicyon

Athens

Corinth

Mycenae

Aegina

CYCLADES

Pylos

Tiryns

PELOPONNESE

Sparta

Vaphio

M E D I T E R R A N E A N S E A

Knossos

C R E T E

Phaistos

*Experienced and aggressive seafarers, the ancient Greeks were
constantly pushing outward to conquer or colonize other lands.
The civilization that arose about 1550 B.C. at Mycenae, Tiryns,
and other centers in the Peloponnese spread throughout the
Aegean, absorbing Rhodes and Crete and advancing as far as
Cyprus. A dark age followed the collapse of Mycenaean power,
but in the eighth century B.C. the Greeks began planting colonies
in Sicily and southern Italy and all around the Black Sea. By
450 B.C. Athens had emerged as the most powerful city-state and
—for a brief time—headquarters of the empire.*

AFRICA

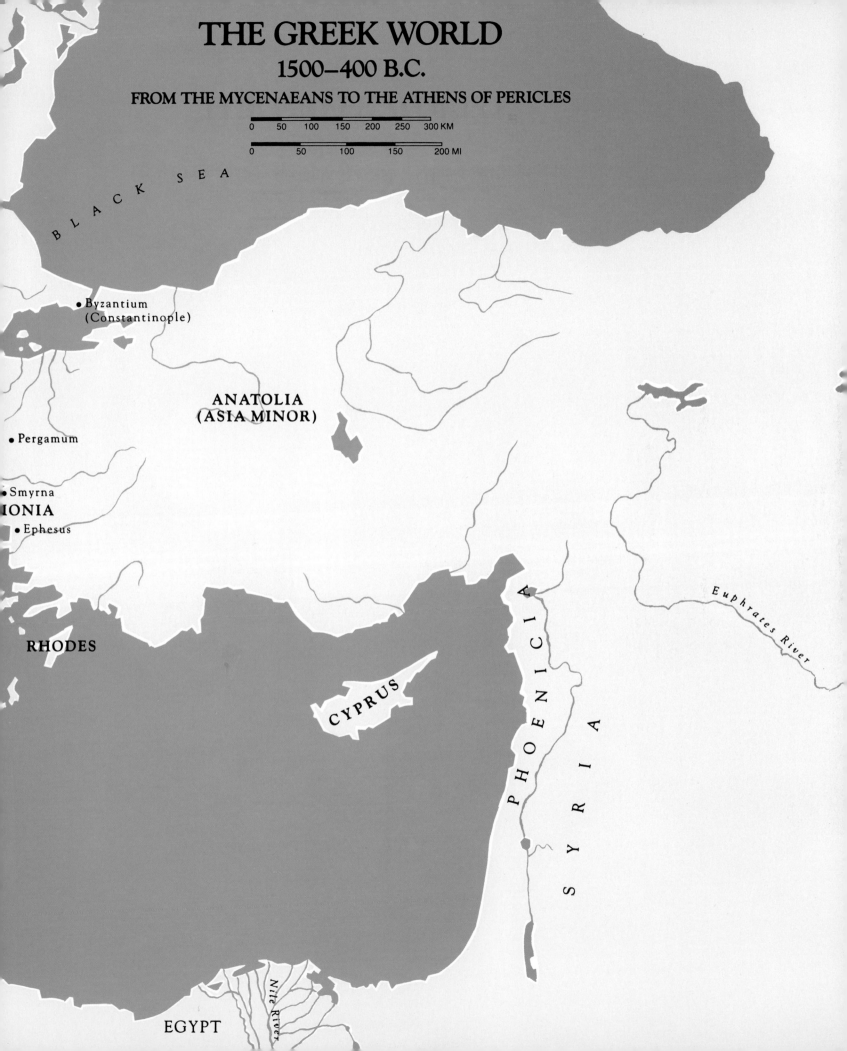

THE GREEK WORLD
1500–400 B.C.
FROM THE MYCENAEANS TO THE ATHENS OF PERICLES

BLACK SEA

• Byzantium
(Constantinople)

ANATOLIA
(ASIA MINOR)

• Pergamum

• Smyrna

IONIA

• Ephesus

RHODES

CYPRUS

PHOENICIA

SYRIA

Euphrates River

Nile River

EGYPT

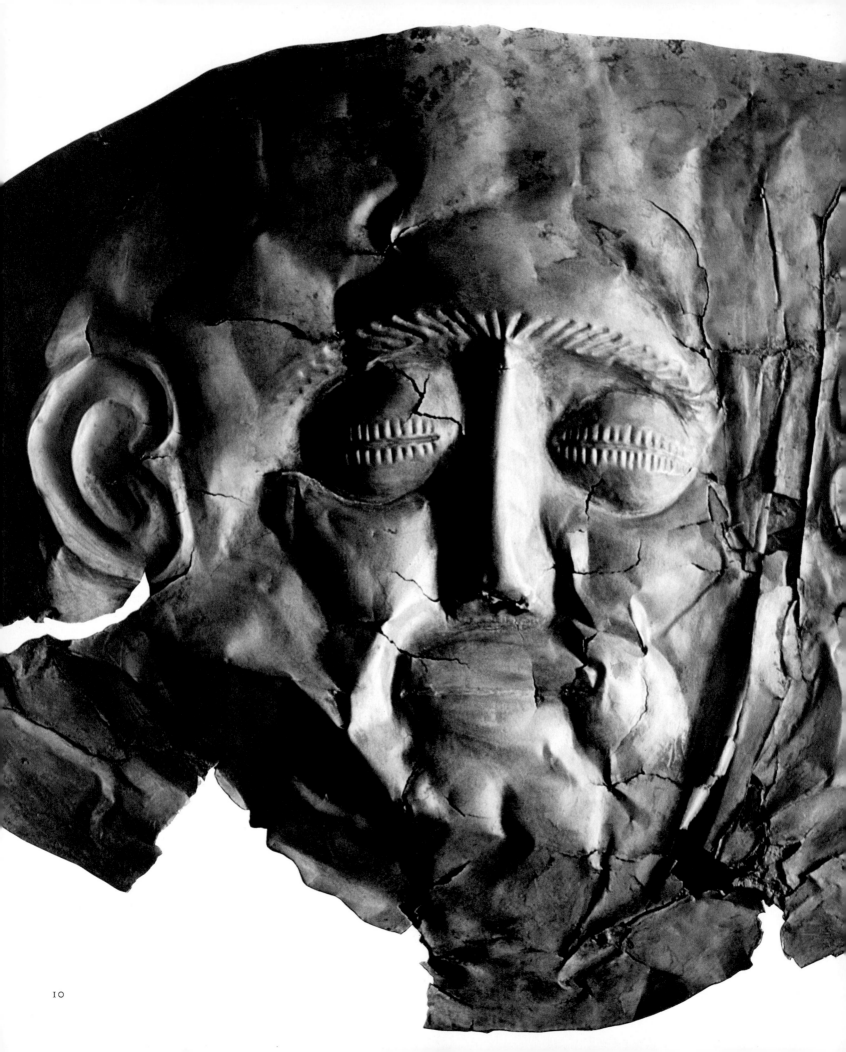

I

THE AGE OF

THE WARRIOR-KINGS

A thousand years before the flowering of Athens, an age of sudden and almost unimaginable richness began in Greece. For centuries, scattered among the inhospitable hills of Attica and the Peloponnese, a simple farming people had raised sheep and olives and had somehow made a skimpy living from this most unpromising terrain. Then suddenly, in about 1550 B.C., for no readily apparent reason, princely courts sprang up, where the style of living was so opulent as to become a legend for all time. The poet Homer, who made epic verse out of the doings of these courts long after they had vanished, speaks often of their splendor, and marvels at the wealth that these shadowy kings possessed.

He tells, for example, how a young nobleman named Telemachus and his friend Pisistratus paid a visit to the court of King Menelaus at Sparta, which was not even the wealthiest of the Greek kingdoms. When the king and queen and the two young men sat down to dinner at the royal table, the poet reports:

The formidable countenance of a Greek warrior-king who lived more than 3,500 years ago survives, in dim outline, in this gold burial mask.

a maid brought water in a beautiful golden pitcher and poured it out into a silver basin so that they could wash their hands ... The butler carving meat served helpings of all kinds and set golden cups before them ... Telemachus bent his head close to Pisistratus and whispered so that the others could not hear, "Look at this echoing hall, my dear Pisistratus. The way it gleams with bronze, gold, silver, amber, ivory! Zeus' palace on Olympus must be like this inside. What a mass of things–indescribable! Just the sight of it has me awestruck."

Those who decked their banquet halls, their palaces, and their persons with such riches were the heroes and heroines that Homer's *Iliad* and *Odyssey* describe. The greatest of them were Agamemnon, king of Mycenae, and his faithless wife, Clytemnestra; Achilles, the fiercest of the Greek warriors, who died of a wound in his only vulnerable spot, the heel; Odysseus, who lived by his wits; Menelaus and his queen, Helen. At the time of Menelaus' sumptuous dinner party, Helen "of Troy," as she is always called, though "of Sparta" would be closer to the truth, had just been reunited with her husband after ten years of happy adultery with a handsome Trojan prince–who had kept her in just as much elegant comfort at Troy as her husband had at home. The ten years was how long it had taken a Greek army to smash Troy and get Helen back. Menelaus was perfectly willing to take her as his queen again; she was, after all, the most beautiful woman in the world.

These are the first Greeks we know of by name, the first identifiable individuals among that supremely gifted people who contributed so much to Western culture. In those early days they were not one nation, not citizens of Greece at all, but a scattering of people who spoke the same language, a primitive form of classical Greek. Their walled cities–fortresses much more than cities–studded the peninsulas and islands of Greece. Mycenae was the most powerful, and "Mycenaean" has come to denote the whole culture. There was Pylos, too, and Tiryns, Sparta, Ithaca, and Thebes, as well as many smaller settlements. The common people in this disunited dominion lived by farming as they had always done. But in the times that Homer describes, there was now an aristocracy that went to sea in ships, dis-

King Agamemnon, the legendary ruler of Mycenae, stands ready for battle in this detail from a fifth-century-B.C. vase painting. Richest and most powerful of the Greek lords in the Iliad, *he was commander in chief in the assault on Troy.*

patched trading missions, and–most enthusiastically of all–went to war.

Neither gold or silver nor anything at all precious was to be found in the baggage of the Greeks when they made their first appearance in history. They arrived in the peninsula that was forever after to be their home some time about 2200 or 2000 B.C., as immigrants from southern Russia or even farther east. Their villages were collections of dwellings, mud brick huts with the barest of furnishings. They buried their dead in mere shallow pits with either no gifts to help them in the next world or but a few objects of clay.

In Crete, however, just an easy sail across the water to the south, a people now known as Minoans (because of Minos, their legendary king) were enjoying a remarkably rich and sophisticated way of life. They had grown wealthy supplying overseas customers with Minoan jewels, Minoan fabrics, Minoan ceramics, and other products. Their network of trade reached as far as Italy and Sicily to the west, and the Levant to the east. At Knossos, Phaistos, and other sites, Minoan nobles lived in vast palaces with dozens of rooms filled with handsome pottery and magnificently decorated with wall paintings. These paintings record a life of luxury and elegance. Minoan women in revealing clothes loll about or, along with the menfolk, watch what appears to be an early version of bullfighting. "Bull-dancers," barely clad young men and women, vault over the horns with apparently fearless ease.

For centuries all this splendor to the south meant little to the primitive Greeks. They continued in their plain and bare existence. Then, certain of these erstwhile frugal farmers took a giant step into an age of gold. The ruler of Mycenae built himself a palace of stone, lavishly decorated. Its great central hall had a gaily painted floor and walls adorned by pictures of warriors and chariots and horses; an adjoining bathroom was painted blood-red. The building stood on a hill entirely circled by a forbidding defense wall two thirds of a mile long and twenty feet thick in places. Outside the citadel stood the houses of both rich and poor. Those of the rich were stocked with large storage jars for

Ajax, a leading Greek fighter in the Trojan War, retrieves the body of his slain comrade Achilles. Ajax killed himself soon afterward, but the loss of these two heroes did not save Troy from destruction by the ferocious Greeks.

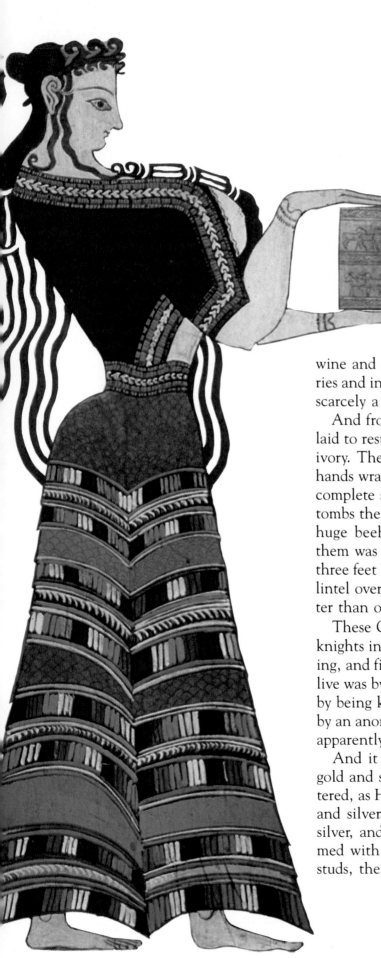

A highborn lady presents an ivory box as a religious offering in this fourteenth-century-B.C. fresco from the Mycenaean palace at Tiryns. She is wearing fashionable court attire that consists of a flounced skirt with an open bodice.

wine and oil and boasted such fittings as exquisitely carved ivories and inlaid furniture; those of the poor have disappeared with scarcely a trace.

And from this time on, at Mycenae, the honored dead were laid to rest surrounded by a wealth of objects of gold, silver, and ivory. Their faces were covered by masks of gold, their feet and hands wrapped in gold. One corpse, of a child, was clothed in a complete suit of gold–a glittering shroud. As time went on the tombs themselves got grander and grander, ultimately becoming huge beehive-shaped mausoleums. The most magnificent of them was nearly fifty feet in diameter and rose to a point forty-three feet high; it was made of massive stone blocks of which the lintel over the doorway is a Brobdingnagian piece weighing better than one hundred tons.

These Greek chieftains were rather like King Arthur and his knights in their ways. They, too, devoted their days to fun, feasting, and fighting–above all, the last. The finest way for a man to live was by gaining glory on the battlefield, the finest way to die by being killed in action. In both cases it was all made possible by an anonymous, faceless mass of subjects whose prime task was apparently to maintain their betters in resplendent luxury.

And it was resplendent–literally an age of gold or rather of gold and silver, for silver then was equally precious. Tables glittered, as Homer relates, with pitchers and bowls and cups of gold and silver. In Menelaus' household even the bathtubs were of silver, and Helen kept the wool she spun in a silver basket rimmed with gold. The heroes' swords were decorated with silver studs, their bows with tips of gold. Nestor, king of Pylos, had a

Clad only in a kilt, a broad-chested courtier carries a vase with tribute for a deity. In the sixteenth century B.C., when this palace fresco was painted in Crete, men wore kilts not only in ceremonies, but for war and hunting as well.

layer of gold in his shield, and one particularly well-heeled Trojan had a suit of armor made entirely of gold.

How did this age of gold come into being? How did communities of Greeks who had been content to be humble farmers for five or more centuries elevate themselves so dramatically? How were they able to afford to build palaces and huge tombs and city walls, to buy objects of gold and silver and ivory?

It was a world with ample chance for trading and for fighting. Across the Mediterranean were Egypt, still a great power though past its pyramid-building epoch, and Italy, a backwater, but both potential markets for Mycenaean goods. Across the Aegean, in Anatolia, was the Hittite Empire, renowned for its formidableness in warfare, and a string of walled cities leading down toward and along the Levant. The gold probably came from Egypt, where the pharaohs mined it in Nubia, the silver perhaps from farther north in Greece but more likely from Asia Minor, the ivory probably from Syria. How and when did the Greeks establish contact with these far-off places?

No one bothered to chronicle this economic revolution. The tombs and palaces that have been excavated at Mycenae and elsewhere are all anonymous. Homer, who took the heroic characters of this age as his inspiration, lived in the eighth or seventh century B.C.—as remote from the kings of Mycenae as we are from the knights of the Crusades. In any case, he was writing verse, not a chronicle. Yet he started with a hard core of history: actual people and events. This core has been borne out by what archaeologists have unearthed in the past century and a half.

At some stage the mainland Greeks must finally have learned

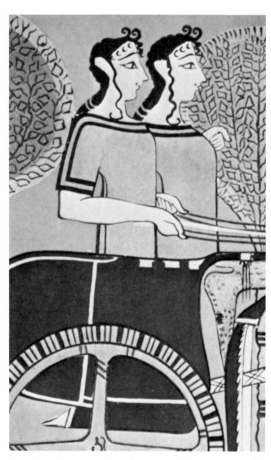

A pair of women in a fresco at Tiryns set out by chariot to accompany their menfolk on a hunt. With greyhounds and bronze-tipped spears, Mycenaean hunters left at dawn to pursue deer, boars, and wild bulls.

a lesson from the Minoans about acquiring wealth. They, too, turned to the sea, and with such success that soon they had a navy, which enabled them, shortly before 1450 B.C., to invade and conquer Crete. With a navy they undoubtedly also had a merchant marine, which enabled them to take over the lucrative maritime trade of the people they had conquered. It was now Greeks and no longer Minoans who shipped out ceramics, textiles, olive oil, and other products and brought in the gold, silver, and ivory from which their precious objects were fashioned; it was now Greeks who lived in sumptuous palaces, and gloried in the possession of treasure.

The men and women who lived amid the splendor at Mycenae, Tiryns, Pylos, and Sparta are not mere names but, in Homer's account, vivid personalities, some of them mortals, some gods and demigods, but all pulsating with life. The men are arrogant, cannot be crossed in any way. They have hair-trigger tempers; they explode at the slightest feeling that they are not getting their due. The very theme of the *Iliad* is Achilles' Homeric fit of sulks, which almost cost the Greeks the war. Agamemnon had angered Achilles by depriving him of an item he had been awarded in a division of loot.

A raid had netted, among other things, two lovely women: Chryseis, whom Agamemnon claimed, and Briseis, who was given to Achilles. But Chryseis, as the *Iliad* relates, turned out to be the daughter of a priest of the god Apollo. When Apollo sent plague down on the Greek camp in answer to the father's agonized prayers, it was clear she had to be returned. Agamemnon at first refused to do anything about it, but he eventually sent Chryseis home and took Achilles' woman as his own. Achilles retired to his tent in a rage and stayed there, watching his fellow Greeks die by the hundreds while he nursed his pique.

To make matters worse the heroes were men of the hot-blooded South. They would gnash their teeth, tear their hair, break into floods of tears; the thought of maintaining a stiff upper lip never crossed their minds. It is the women in the *Iliad* and the *Odyssey* who must do that. Their husbands loved them, honored them, adorned them with splendid jewelry, enjoyed their

company at gatherings in the palace–but there was no question of who was in control at all times. Husbands died in glory on the battlefield; wives got carted off to a lifetime of slavery. Only one time in the *Iliad* does a woman–Agamemnon's wife, Clytemnestra–kick over the traces. The king had made a human sacrifice of their daughter and then brought home a concubine from the war. This was too much, even for a Greek wife; Clytemnestra murdered him. She went down in legend as villainess par excellence.

But Clytemnestra is the exception. As Homer sees these people, there are no evildoers, just men and women working out their fate. It was proper for Achilles to refuse to give way, proper for Agamemnon to take whatever he wanted. Men may have died while they wrangled, but that was less important than a hero's assertion of what was his due. And it was a hero's due to live amid splendor, enjoying wealth and the good things in life. He had, however, to earn this, to earn the right to order people around and to siphon off a disproportionate share of his country's riches. This he accomplished by achieving glory on the battlefield and by his success in war.

Wealth consisted in good part of the things one put on a table at dinnertime. The heroes were great trenchermen; their palaces resounded with the cheerful din of banquets, and these were occasions for hosts to display their riches as well as their hospitality. As guests took their places, servants poured water from golden pitchers into silver basins so they could wash their hands. Then there were golden pitchers to hold the water for mixing with wine (Greeks drank their wine well diluted, generally two parts of water to one of wine; only alcoholics and barbarians took it straight), as well as golden bowls for holding the mixture, and golden goblets for drinking. A host had to make a show with pitchers, bowls, and goblets since no other tableware was used. People ate with their hands–hence the careful washing upon sitting down–and without any plates: portions were slapped right down on the table.

The rich of course displayed their wealth on their persons as well as their tables. Mycenaean women, to judge by what has

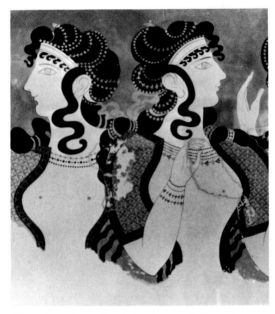

Their hair adorned with beads, two ladies in breast-baring jackets observe a palace function in this fresco from Crete. Women of the Mycenaean era, unlike those of later classical Greece, socialized freely in public.

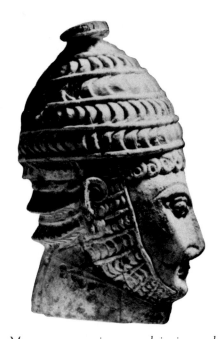

This Mycenaean warrior, carved in ivory about 1300 B.C., wears a helmet decorated with rows of boars' tusks. As many as forty animals had to be killed to obtain the tusks for one helmet, which was the mark of high rank.

turned up in their tombs, not only wore gold and silver rings, earrings, beads, tiaras, and the like, but also sewed gold sequins all over their clothes and gold stripping along the hems. Homer does not say much about women's clothing except to describe it as "shimmering" and "long-trailing," but the wall paintings of Mycenae show what it was like: a woman, at least when dressed up for company, wore a gown with a short-sleeved tight bodice that left the breasts exposed, a pinched waistline, and a tiered, bell-shaped skirt that, reaching to the floor, must indeed have been "long-trailing."

It was no doubt an outfit like this that Hera, queen of the gods, donned to draw Zeus' attention away from some mischief she was creating in the fighting between Greeks and Trojans. She had decided to seduce him–even though, says the poet with Homeric candor, "he was hateful to her in her heart." After perfuming herself with a scent used exclusively by goddesses, she: "put on an ambrosial gown. . .with many figures on it and pinned it with golden clasps across her breast. She circled her waist with a belt fitted with one hundred tassels. In her ears, carefully pierced, she hung earrings with triple pendants." Zeus did not like his wife any more than she liked him, but this vision of beauty was too much for him: "When he saw her, desire enveloped his strong mind, just as when the two of them for the first time had gone to bed together and made love, keeping it hidden from their parents."

Homer's heroines displayed their possessions, as Hera did, in the palace halls and bedchambers. His heroes displayed theirs on the battlefield: on swords, bows, daggers inlaid with gold and silver, even pieces of armor decorated with precious metal. The item that was most prized, however, owed its value to neither gold nor silver: this was a boar's-tusk helmet, a sort of leather skullcap all over which were sewn boars' tusks that had been sliced into oblong plates and then pierced with holes for thread. When Odysseus, for example, went off on a daring expedition behind the Trojan lines in order to gather intelligence: "He put on his head a helmet of ox-hide ... On the outside the white tusks of a flashing-toothed boar were closely set."

While gold and silver tableware and jewelry conferred prestige upon the owner, they also served other, more practical purposes. In an age that had not yet learned the coining of money, objects of value doubled as liquid capital. Today we have our banknotes or bonds or stock certificates which we lock up in a safe-deposit box; Homer's heroes had their objects of value which they locked up in the palace storeroom. Anything of gold was a natural candidate; gold has always been rare, and in the case of Mycenae and the other Greek centers had to be brought from afar.

Silver, too, had to be imported, most likely from overseas. And, surprising as it may seem to us, bronze was also precious. Bronze is copper alloyed with tin; in ancient times the tin content ran rather higher than now. The Mycenaeans had to obtain both metals from abroad. The copper probably came from Cyprus, where there were deposits so rich that the name of the island is the source for the name of the metal in several languages including English. (Our word "copper" derives from it. The Latin *Cyprium* became *cuprum* and finally, in Medieval English, *coper.*) The tin must have come from farther away, probably from deep in Persia, since there is none whatsoever in the Mediterranean area.

As a consequence a suit of bronze armor was something only the well-to-do could afford. There was a long-standing, unwritten property qualification for a soldier in a Greek army: he had to provide his own uniform and weapons. Therefore, for many decades only men with money enough for bronze cuirasses, helmets, swords, and spears were able to serve. And certain bronze objects were reckoned as riches—not little things, to be sure, not cups and bowls, but kettles and tripods (the stands used for setting a pot over a flame). In Odysseus' storeroom, for example, "gold and bronze lay piled up." One of the prizes for the winner of a chariot race or other competition might be a tripod of bronze. To coax Achilles out of his tent and back onto the battlefield at Troy, Agamemnon offered him a king's ransom in gifts, not least among which were twenty "glittering kettles" and seven "tripods that had never seen the fire."

Agamemnon's offer exemplifies yet another important use for

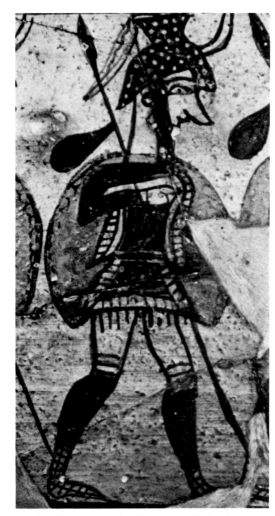

Outfitted with a sack of food attached to his spear shaft, a Mycenaean infantryman marches off to battle in this detail from a thirteenth-century-B.C. vase painting. His armor is probably made of leather, plated with bronze disks.

objects of value—as gifts. The Greeks of this age, like many primitive peoples today, gave gifts not as an act of disinterested generosity but as part of an arrangement that both parties understood perfectly: the giver expected a proper recompense at the appropriate time. And in the society Homer writes about, the gifts most often were the gold cups and silver bowls and bronze kettles that the wealthy kept in their storerooms. One common occasion for gift giving was at the parting of a guest. The richer a host was, the finer the gifts he provided; Menelaus, for example, gave Telemachus, among other things, a splendid silver mixing bowl with a gold rim.

About 1200 B.C. this age of gold came to an end. After that date there are no more grandiose tombs, indeed no grandiosity or opulence of any sort. It was a time of upheaval throughout the Mediterranean world. The palaces show signs of having been burned; the end must have been violent, so violent that when Greek civilization reemerges, it is at low ebb: people are back to a frugal agricultural existence, to the mud brick houses, and to the bare and undistinguished graves of the centuries before the great leap to wealth and power. There may have been earthquakes and volcanic eruptions. But the cause may have been man not nature. Egyptian records reveal that at just about this time the pharaohs were hard put to withstand a massive invasion from a mysterious horde they called the Sea Peoples. These Sea Peoples left a path of devastation through Asia Minor and the Levant before they were halted at the borders of Egypt. Perhaps it was they who fired the palaces at Mycenae and elsewhere, who delivered the coup de grace to early Greece's golden age.

Whatever the cause of the destruction, two things, fortunately, survived: people's memories, which preserved enough to inspire the *Iliad* and the *Odyssey*, and the objects archaeologists have unearthed. The Greek word for treasure means literally "something laid away." And what the Mycenaeans laid away in their tombs and their palace storerooms—their diadems and jewelry, their prized weapons and masks—are more than gold and bronze. They are treasures that bear witness to the beginnings of our civilization.

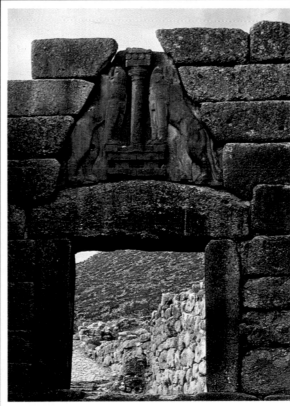

Set into the massive defense wall, the gateway to Mycenae is ten feet high and crowned by a pair of sculpted lions, probably symbols of the king's authority.

The aggressive nobles of Mycenae and other early citadels in Greece relished a variety of precious stones and metals, but above all gold. Scarce in Greece, gold had to be imported, probably from Egypt, in exchange for wine, textiles, and perhaps mercenary soldiers. To show their status, rulers had the costly metal turned into finely crafted drinking vessels, decorations on bronze weapons, and personal adornments for public display and royal burial.

For these and other treasures of silver, ivory, alabaster, and crystal, the Mycenaeans borrowed ideas and techniques from areas they traded with or plundered. Mycenaeans at times even employed artisans from Crete. But the dominant Greeks constantly imposed their own tastes, evolving a style unique in its day.

Created over a period of four hundred years, many of these riches were destroyed after the Mycenaean empire collapsed in the twelfth century B.C. The pieces here and on the following pages, recovered from graves, testify to the splendor that later Greeks, in poem and legend, attributed to this age of heroes.

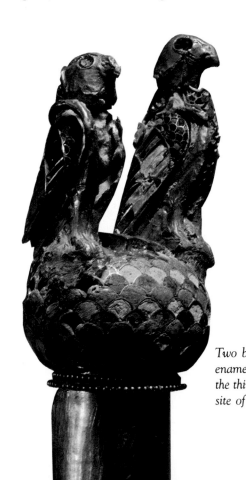

Two birds of prey, their wings inlaid with colored enamels, top this princely scepter. Probably made in the thirteenth century B.C., it was discovered at the site of a Mycenaean colony on Cyprus.

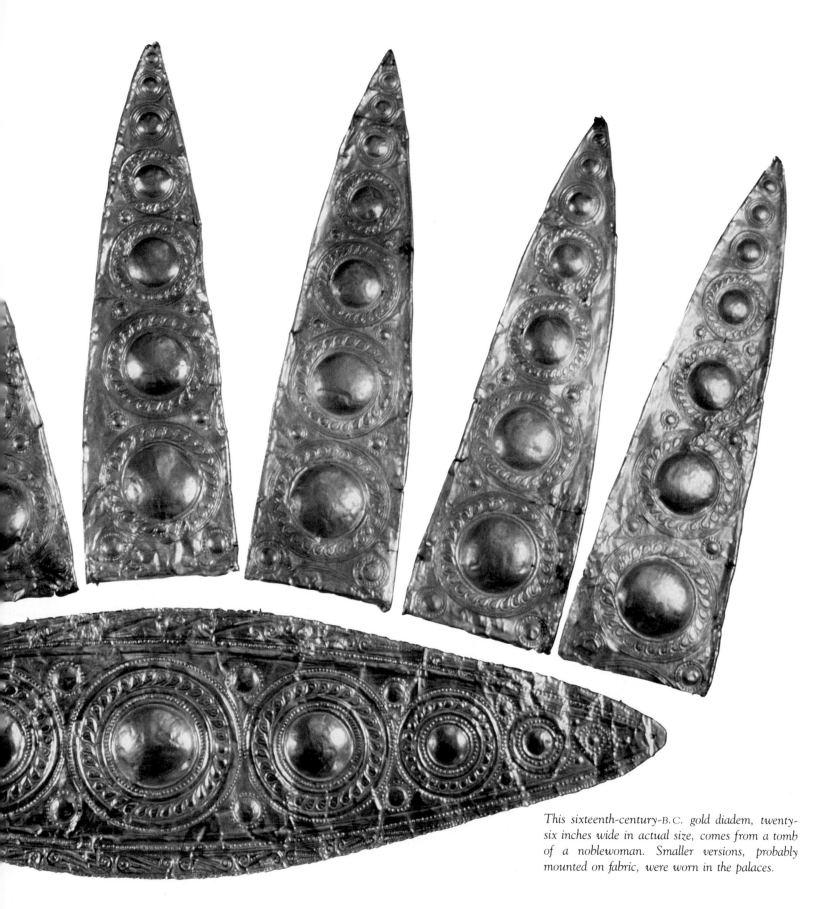

This sixteenth-century-B.C. gold diadem, twenty-six inches wide in actual size, comes from a tomb of a noblewoman. Smaller versions, probably mounted on fabric, were worn in the palaces.

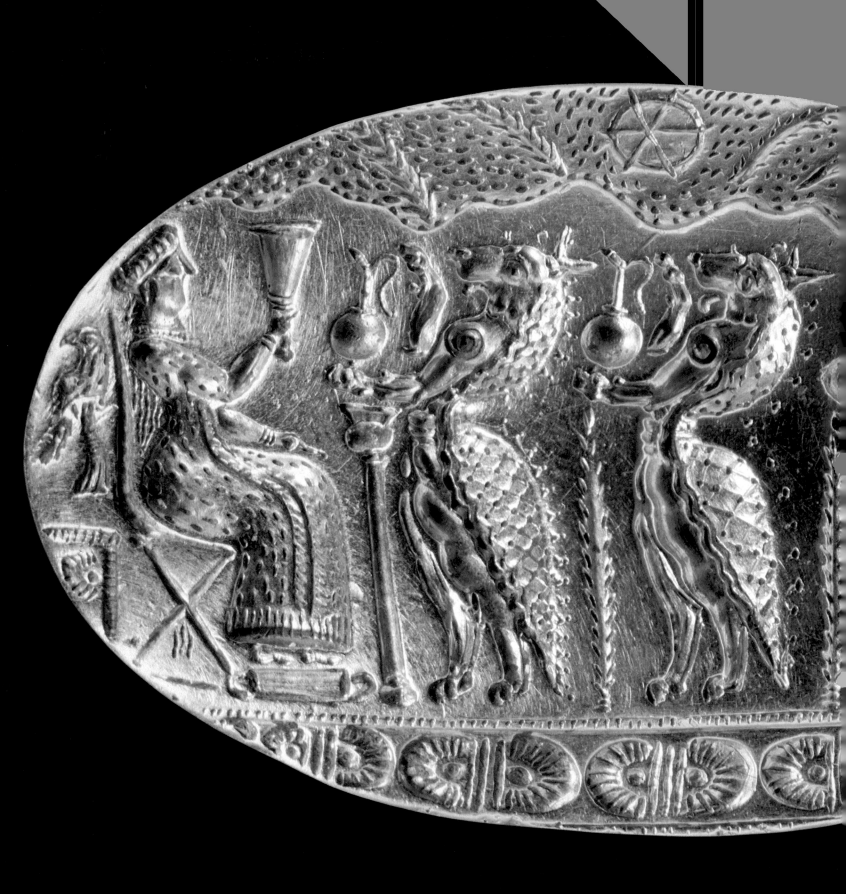

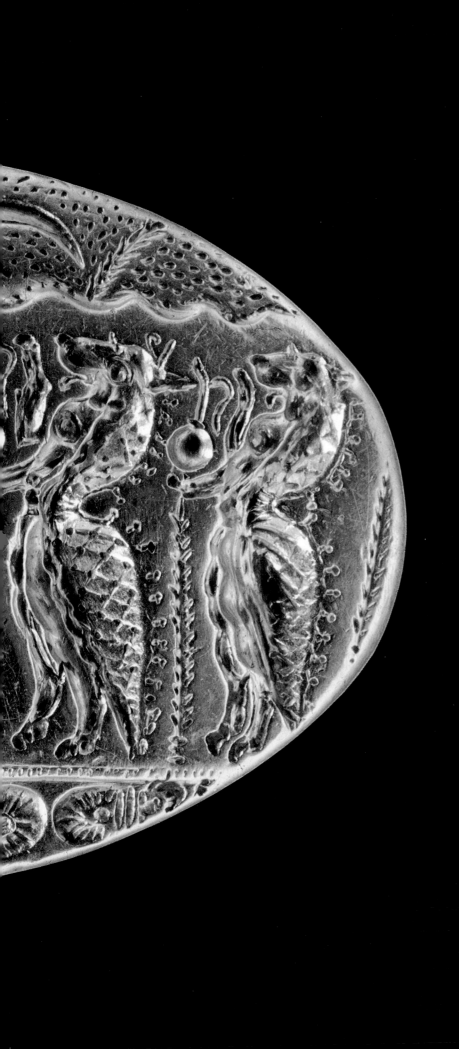

Above, a man tames a lion on a seal of cyanos, a semiprecious stone. Below are two more lion-tamers, on a chalcedony seal.

In a mystical fertility rite cast and incised in gold, four hybrid demons with stalks of wheat in front of them carry offerings to the Aegean mother goddess. The Mycenaeans, whose gods foreshadowed those of classical Greek myth, also observed the cult of the goddess. This scene is from a fifteenth-century signet ring found in a tomb at Tiryns. More than two inches across, it was probably the insignia of a nobleman. Signet rings, along with seals of semiprecious stone such as the two above, were used as talismans and to stamp property. The Mycenaeans also prized them as jewels, apparently displaying them on a wrist cord or necklace, as they were often too small to have been worn on the finger.

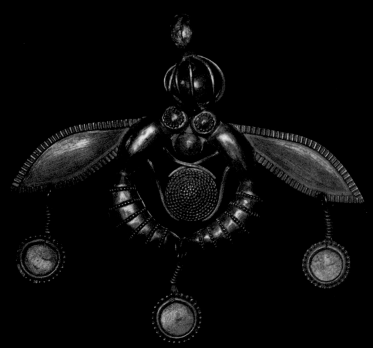

BEE PENDANT

The Mycenaeans loved ornaments, and for their finest jewelry turned to nearby Crete. All the pieces here, made during the seventeenth and sixteenth centuries B.C., were executed or inspired by Cretan goldsmiths, who excelled at creating elegant shapes and designs. The pectoral shown more than twice its actual size at right, part of a treasure found on the island of Aegina, is hung with gold disks and ends in two heads cut in a classic Greek profile. On the pendant (above, right) recovered from Crete itself, two bees clasp a "honeycomb"—a disk decorated with dozens of tiny gold balls, painstakingly soldered on in a technique known as granulation. Another pendant (opposite page, right) has a nature god holding a water bird in either hand. The gold plaque in the shape of an octopus (opposite page, left) was probably sewn onto clothing. Mycenaeans evidently covered themselves with such plaques and gold disks; in one grave, nearly seven hundred were found among five men and women.

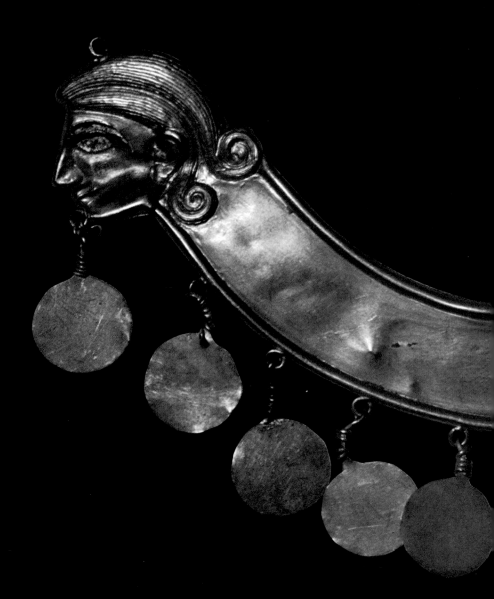

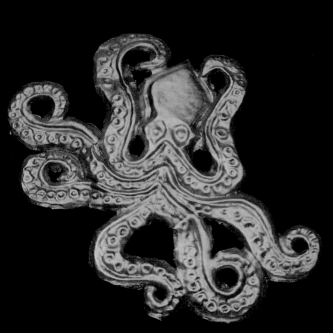

OCTOPUS-SHAPED PLAQUE

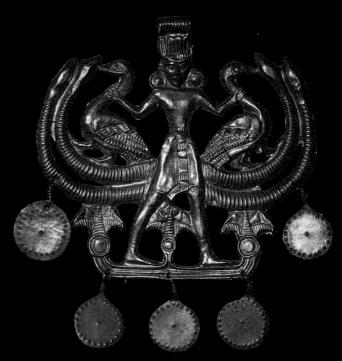

PENDANT WITH NATURE GOD

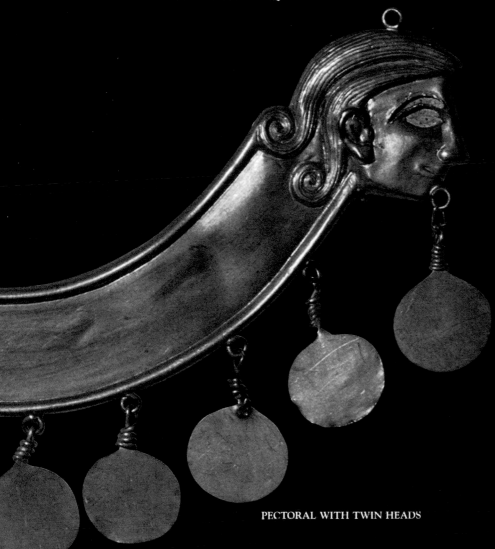

PECTORAL WITH TWIN HEADS

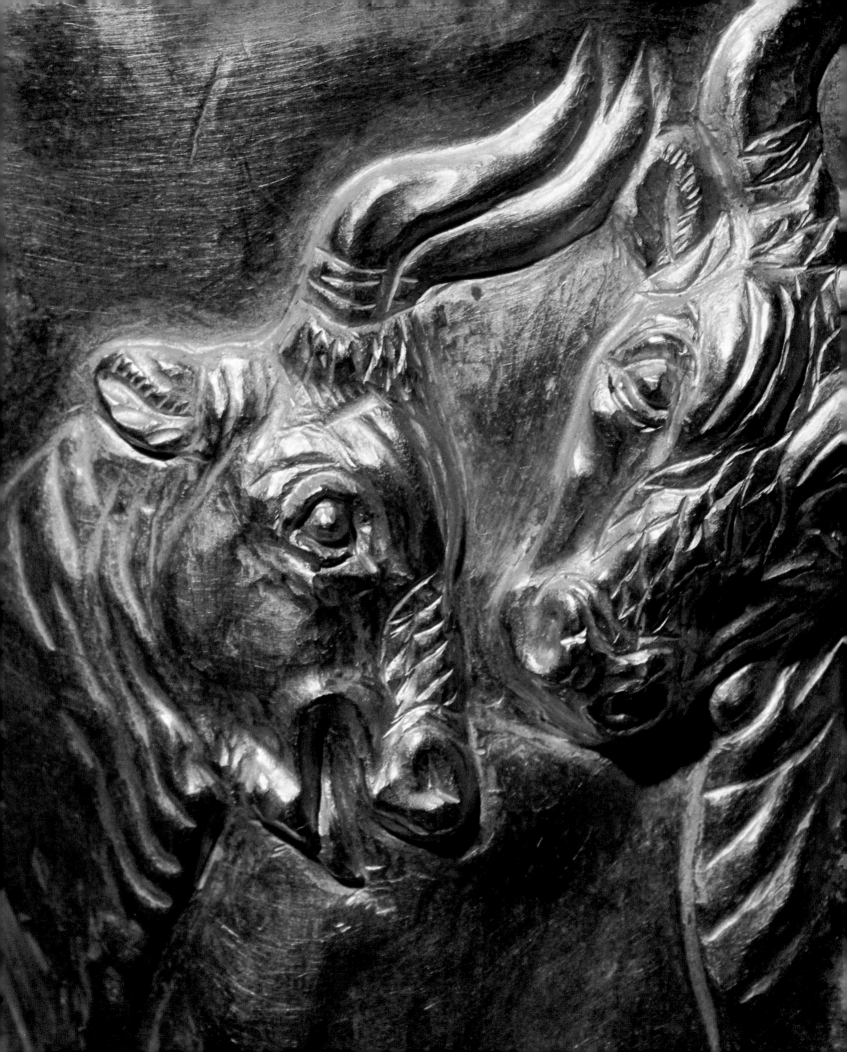

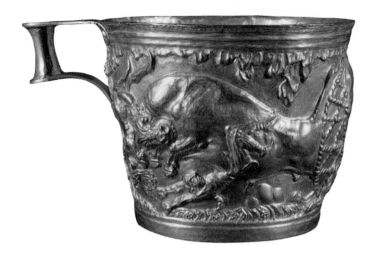

GOLD CUPS, FIFTEENTH CENTURY B. C.

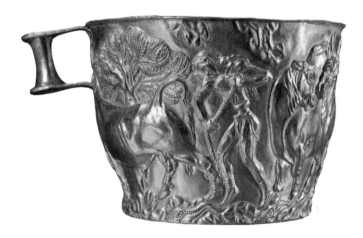

A bull nuzzles a cow in the scene, left, from the leading edge of the embossed gold cup above. Though less than four inches high, the two figures, in high relief, are astonishingly realistic. The cow is a decoy set out to entrap the bull; in the next scene on the cup, the animal has been captured by a herdsman, who tethers it by the hind leg. On the cup at top are charging bulls, one of which is goring and trampling his would-be captors. The two cups rank among the finest examples of goldwork from the Mycenaean age. Known as the Vaphio Cups, they were found in the tomb of a wealthy prince who ruled the province of Vaphio, near Sparta, and were undoubtedly used at his banquet table—not just as palace ornaments.

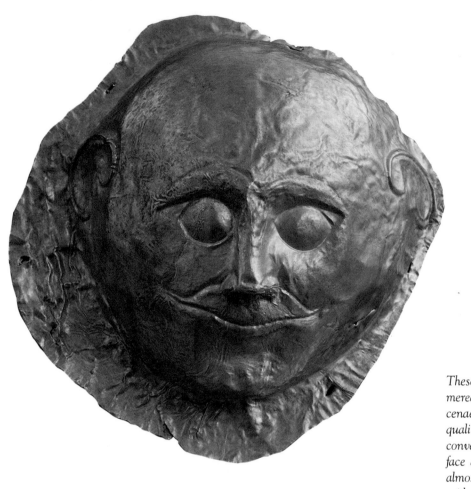

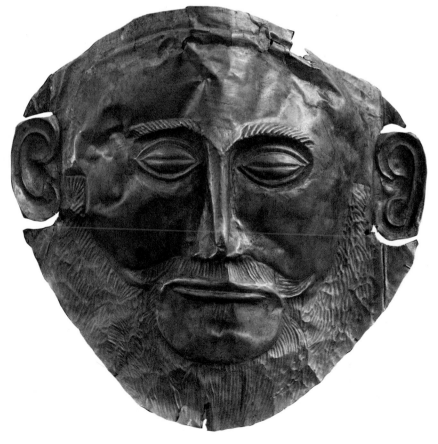

These inscrutable faces, in burial masks of hammered gold, belong to sovereigns who ruled Mycenae in the sixteenth century B.C. Though the quality of the portraiture is primitive, each mask conveys a sense of character. The plump, moonlike face above smiles, while the one at right is grim, almost sneering. The bearded visage below is evidently that of a proud warrior-king, his imperious features so striking that the mask has been known, mistakenly, as King Agamemnon's. No other masks like these have been found elsewhere in the Aegean. They may have been inspired by the gold faces on the coffins of Egyptian pharaohs.

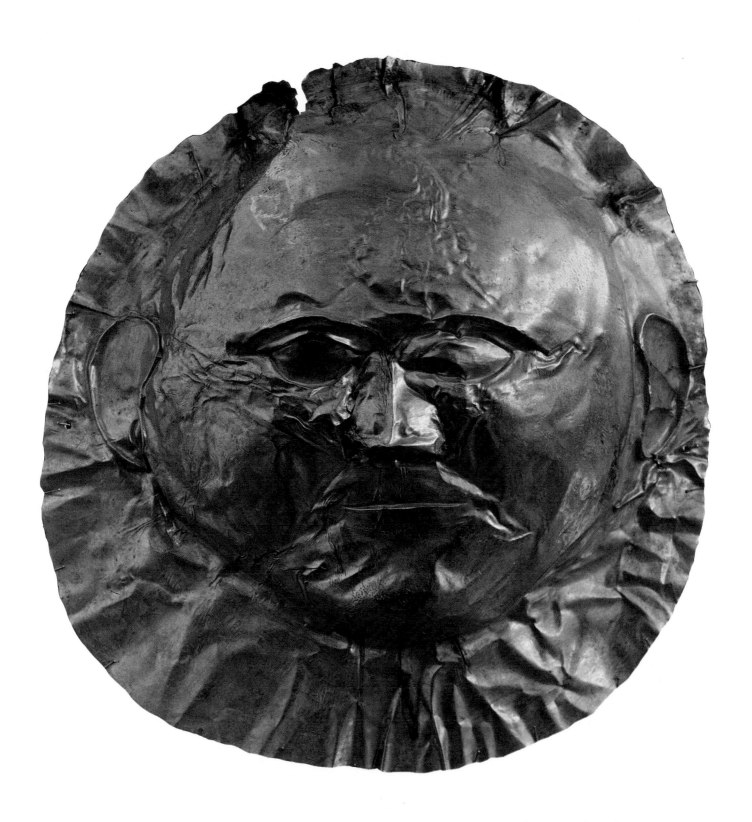

OVERLEAF: *This duck-shaped bowl of rock crystal, nearly six inches long, probably held cosmetics. Using tough reeds as bits, which were twirled in sand, the craftsman hollowed out the bowl by drilling. He then rubbed the sides with an abrasive, tapering their thickness to an eighth of an inch.*

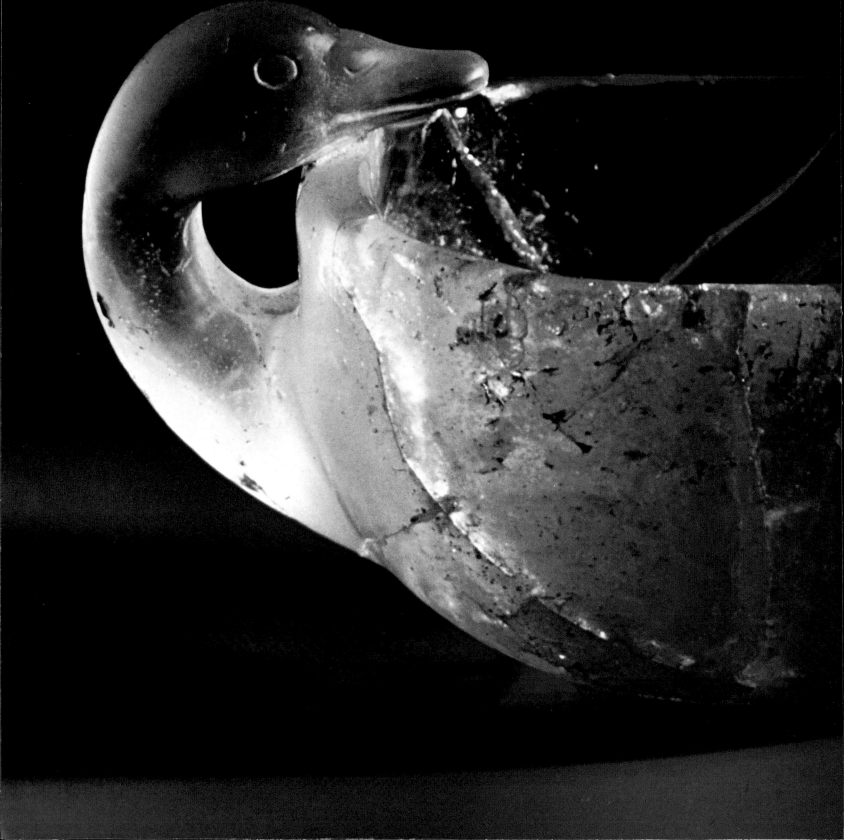

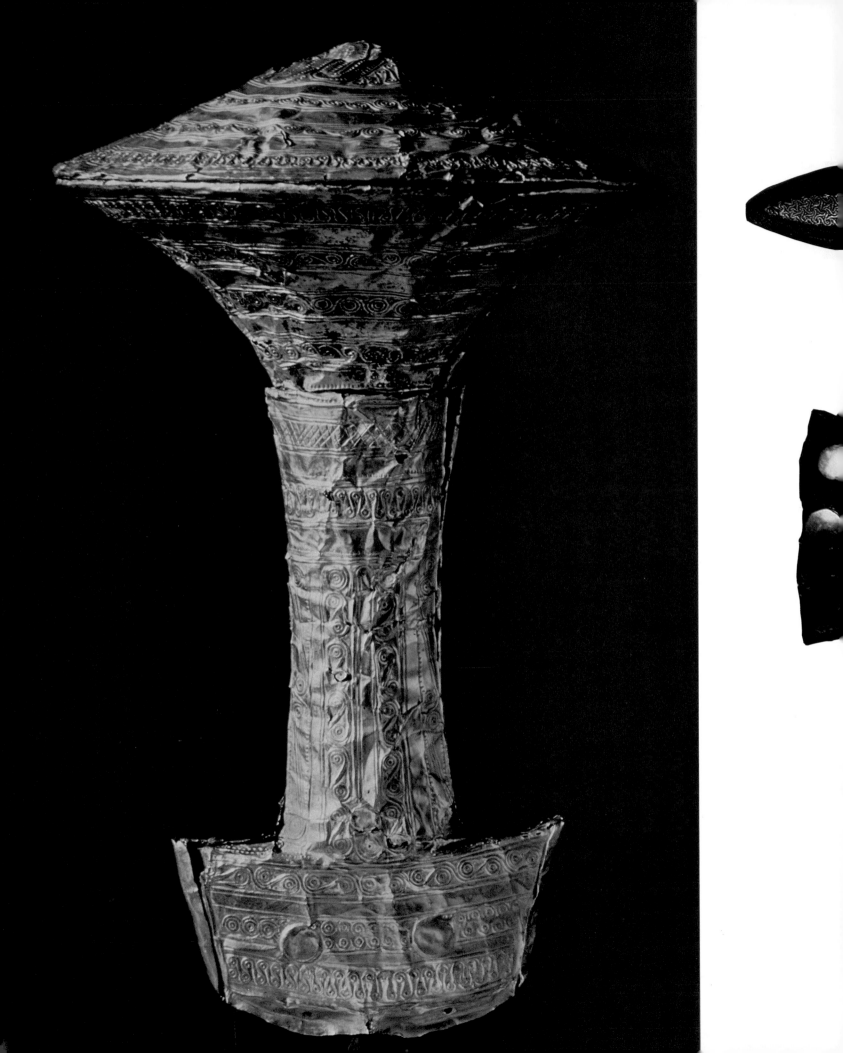

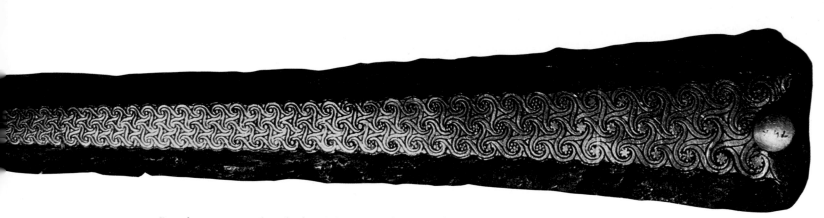

Prized possessions of warlords at Mycenae in the sixteenth century B.C., these two nine-inch bronze dagger blades bear finely decorated metal strips. On the blade above, an elegant network of spirals has been incised on a band of gold. Below, hunters battle a lion in a scene rendered with inlaid figures of gold and silver (detail, overleaf). The owners of these weapons must have been proud of them, for they combine incomparable workmanship with a subject dearly loved by Mycenaeans.

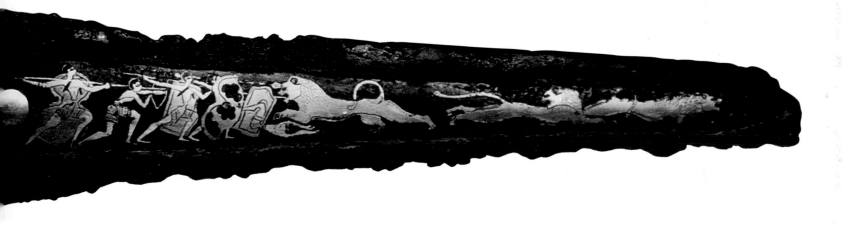

Finely embossed gold plate encases this fifteenth-century-B.C. bronze sword handle (opposite), the largest ever found in a Mycenaean tomb. Nearly ten inches high, it was discovered in the grave of a prince on the island of Staphylos.

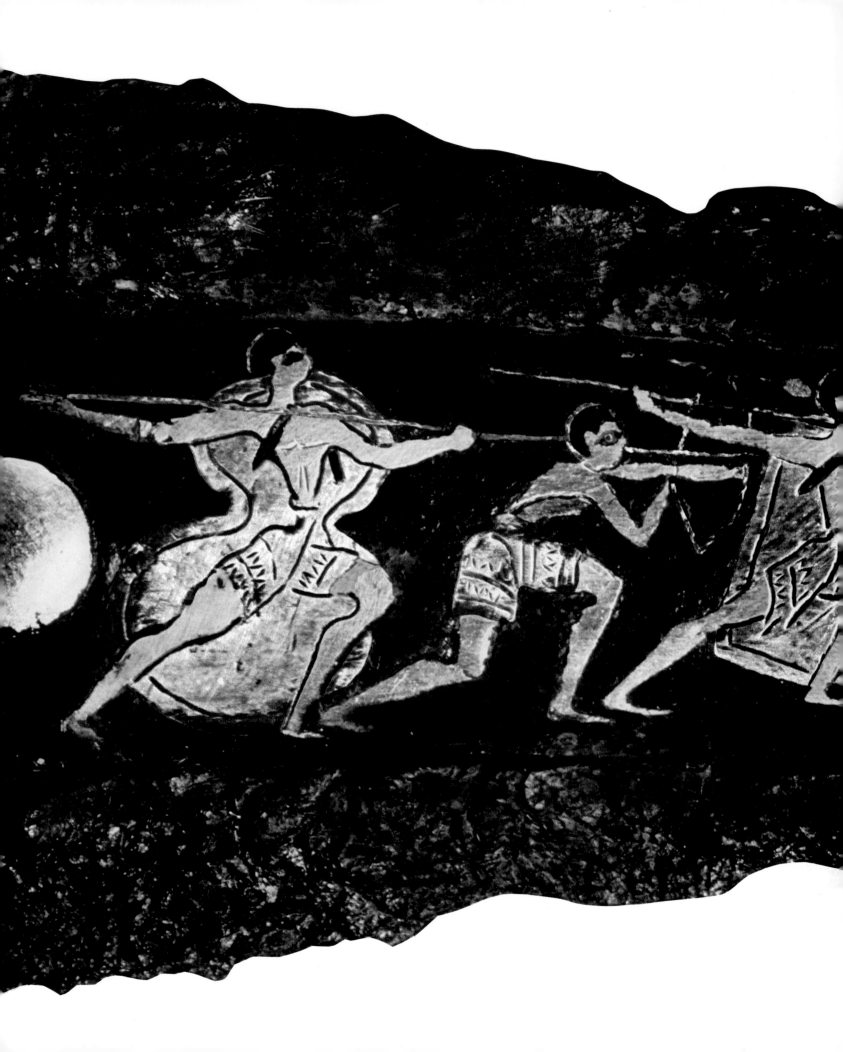

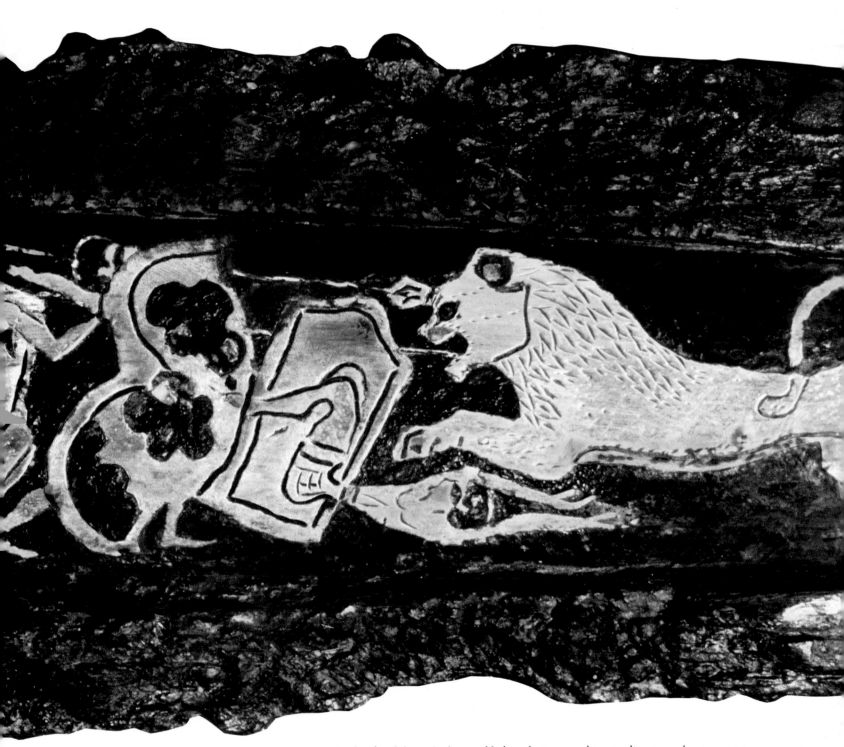

In this detail from the bronze blade at bottom on the preceding page, hunters meet the charge of a wounded lion that has felled their leader.

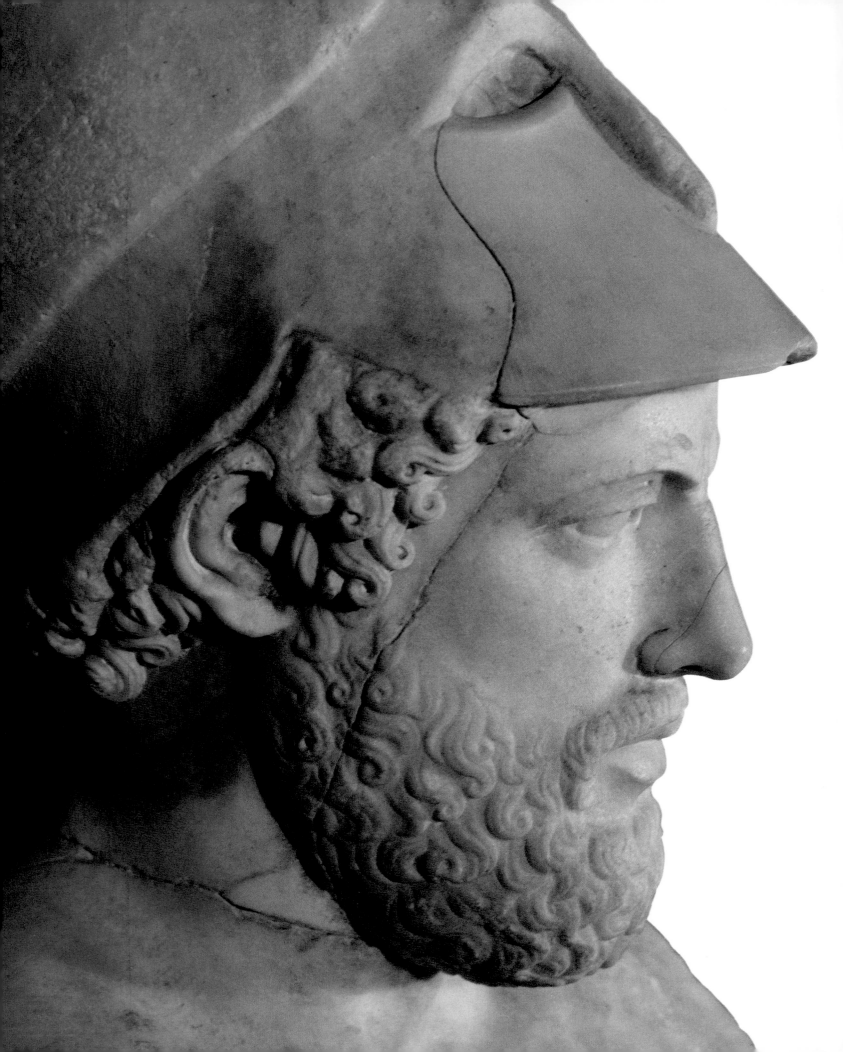

II

PERICLES

AND THE TREASURES
OF DEMOCRACY

The invasion that devastated Greece between 1300 and 1200 B.C. left her people poverty-stricken and relatively isolated on their peninsula and islands. For the next two centuries they passed through a period of darkness, and when they emerged it was with a new way of life. They were still disunited and quarrelsome: a loose group of mutually suspicious villages. But their politics had changed. Powerful kings who ruled autocratically over masses of subjects and were maintained by them in expensive splendor were gone. Powerful states that could afford fine palaces and massive defense walls were gone. In their place had arisen a multitude of new farming communities governed by councils drawn from a thin upper crust of the wellborn and the well-to-do.

One of these small principalities eventually rose to be the foremost Greek state of the day—Athens. There about 450 B.C. an Athenian aristocrat named Pericles gathered up the reins of power by attacking the council of elders, the old fogies of the aristocratic establishment. The next fifty years or so was one of

Commerce, art, drama, philosophy, and architecture all flourished in Athens during the time of Pericles (opposite)—the colossus of his age.

those rare moments in history when, at a certain time in a certain place, there is a burst of inspired creativity. In every sphere –art, literature, thought–Athens under Pericles rivaled Florence under the Medici or England under Elizabeth I, perhaps even surpassed them. For it was there and then that Herodotus and Thucydides wrote the Western world's first preserved histories, Aristophanes its comedies, and Sophocles and Euripides put on their greatest tragedies. It was there and then that the first democratic government, whose lawmakers passed the resolutions authorizing the building of the queen of Greek temples, the Parthenon, came into being.

It is rightly called the age of Pericles because, although he did not live through it all (he died of plague in 429 B.C.), he shaped it, guided it, was its eloquent spokesman. In one way, Pericles was like a renowned statesman of our own century, Franklin D. Roosevelt: he too was an aristocrat whose political base was just the opposite of his own class. It was the little people of Athens –artisans, shopkeepers, have-nots in general–who cast their votes in favor of the motions he introduced. By their will he came to power.

In character and manner he also resembled yet another great man of this century, Charles de Gaulle. Like de Gaulle, Pericles was authoritarian, dignified, aloof–keeping people at a distance, acting as if he were superior to the common run of mortals; his enemies, like de Gaulle's, made jokes about his behaving as if he were God Almighty.

Pericles was a gifted orator in the grand, lofty style. No rival could match his golden flow of words. No rival could match his uncanny ability to persuade. "When I wrestle with Pericles," lamented an opponent, "and pin him to the mat, he argues he wasn't pinned–and convinces the very people who saw it."

He was a man of principle. Once, when he and the playwright Sophocles were serving as co-commanders of the Athenian forces, Sophocles pointed out to him a good-looking young boy; "Sophocles," observed Pericles, "a commander has to keep not

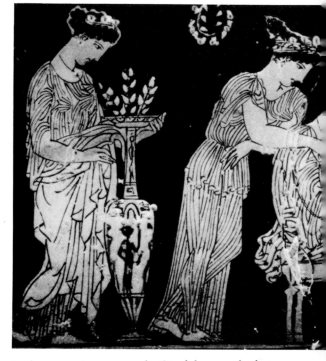

In the women's quarters of a Greek home, a bride-to-be (on the right) waits for her wedding to begin. Two friends play affectionately with a pet dove as another arranges flowers in a loutrophoros–a special vase used to bring water for the bride's bath on her wedding day.

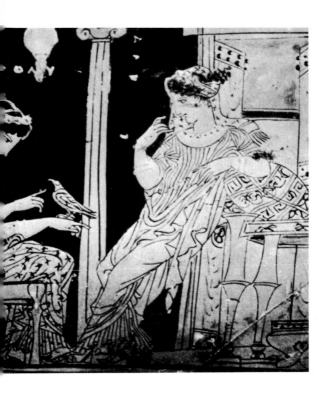

only his hands but his eyes clean." A true moral sense bound him, not mere convention. As a young man Pericles had married an eminently proper blueblood, a union unquestionably arranged, as was the way at Athens, for family and financial reasons. He then fell in love with a courtesan named Aspasia. Like all women in her profession, she had been trained in the art of entertaining men, but unlike most of the others, she was a person of outstanding intellect. It was this that drew Pericles to her.

He arranged an amicable divorce from his wife and, in his Olympian fashion, as deaf to gossip as he was to political abuse, moved Aspasia into his house as his concubine, living devotedly with her until his death. He loved her dearly, even kissing her in public ("twice every day, on leaving for business and on coming back," the Greek biographer Plutarch gravely reports), which was outrageous behavior in Athens in the fifth century B.C. Wives were not even seen in public, much less kissed; their husbands kept them as strictly secluded as Muslim husbands do today. Pericles cherished Aspasia, honored her, yet did not deck her out with gold and silver jewelry nor serve her from golden goblets. This was an age and place that valued sculpture and architecture over precious metals, that had unorthodox views on what constituted objects to be treasured.

Even before the age of Pericles, communities like Athens had become the distinguishing mark of Greek civilization. They were very special in nature. Though consisting of nothing more than an urban center and the surrounding farmlands, by the middle of the sixth century B.C. each was an independent state boasting its own government, code of laws, tax system, patron deity, coinage, import duties, army (navy, too, if the community was on the sea), and so on. The Greeks called such an entity a *polis* (whence our English words "polity," "politics," and the like), which is usually translated "city-state." This is not quite exact. A polis was certainly a state, but most were too diminutive to be called cities. They were rather what we would term towns, even villages. Only the biggest of them in their prime, such as

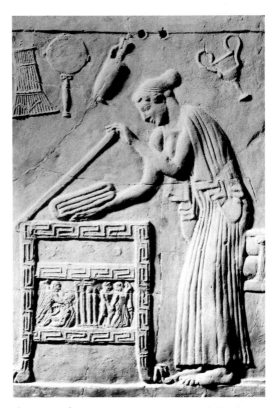

A woman lays a garment into a carved chest, in a scene from a terra-cotta relief. In fifth-century Athens, women lived a life of secluded domesticity whereas their husbands, busy with city affairs and parties, were seldom home.

Athens in the age of Pericles and after, ever achieved the size to merit the name.

Before Athens began its climb, it was no different from any of the other Greek city-states that had emerged over the centuries. It had its artisans and its slaves: ironically, the economic base of the city that invented democracy was slave labor. It had its ruling class, which, while considerably better off than those they ruled, were by no means men of great wealth able to go in for ostentatious display. But then toward the end of the sixth century B.C., the Athenians made a daring political move. They took the power to govern out of the hands of the council of aristocrats and the wealthy, which had held it for centuries, and instituted a democracy. (The vote belonged only to free Athenian males; no one else took part.) This brought Athens fame—but only later. What brought her immediate fame—indeed catapulted her into it—were the Persian Wars.

Persia, the richest and strongest nation of the day, ruling an empire that reached from India to Egypt, twice attempted to invade Greece, in 490 B.C. and again in 480. Both times David threw Goliath back. The first time Athens, still a very young democracy, did it single-handedly; the second time she spearheaded the defense of all the Greek cities. Then, to make sure there would be no more invasions, Athens organized a voluntary league consisting of the Greek city-states on the islands of the Aegean and along its coasts; all were to chip in to maintain a navy big enough to thwart any future Persian thrusts.

In short order the league was transformed from a collection of voluntary participants into an Athenian empire: the contributions became compulsory tribute, the allies—as the members were called—became subjects, most of the ships in the navy came to be manned and commanded by Athenians, and, eventually, the league treasury, originally located on a sacred island carefully chosen for its neutrality, was moved lock, stock, and barrel to Athens. The "contributions" turned out to be greater than the expenses, a surplus developed, and Athens, instead of lowering

the rates or returning the excess, pocketed it. Thereby Athens became that rara avis among Greek city-states, one that was rich enough to spend money on itself on a grand scale. This happened just about the time that Pericles achieved prominence.

Life in Periclean Athens (or any Greek polis) was anything but free and individualistic. The citizen body was a tight group held together by almost familial bonds. And they held one truth above all others to be self-evident: that the polis came first and the individuals who made it up were a distinct second. Citizens assigned top priority to what they could do for the state rather than for themselves. The leisured and the working classes alike willingly gave up their lives in its defense; the leisured gave their time also for its governing. Inevitably neither paid the kind of attention to their private concerns, to their persons or dwellings, that people usually do in other societies. Agamemnon would have considered Pericles' house—no doubt among the finest in Athens—a hovel. One could not tell a slave from his master by what they wore in the streets.

In the world of these city-states, unpretentious on principle, there was clearly no place for costly objects, for vessels of gold and silver. In fact, they were frowned upon. A man was to adorn his polis, not his person, flaunt his patriotism, not his purse. Yet every society, even the most unpretentious, has its objects of beauty and value, if not of precious metals then of something else. From about 600 B.C. for the next two hundred years or so, the Greeks prized above all the pottery turned out in the shops of Athens. These are what they displayed on their tables, put into their tombs, gave as gifts, dedicated to their deities as votive offerings. Made out of common clay, they were relatively cheap: big pieces from shops of the highest repute cost only two drachmas, less than a gallon of olive oil or a pig (three drachmas), less than a table (four), far less than a sheep or goat (ten to fifteen). It was the artistry that went into them, their graceful shape and superb decoration, that made them treasures—for the Athenians and for all time.

TEXT CONTINUED ON PAGE 52

A muscular, bearded carpenter works on a chest in his shop as a woman looks on. The Greeks kept their artisans busy, prompting the playwright Menander to write, "there's only one security in life/and that's to have a trade."

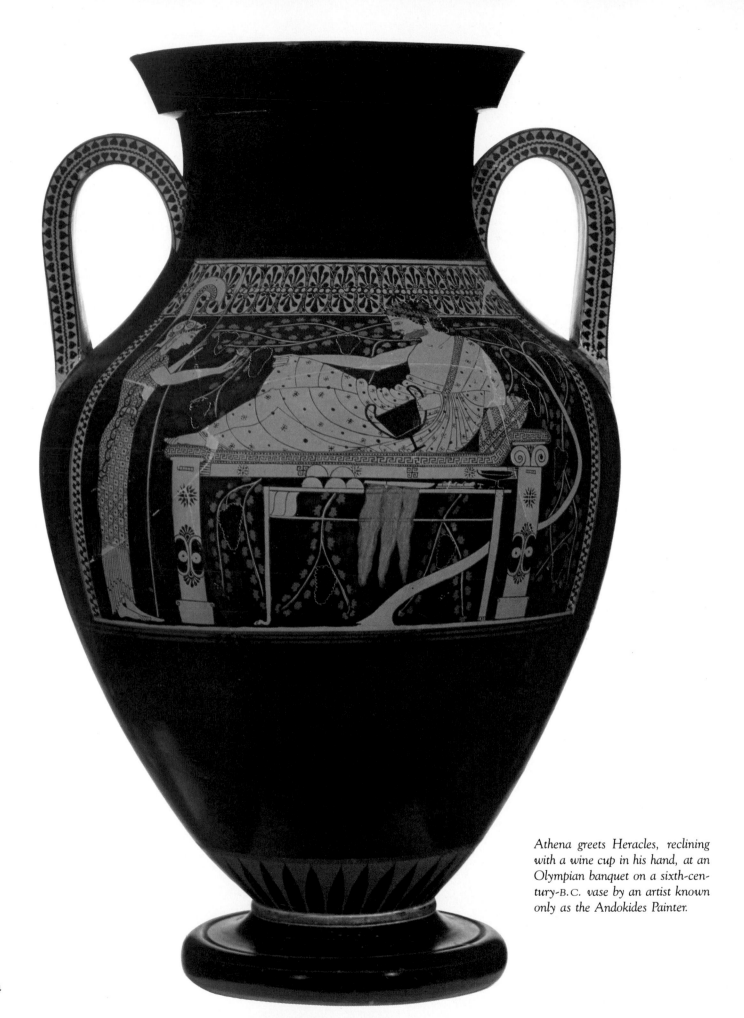

Athena greets Heracles, reclining with a wine cup in his hand, at an Olympian banquet on a sixth-century-B.C. vase by an artist known only as the Andokides Painter.

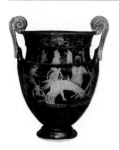

VOLUTE KRATER
mixing bowl

OINOCHOE
pitcher

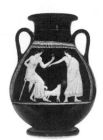

KANTHAROS
drinking cup

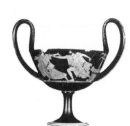

PELIKE
wine jar

HYDRIA
water jar

THE IDEAL OF THE VASE

We like beautiful things, but don't spend a fortune on them," said Pericles in a discourse on Athenian character. He could have been speaking of the vases that adorned the city's households—everyday, utilitarian objects so lovely that the phrase "Greek vase" has become synonymous with perfection in art. The beauty is in the shape: near the end of the sixth century B.C., Athenian potters achieved a subtle elegance of design. A row of vases, like the selection above that would have been seen at an Athenian party, has an almost melodic quality, a voluptuous rhythm of curves.

As the potters were developing vase shapes, Athenian painters achieved their own advances in rendering realistic human figures, evoking moods and creating the illusion of space and depth. On these vases of the fifth century were pictured gods, heroes, warfare, and quite often parties, at which a tippling Athenian could find himself staring dreamily into his wine cup at a painting of a tippling Athenian.

A lyre player throws back his head in exuberant song, his garments swaying as he moves to the music, in this masterful vase portrait.

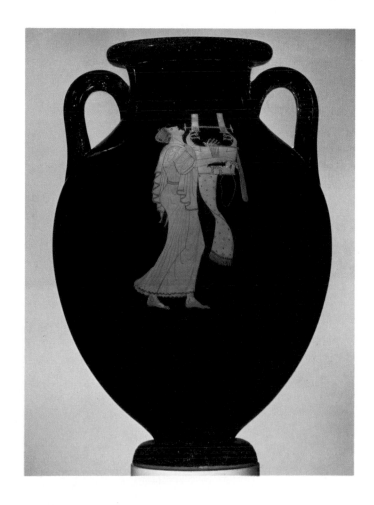

At a pottery shop an Athenian selects vases for the evening's wine party.

Many Athenian vases are decorated with scenes, like the ones on these pages, that reflect the city's love for the symposium, or wine-drinking party. Drinkers used several types of vases at these affairs: a krater for mixing the potent wine with water, a cooler called a psykter that was filled with wine and placed in a bowl of water for chilling the contents, pitchers for serving, and at least five kinds of cups for drinking.

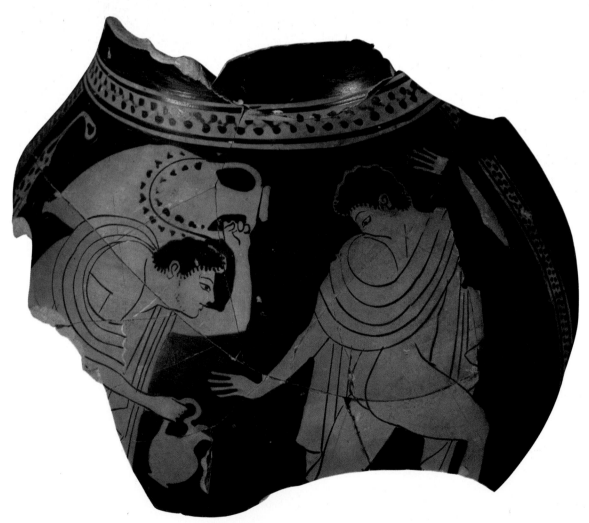

A partygoer staggers under the weight of a wine-filled amphora.

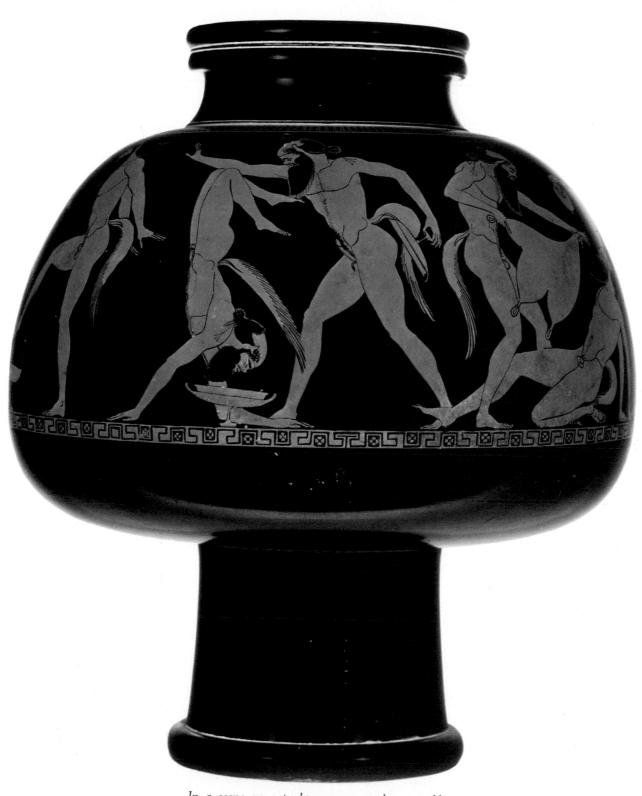

In a scene on a psykter, satyrs revel at a wild party—perhaps the mythical ideal toward which Greek drinkers strove.

In the fourth century B.C., vase making declined in Athens but flourished in the Greek colonies in Italy. The colonial painters revived vase decoration by applying to it the techniques of mural painting, as on the vase at right. The painter represented the couches and tables in perspective, and his free use of colors enlivens the scene of two courtesans entertaining youths at a drinking party. As one girl plays the flute, the other nestles close to her man on the couch. The man on the left with his hand on his forehead may be responding either to the music or to the effects of too much wine.

48

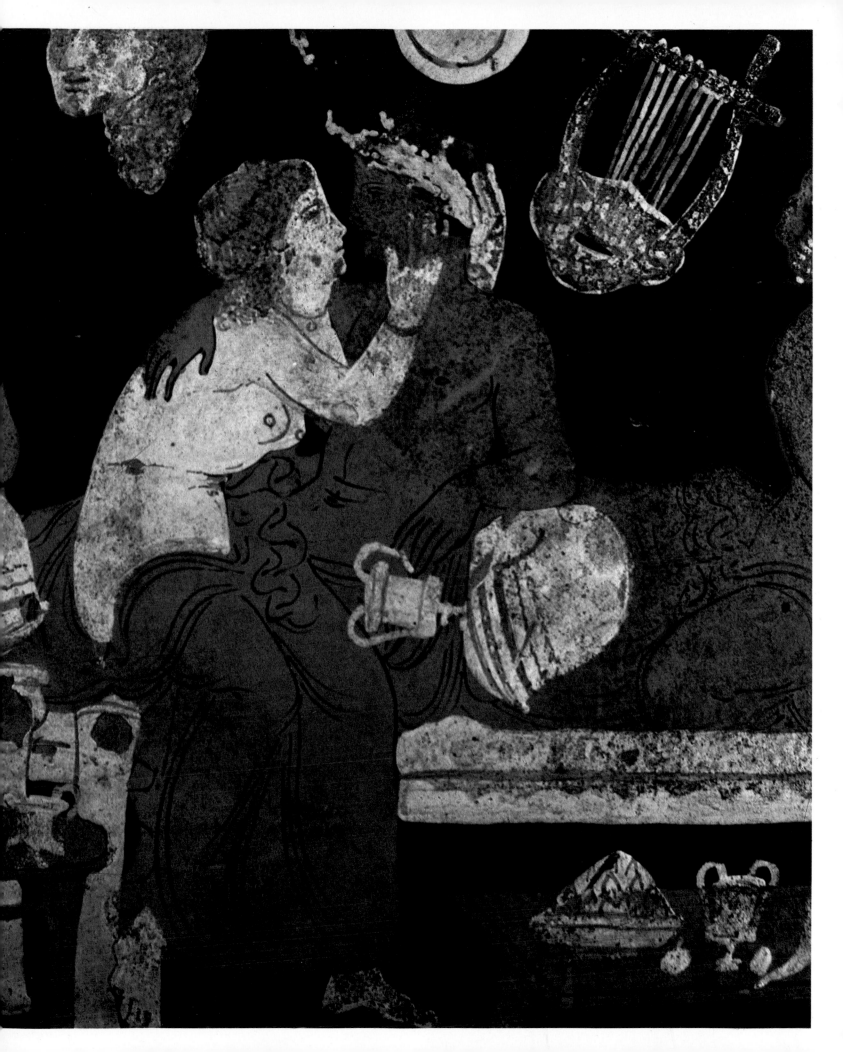

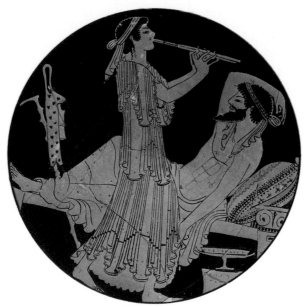

Vase paintings, like classical stage comedies, reveal that the Greeks had a taste for ribald humor. The portrait of the unfortunate drinker at far right is a straightforward example. The cup painting below is a more sophisticated burlesque of a drunken fling. The bearded man on the right below is making a pass at the youth in front of him. This provokes the jealousy of the man on the left whose broad gesticulations give the scene its comic air. The painter of this cup, known as the Brygos Painter, specialized in party scenes and was adept at rendering realistic gestures, faces, and expressions with a freshness seldom rivaled by other vase artists.

The courtesans at drinking parties provided music (above) along with other diversions.

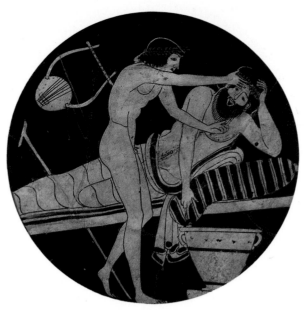

A slave comforts a sick tippler in a fifth-century cup painting above.

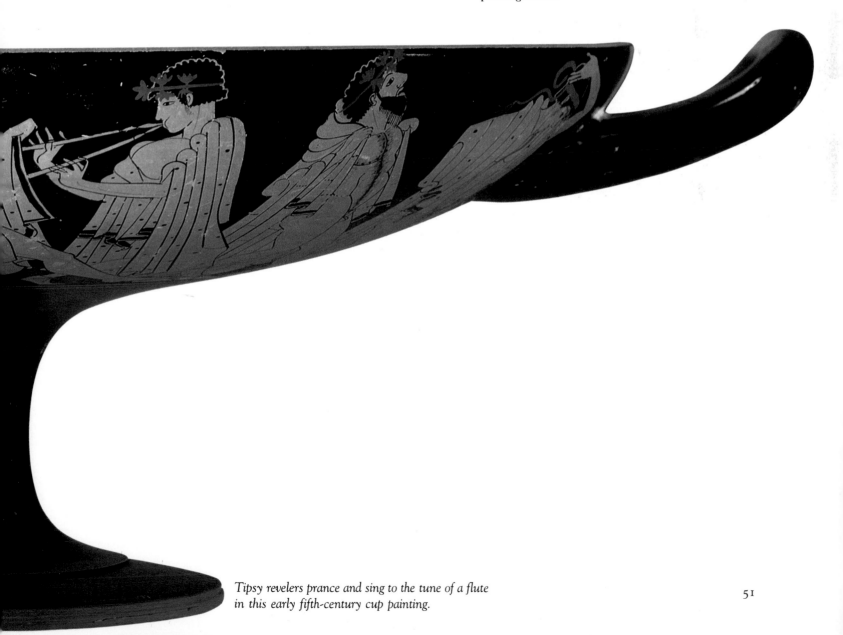

Tipsy revelers prance and sing to the tune of a flute in this early fifth-century cup painting.

51

In his cluttered studio a painter brushes glaze on the bottom of a drinking cup. This detail from a vase painting may have been a self-portrait, although the artist neglected to sign it.

TEXT CONTINUED FROM PAGE 43

Athens' craftsmen were properly proud of their products and often signed them. A piece inscribed "so-and-so made me" gives the name of the potter who shaped it, one inscribed "so-and-so painted me," the artist who did the decoration. Some craftsmen went further and complimented themselves on their handiwork by inscribing "This is a beautiful jar" or "I am a beautiful cup" or the like. One self-satisfied worker wrote "As never Euphronius," which meant Euphronius—one of the acknowledged masters —never made anything this good.

Not only Athenians, not only Greeks, but people all around the Mediterranean were eager customers. Just as in the eighteenth and nineteenth centuries A.D. people bought fine ceramic ware such as English Staffordshire or German Meissen or French Sevres, so in the sixth and fifth centuries B.C. they bought fine Greek Athenian pottery. As a matter of fact, most of the specimens of Athenian pottery now on view in our museums were unearthed not in Greece but elsewhere, in particular in Etruria, the part of Italy that extends, west of the Apennines, from Rome northward to Pisa and beyond. The Etruscans, who inhabited the region, had a passion for Athenian pottery; just as Mycenaean kings were put into their graves surrounded by cups and pitchers of gold and silver, Etruscan notables were put into theirs surrounded by cups and pitchers imported from Athens. No doubt most of these had been bought from local dealers who received bulk shipments from Athens, but it is quite possible that at least some had previously been brought back by the deceased as souvenirs of a visit there. Among the pieces found in Etruscan tombs are a good number which manifestly had been made for Athenian customers, since they bear the customers' names. They must have been sold by the original owners and then reentered the market as antiques.

Those who purchased antique pottery wanted it for display as well as for use. New pottery was for use, and fine new pottery for use above all at parties. Any Athenian who could afford it celebrated important moments—the winning of a sporting event or a

musical contest, a son's triumph in school, departure for war, and so on—with a party. Such occasions called for special ware: pitchers, bowls, and cups with appropriate decoration. Marriage called for a special kind of pitcher to carry water for the bridal bath. Visits to temples called for specific cups to dedicate to the god or goddess. Funerals called for a particular kind of flask to fill with oil and leave with the corpse.

And then there were gifts. In the heroic days of Homer's epics, people gave gold and silver vessels; in this age they gave fine Athenian pottery. One magnificent bowl for mixing wine and water bears two sentences scratched on it. The first is the potter's signature, "Exekias made me"; Exekias was one of Athens' foremost potters about 550 B.C., so this piece was, as it were, the equivalent of a saltcellar by Benvenuto Cellini or a bracelet by René Lalique. The second sentence on the bowl, in the script of the city-state of Sicyon, reads "Epainetos gave me to Charops"; in other words, Epainetos, a citizen of Sicyon, on a visit to Athens secured the bowl to present to his friend Charops. A further reason why Athens' potters carried on so thriving a business was that people all over felt they had to have at least one piece of Athenian pottery accompany them to the next world. The rich took along a cupboardful, some new pieces and some antiques, some so precious as to have been kept intact by mending.

A party was most often the reason a man went down to a shop to buy new ware. Greek parties were held after dinner, and the main activity was congenial drinking (the Greek word for party is *symposion*, which means literally a "drinking together"). They were solely for men; the only women present were not guests but *hetairai*, "courtesans," hired to be part of the entertainment. Hetairai were very much like Japanese geisha, slave girls who had had thorough training in the various ways of pleasing men, who knew how to sing, play musical instruments, dance, make interesting conversation, make love. Men never brought their wives to parties; while the festivities went on, respectable women were

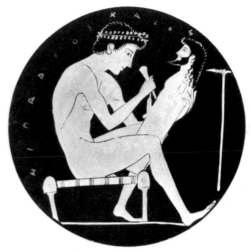

A sculptor fashions a herm—an image of the god Hermes, patron of travelers and of commerce. The Athenians lined the streets of the city with the pillarlike herms to ensure the god's favor.

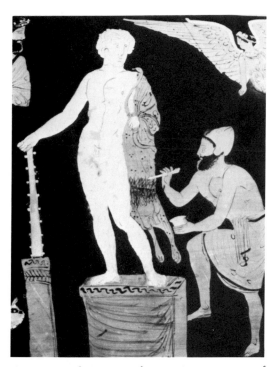

An artist applies a coat of wax paint to a statue of Heracles in a detail from a scene on a krater. Many Greek statues and temples were painted in bright, sometimes gaudy colors.

shut away, as they were most of the time, in the special women's quarters that formed part of every house at Athens. Standard party pottery was adorned with typical symposion scenes: girls singing or dancing, men and girls singing or dancing, men making advances to girls, older men making advances to younger men or boys, men reclining and drinking, men drinking too much. The straitlaced Pericles, it was said, used to leave before the drinking got under way; it is not hard to see why.

Not all parties, however, were like this. In more intellectually elevated circles conversation provided the major entertainment. The famous dialogue of Plato called the *Symposium* has as its setting a party given by a well-known writer of tragedy, and the guests included such gifted talkers as Socrates, Aristophanes, and Alcibiades, the enfant terrible of Athenian politics who briefly ran the state some time after Pericles' death. One of Aristophanes' comedies has a scene in which a sophisticated, citified son tries to teach his father, a tough old rustic fresh from the farm, how to join in at a high-toned party. When the son suggests recounting some learned anecdote, the old man launches into a dirty joke; when the son suggests telling about some important government service, the old man's only government service, it develops, was as a buck private in the army; when the son suggests reminiscing about his youth, the only noteworthy exploit the old man can remember is stealing his neighbor's vine props.

From about 450 to 429 B.C., Athens was guided by the skill and ambition of one man: Pericles. He understood how to use his power base to get what he wanted, which was to maintain the empire and the navy that went with it. The latter had scant appeal for the aristocrats and the rich. Since they had the money to buy armor so that they could serve in the land forces, a navy was of no interest to them. It was, on the other hand, of great interest to men without the means. The standard war galley in this period, the trireme as it was called, required no less than 170

rowers, and there were hundreds of triremes in the league fleet. Since rowers were paid the going wage for skilled labor—the ancient world knew nothing of galley slaves—there were jobs available for young men with strong backs, thousands of jobs, so long as Athens ruled the seas. Whenever Pericles moved a bill in the assembly, he was assured of a sympathetic hearing from the solid block of oarsmen present.

Keeping up the empire meant keeping up the contributions paid by the allies and spending the surplus on public works. It was not the aristocratic or traditionally wealthy who profited from this—for the most part they lived off the return from the farmlands they owned—but the little people of the city: small contractors, teamsters, masons, carpenters, and the like.

In Pericles' thinking, one particular way of spending this surplus had clear priority. The second time the Persians attacked Greece, in 480 B.C., they managed to overrun much of it, including Athens, where they did a thorough job of destruction. All the temples were leveled, among them the temple of the patron goddess of the city, Athena Parthenos, "the Virgin Athena." She deserved one in her honor now more than ever: had she not seen to it that her own city emerged victorious against tremendous odds? What is more, the wherewithal was now available to erect a fitting monument for her—a temple of gleaming marble housing her image in gold and ivory—a veritable treasure that would belong to no one individual but to the whole polis, truly a national treasure. The money, to be sure, would not be Athenian, but would come from the league treasury. And why not? As Pericles explained with Olympian sophistry, Athens' temples had been destroyed in the common cause, let them be rebuilt from common funds.

He ran into opposition, plenty of it. Many voters objected to spending league contributions that way, particularly the aristocrats; they did not directly benefit from the project and, in any case, resented that the power they had traditionally wielded was now in the hands of Pericles and the voting blocks behind him.

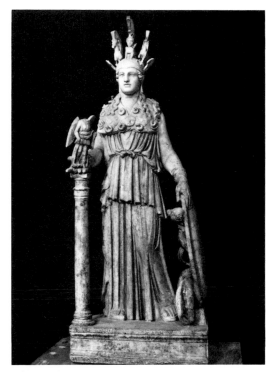

The Parthenon's gold and ivory statue of Athena was carried off to Constantinople in the fifth century A.D. *and vanished. A clumsy second-century-*B.C. *Roman copy (above) survives.*

When he bared his plans for erecting the Parthenon, the opposition's cries reached a crescendo: what did he mean by "gilding and dressing up the polis, like some loose woman, in expensive marble, statues, temples costing a thousand talents?" While it is nearly impossible to translate Greek money into the currency of today, a thousand talents would, at the very least, be worth sixty million dollars.

Even after the work started they kept after him. Pericles hired the famous sculptor Phidias to serve as general overseer of the project as well as to fashion the statue of the goddess it was to house. When Pericles visited to check on progress, his enemies charged he was there to have assignations with respectable Athenian ladies whom Phidias had lined up for him. Pericles proved immune to attack, so they switched to Phidias. The statue was to be the most costly kind, with plates of gold and ivory mounted on a wooden frame, and Phidias had been issued appropriate amounts of both materials. When his enemies accused him of embezzling some of the gold, Phidias got off only because he had foresightedly made the plates removable so that they could be weighed. Next they claimed he was introducing portraits of himself and Pericles in the figures—Greeks fighting Amazons —decorating Athena's shield, and this charge stuck. The sculptor was thrown into jail, where he fell sick and died. Aspasia also came under attack. Like Pericles, she enjoyed philosophical discussion on all matters, including the nature of divinity. So the opposition hauled her into court on trumped-up charges of impiety, and for setting a poor example for Athenian women. Pericles pleaded for her acquittal, and it took not only the full force of his eloquence but also his tears to get her off.

Through it all, the work continued. The Parthenon was begun in 447 B.C.; fifteen years later it was finished. Like Athens' pottery, what made it precious was the artistry that went into it. The sculptures that adorned the walls and pediments are now the pride of the British Museum. The building, even in ruins, remains the emblem of the city's finest hour.

THE JEWEL OF ATHENS

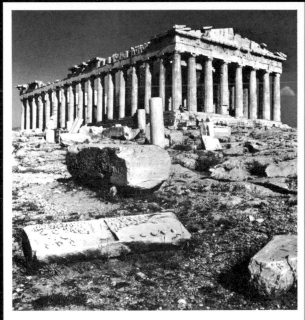

Atop the Athenian Acropolis stands the Parthenon, the product of inspired mathematics and meticulous handcraftsmanship on a gigantic scale.

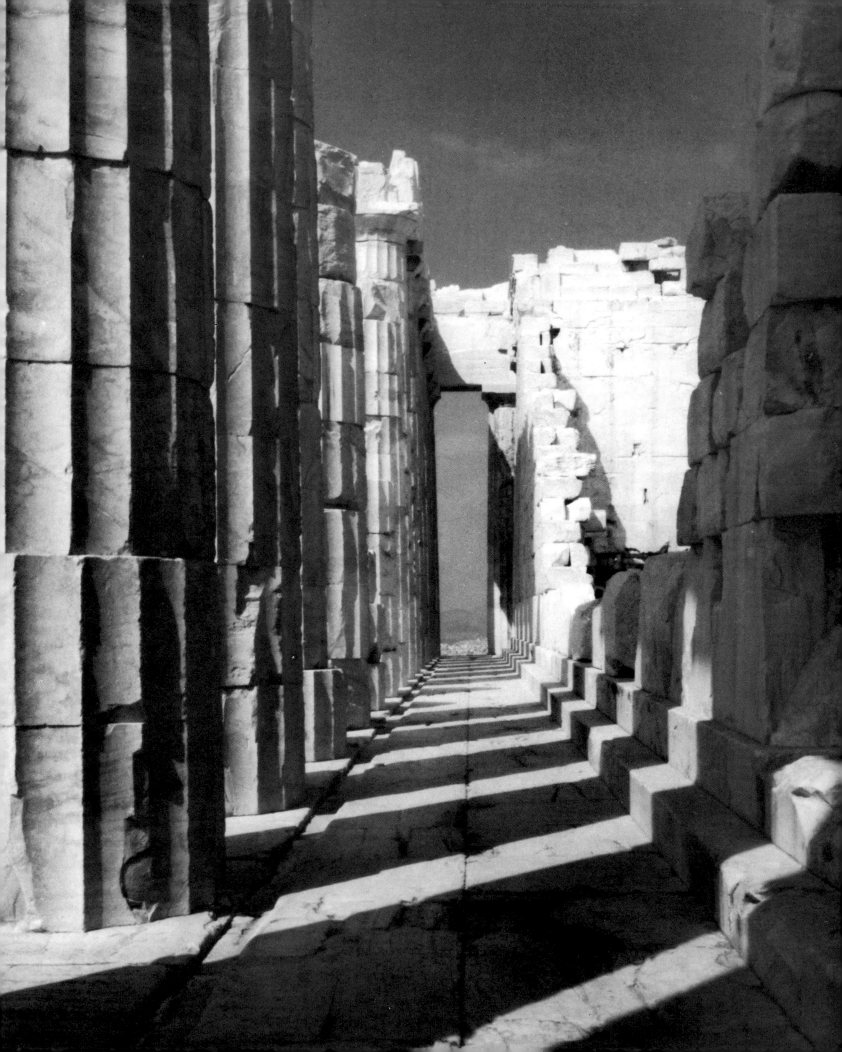

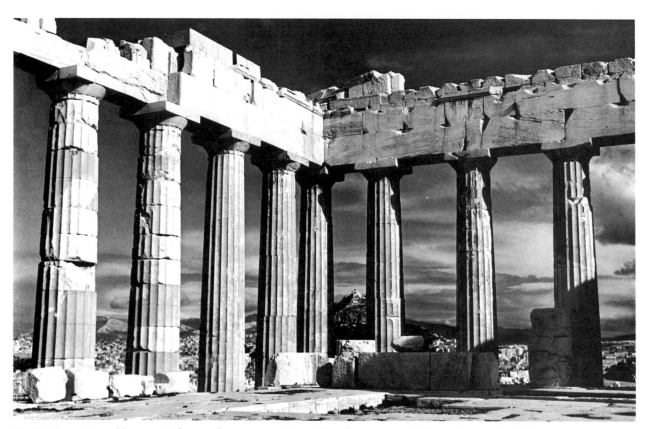

The Parthenon's marble, quarried ten miles away on Mount Pentelicus, was a brilliant white in the fifth century B.C. *Iron particles in the stone have oxidized over the centuries, transmuting the color of the temple to a soft honey beige.*

The Parthenon was Athens' grand monument to the city's tutelary goddess and to itself, the emblem of both piety and newfound imperial power. Pericles' choice for overseer of the project was not an architect but a sculptor, indeed the greatest sculptor of the age–Phidias. He designed a temple that was the largest ever built in Greece; but he also had in mind subtle features not obvious at first sight. The Parthenon's columns taper and lean inward ever so slightly, the flutes of the columns grow shallower near the top, and the side foundation walls rise at the center. Architects had used these so-called refinements individually in other temples; Phidias used them in concert. By bending all the temple's straight lines, Phidias imbued the immense marble structure with the illusion of upthrusting motion. The same illusion of movement is just as striking at a distance. Viewed against the sloping, angled wall of the Acropolis, the Parthenon seems to advance toward the onlooker "like a great ship," in the admiring words of a modern critic. The ancients too stood in awe of the building that embodied the ideal of harmony of form. Plutarch saw in the Parthenon "an ever-flowering life and unaging spirit...shining with grandeur."

Seventeen columns, some rebuilt in the last century and a half, cast their shadows across the south portico of the Parthenon (opposite).

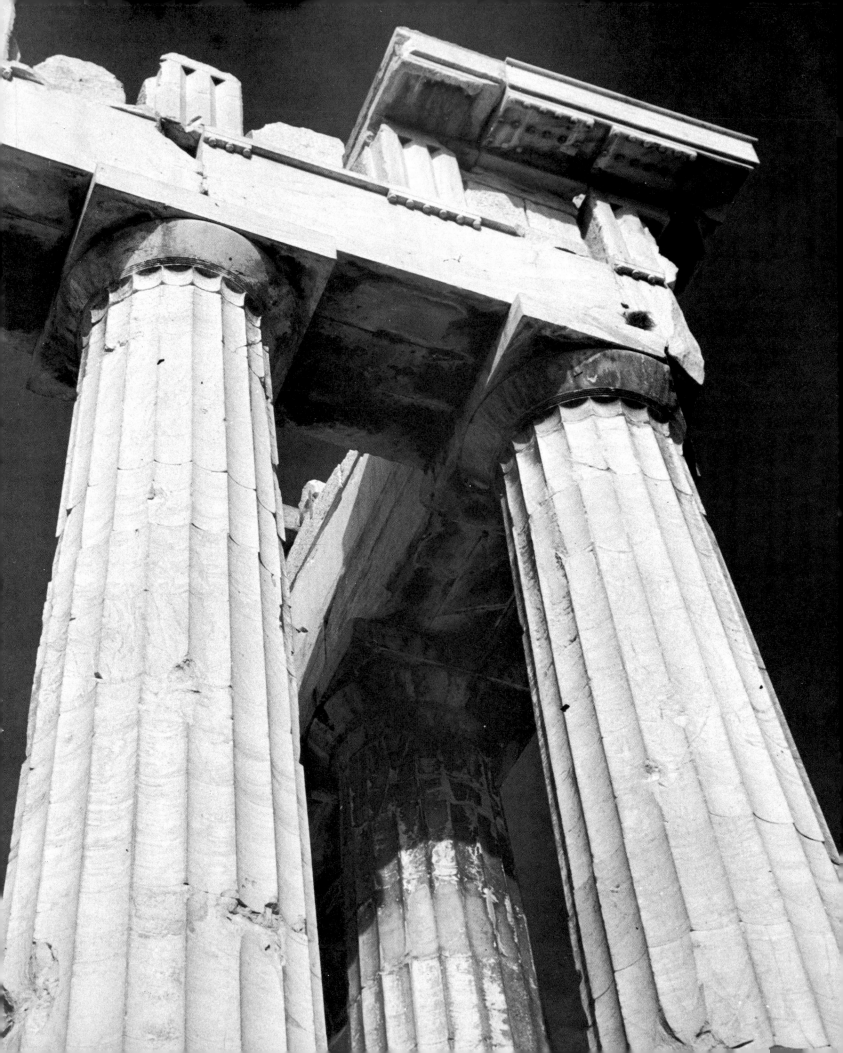

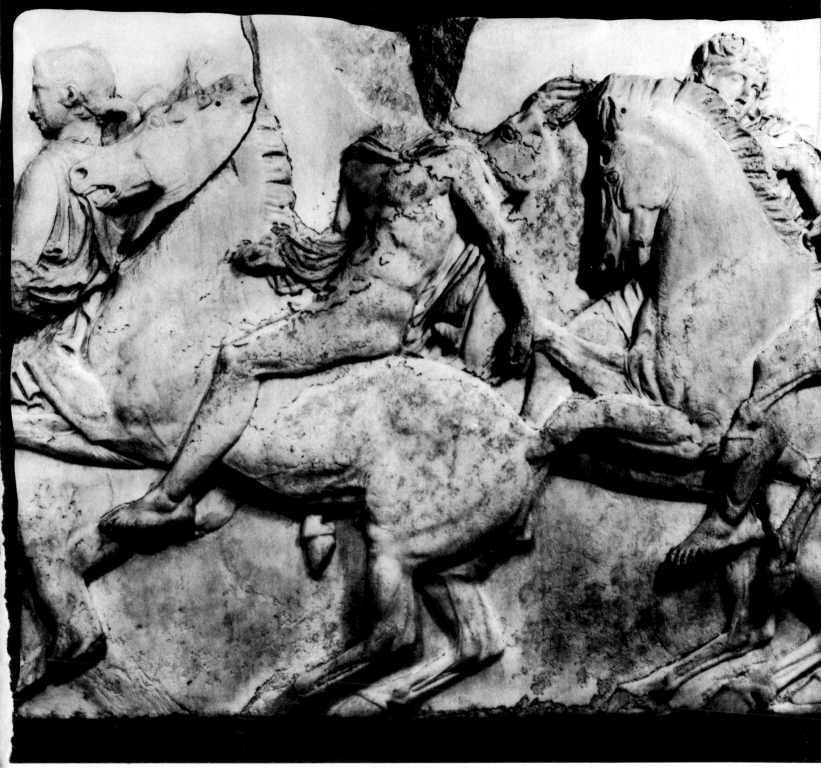

Nowhere is the genius of Phidias and his sculptors more apparent than in the dramatic cavalcade of Athenian youth on the Panathenaic frieze.

Never before in Greek architecture had a building been so richly adorned with sculpture as the Parthenon. Over the colonnades Phidias placed ninety-two panels showing mythical battle scenes. Above the porticoes a 524-foot-long frieze depicted the Panathenaic procession—the march of the citizens of Athens to the Acropolis with offerings for their goddess. Two sculptural groups, nearly ninety feet

wide, represented the birth of Athena and her struggle with the sea god Poseidon for Attica. Though these pedimental sculptures were about forty-five feet above the ground, Phidias and his team of artists sculpted to perfection even the backs of the statues, which were invisible from below. The sculptures remained intact until the sixth century A.D. when the Parthenon was converted to a Christian church

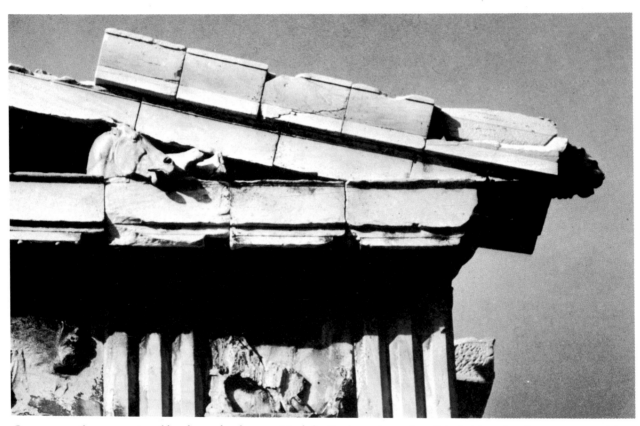

Over twenty-four centuries of harsh weather have stripped the Parthenon's cornice of the bright paint that once covered it. The horse's head at the edge of the pediment is a reproduction of the original piece now in the British Museum (see page 62).

(see page 62).

Composed of ten separate drums, the Parthenon's columns (opposite) were complex pieces of sculpture. Each drum had to be carved precisely so that the column would tilt to just the right degree and the twenty sharp-edged flutes would join perfectly.

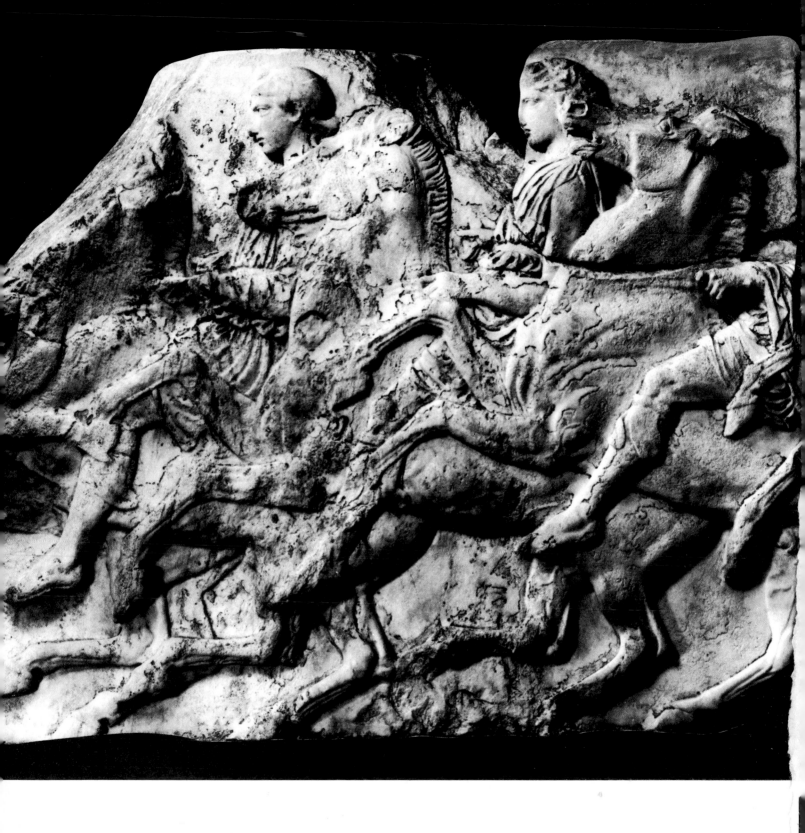

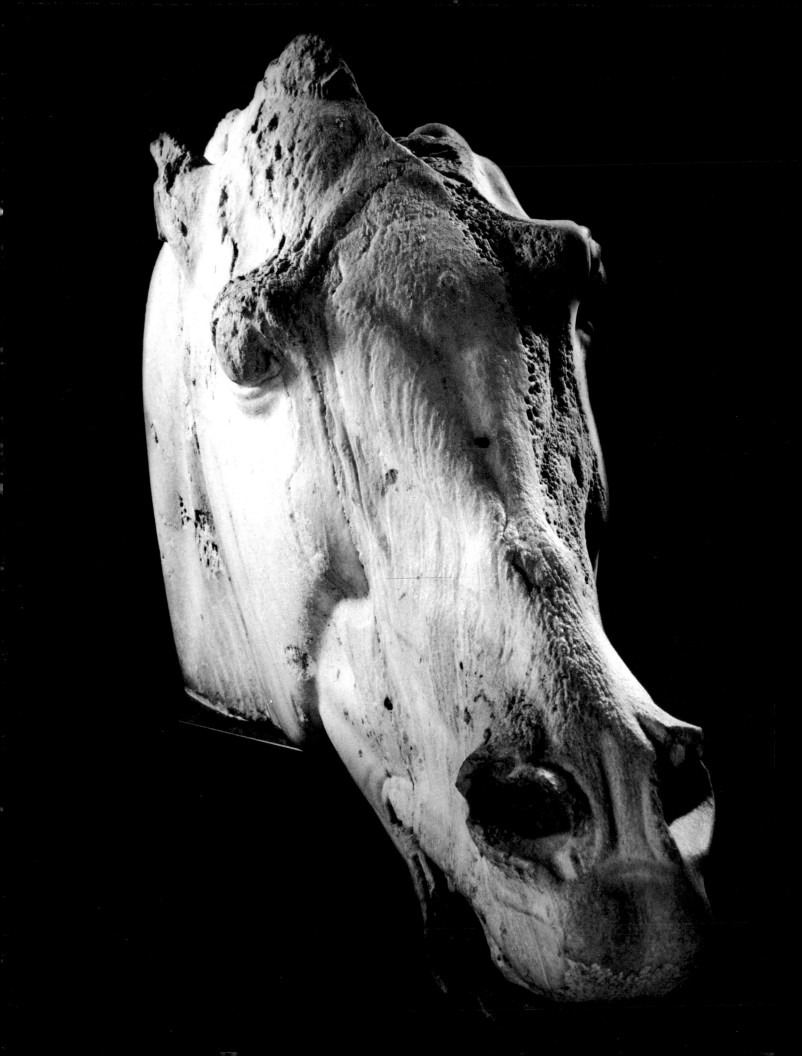

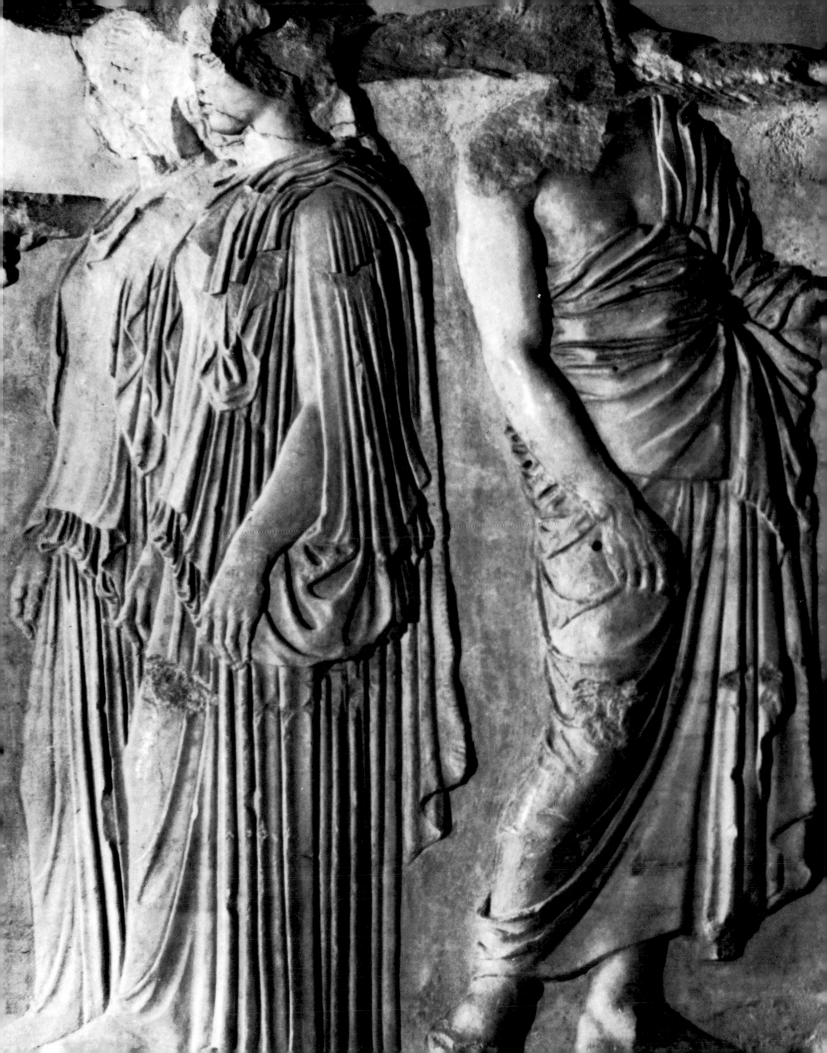

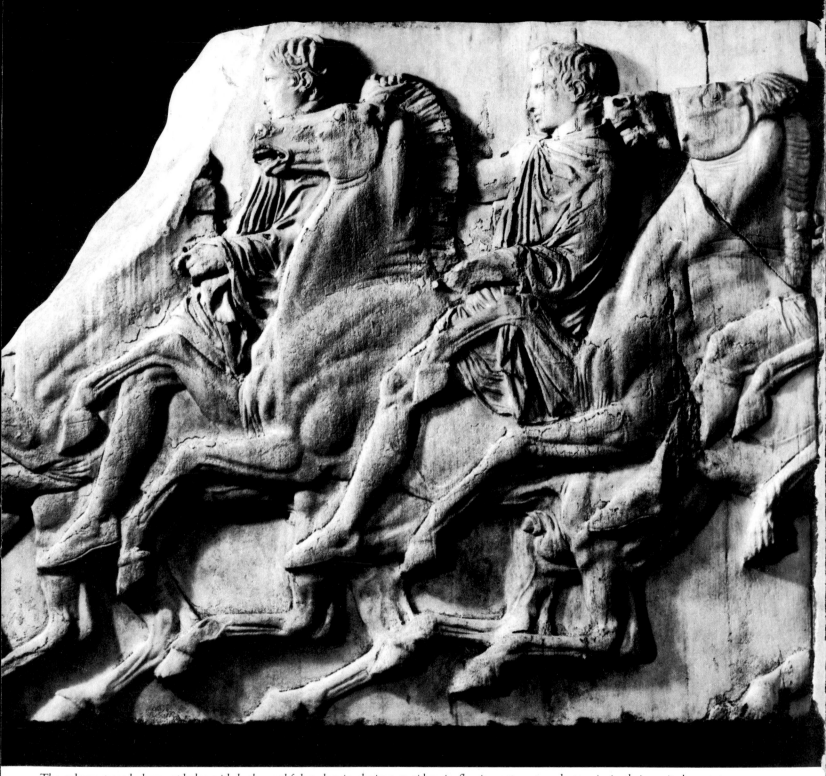

The solemn parade here explodes with both youthful and animal vigor as riders in flowing capes struggle to rein in their excited mounts.

and part of the west pediment collapsed during construction; but the most serious damage was wreaked in 1687 by the explosion of a Turkish powder magazine housed in the temple. Early in the nineteeth century the British diplomat Lord Elgin removed the bulk of the surviving sculpture to London, where it first went on display in 1807 and created an immediate sensation. Among the enthralled viewers who flocked to see the Elgin Marbles was the poet John Keats, who sat for hours gazing at them "like a sick eagle looking at the sky." For centuries European scholars had denigrated Greek art because they had only late, inferior copies to study. The abrupt appearance of the breathtaking Parthenon sculpture unseated Roman art from its throne in the Western imagination and gave Greece pride of place.

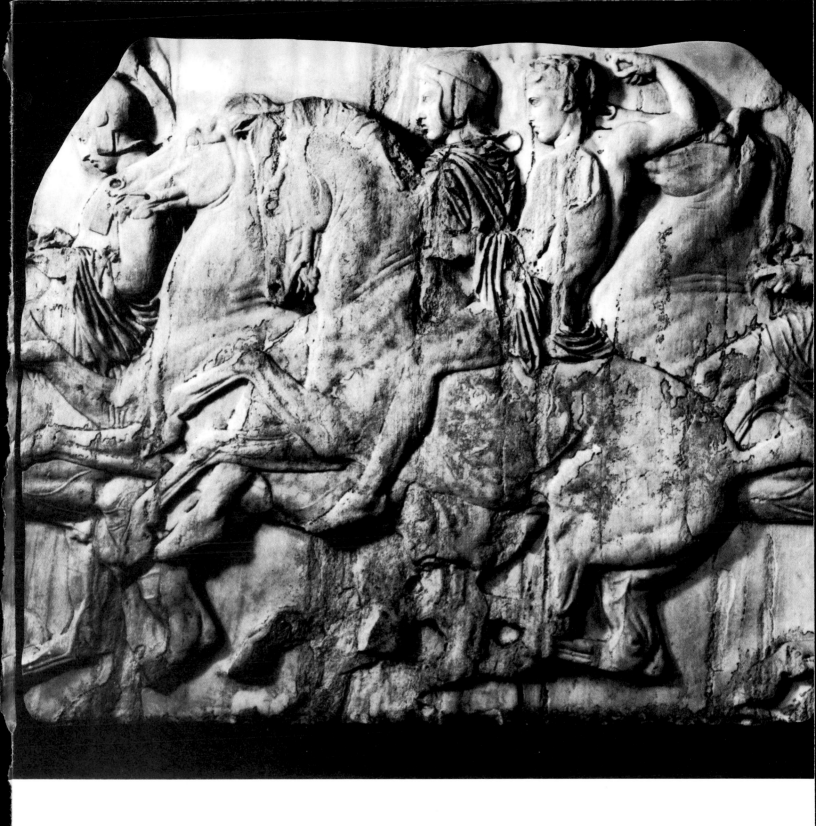

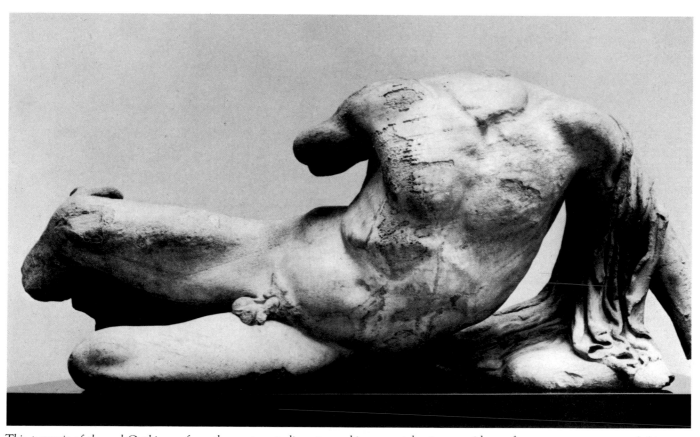

This portrait of the god Cephissus, from the western pediment, combines muscular power with a soft, sensuous treatment of skin.

Flaring nostrils and a drooping mouth express the exhaustion of the horse opposite, one of the steeds of the moon goddess Selene. The heroic representations of horses on the Parthenon have been called the finest in Greek art.

← FOLDOUT

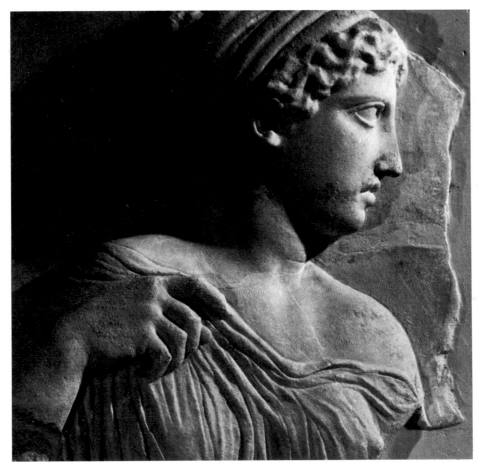

Artemis (above) tugs at her clothing in a gesture both chaste and erotic.

Two Athenian girls (opposite) who probably carried Athena's sacred robe pause behind a marshal during the Panathenaic procession.

OVERLEAF: *The morning sun outlines the Parthenon's eastern colonnade and illuminates Athena's bare, ruined sanctuary.*

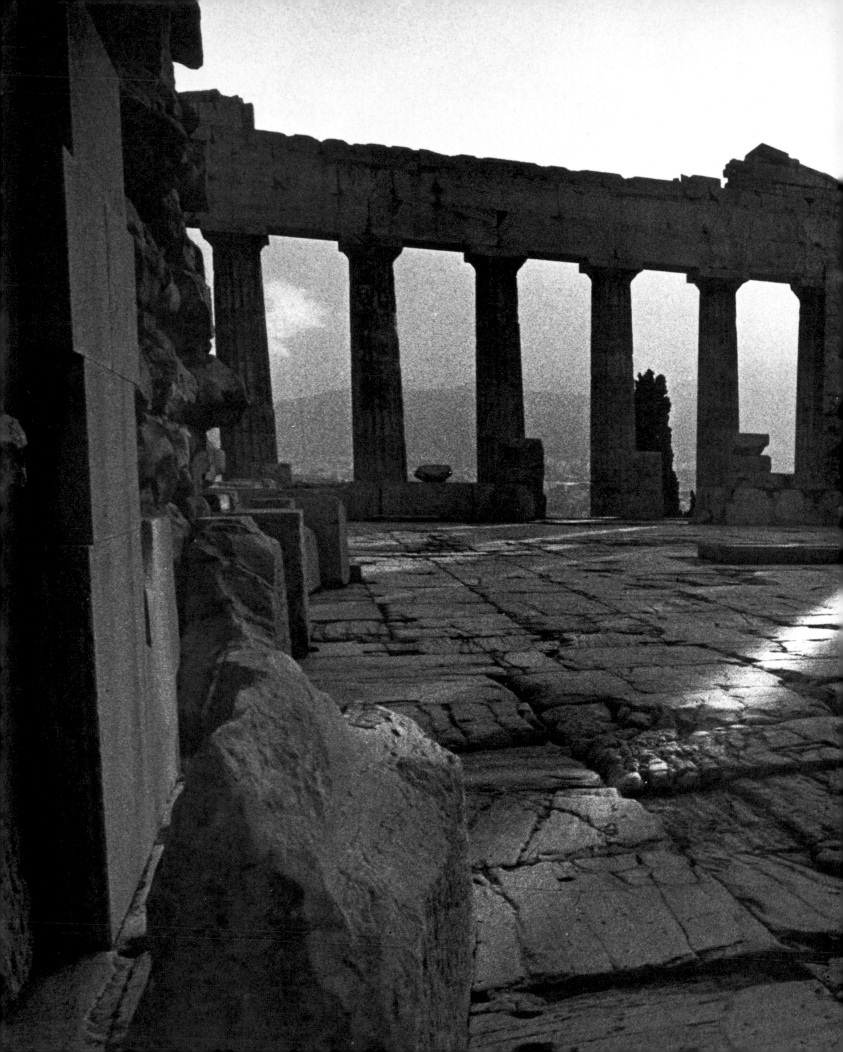

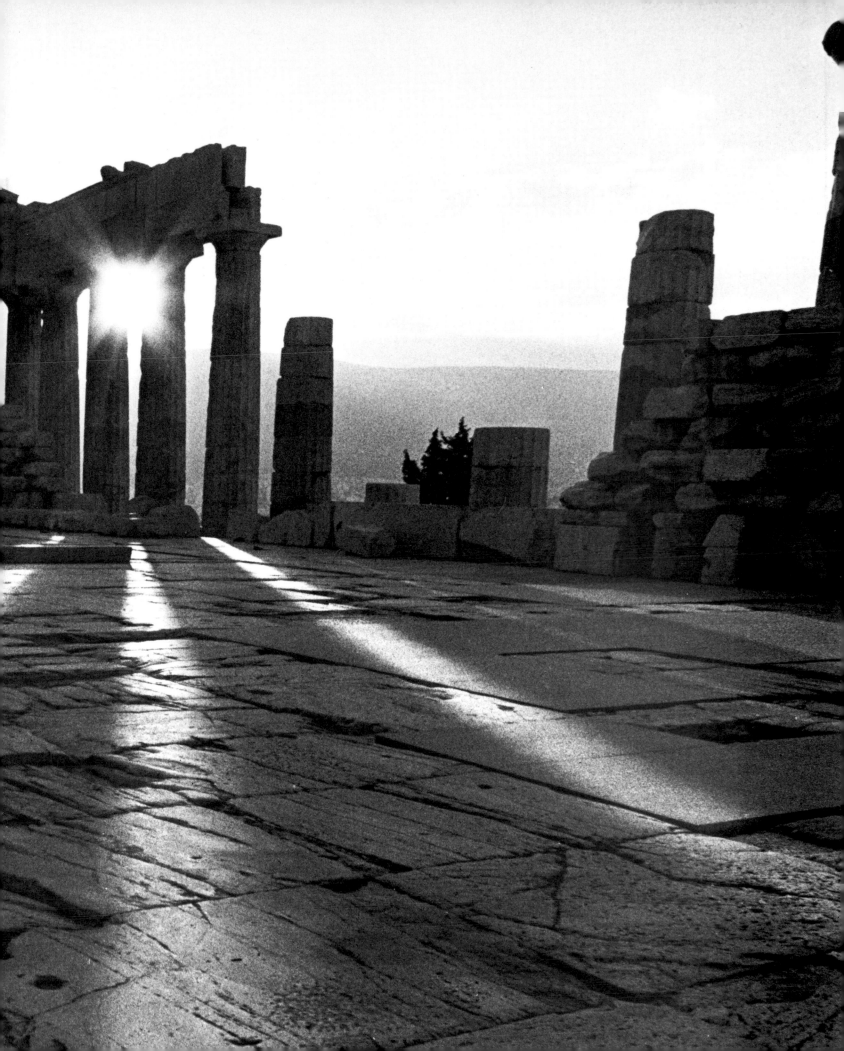

III

THE PLUNDER OF

PHILIP II OF MACEDON

The golden years that Pericles and his successors presided over at Athens lasted only until about 400 B.C. They were brought to an end by defeat in a bitter and exhausting war—not, ironically, against a foreign aggressor but by a fratricidal war among the Greek city-states themselves. By the time the Greeks recovered from this convulsion, they found themselves in a world of different values, a world, moreover, increasingly menaced by a new leader—Philip, king of Macedon—who ruled a people Athens looked down on as boorish country cousins.

Macedon had always been a poor and backward country, heavily forested and populated by hard-bitten mountaineers who spent their days eking out bare livings as hunters and herdsmen while shedding one another's blood in ceaseless tribal warfare. They spoke Greek, but a dialect incomprehensible to other Greeks. And even Macedonian nobles were rougher and wilder than their refined cousins to the south. To the Greeks, Philip and the Macedonian nobility were as much barbarians as any

A profile of Philip of Macedon, in this detail from a gold medallion, embodies the confidence and cunning behind his drive to command all of Greece.

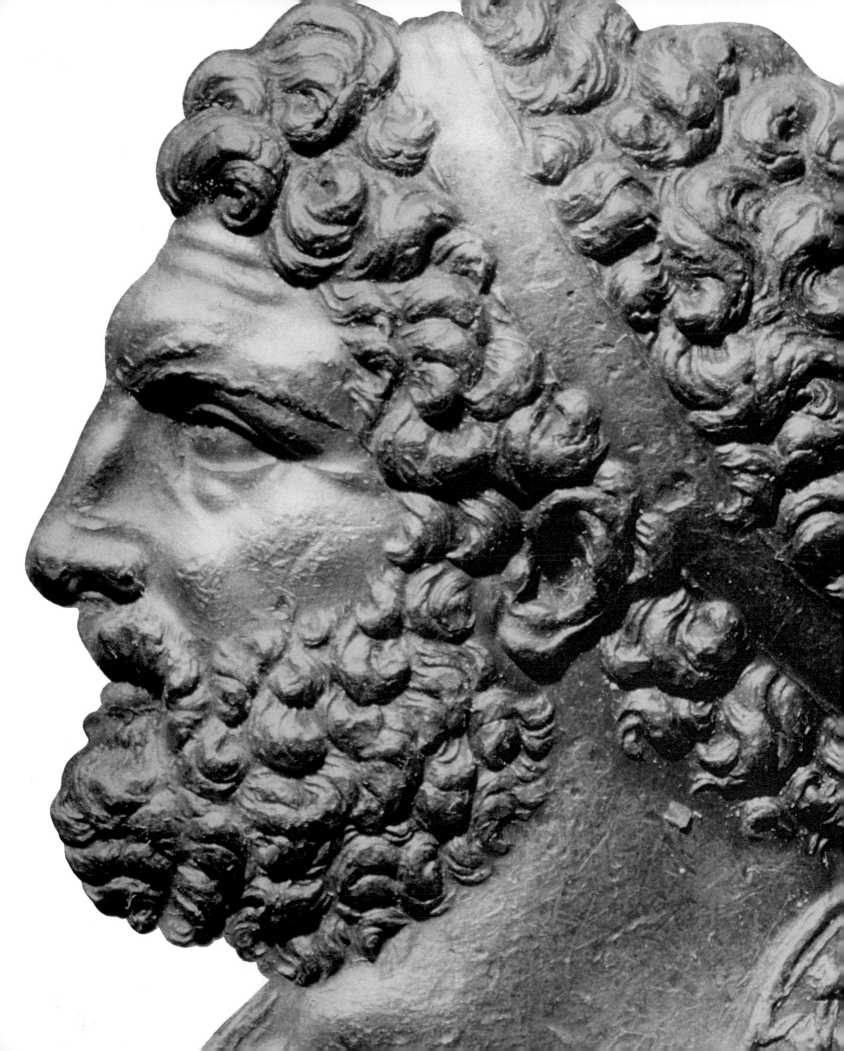

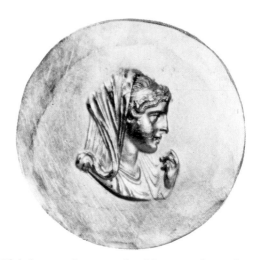

Philip's most famous wife, Olympias, depicted on this third-century-A.D. gold medal, claimed descent from the hero Achilles. Quick-tempered and a religious fanatic, she became estranged from Philip after Alexander's birth in 356 B.C.

wild, non-Greek tribe. Now, as Athenian power waned, one of these presumably uncultivated boors was threatening to make vassals of the city-states.

Philip was a Macedonian autocrat dedicated to building up the hardy peasants of his country into a mighty military force and leading it to conquer the city-states of Greece. In Pericles' day these city-states had commanded the unswerving devotion of their citizens; individual concerns, individual possessions were secondary. In 490 and 480 B.C. Persia, a vast and opulent nation, had tried to take over Greece by force of arms and had failed. But in Philip's day the Greek spirit of devotion had grown feeble as citizens more and more thought of themselves before their state. Philip was fighting Greeks who no longer were willing to give their all to their polis, who were open to appeals to self-interest, to the blandishments of money, to the allure of owning precious objects. He overcame them with diplomacy, guile, and bribery as much as with arms.

Philip was born with a gift not only for leading men in battle but also for manipulating them; his judgment of people was shrewd and sure, and he was a genius at weaving political intrigue. All these tools were at the service of an unshakable determination to become a monarch of renown. As a fighter he was immune to fear and all but impervious to pain. An arrow landed in his right eye as he was besieging a city-state in 355 (he must have been in torture, but he went right on directing the operation to a successful conclusion), a shattered shoulder as well as a lance thrust in the calf came a decade or so later during a campaign against barbarian tribes to the northwest, and he again took a lance thrust through the thigh while warring against another tribe in 339. This last wound nearly did him in; he was knocked flat and for a while was believed to be dead; he eventually recovered but walked with a limp the rest of his life. As Demosthenes, Athens' eloquent political leader and Philip's bitterest enemy, reminded his countrymen, "For the sake of ruling and wielding power, he has had an eye knocked out, his shoulder

smashed, his leg and hand mutilated; he jettisons whatever part of his body fate wants to take away, just so long as he can live in honor and glory with what is left."

Yet he was perfectly willing, indeed he preferred, to get what he wanted without fighting; many of his greatest triumphs were bloodless. "The credit for a military victory," he used to say, "I share with all my soldiers; for a diplomatic victory, it's all mine." Once an informant insisted that the walls of an enemy town were impregnable. "So impregnable," Philip asked, "even gold can't scale them?" Throughout his career, a canny choice of what bait to dangle before what city-state or tribal chieftain, what envoy or politician to bribe, were key elements in his success. He knew the ins and outs of exploiting people of all ranks, en masse or singly. He made friends with all the influential people in any given place, both the decent folk and the rascals; later he could use the first and abuse the second. The trick was telling one from the other, and in this regard Philip took no chances. Once he appointed a man as judge, but removed him on learning that he dyed his hair. "If I can't trust his hair," he observed, "how can I trust his actions?" He was also successful—at least a large part of the time—with a most important person who required consummately delicate handling, Alexander, his brilliant but willful son.

And he was successful with yet another difficult person—himself. Philip had a temper, but he schooled himself to take abuse with the imperturbability of a Pericles, to meet harsh words with a convincing show of sweet reason. When a group of Greeks whom he had treated very well hissed him while he was watching the Olympic Games, his friends got worked up about it. "Just imagine," he told them, "if I had treated them badly." He claimed he was a better man thanks to the nasty things Athenian politicians said about him: he had to work hard to prove they were liars. Like all Macedonians he was a hard drinker and took his wine neat and not, as Greeks did, in water; but he knew how to keep from going too far.

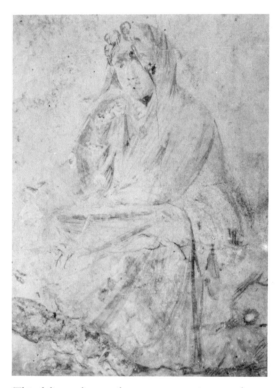

This delicate figure of a woman wearing a veil may be a representation of a Macedonian princess. One of the few portraits surviving from the age of Philip, it was painted in the fourth century B.C. on the wall of an elaborate tomb.

Polygamy was standard practice among Macedonian nobles, and in the course of his reign Philip acquired no less than seven wives. Most of them were "war brides," daughters of kings or chieftains or other major enemies he had just defeated in battle; the bigger the harem the better was Philip's view, and such marriages had the added advantage of improving Macedon's relations with the defeated parties. One exception was Olympias, his acknowledged queen and Alexander's mother. She had the appropriate qualification, being a princess of Epirus, a powerful neighbor with whom he wanted to stay on good terms. He met her through a casual encounter at a religious festival. Though he happily bedded with all his other wives, he soon gave up on Olympias. She was ambitious, bitchy, jealous, and a religious crank; besides, her habit of keeping a pet serpent by her bed was not calculated to encourage visits. Olympias was the one person Philip did not get along with; he probably did not try very hard.

Philip's needs drove him into continual extramarital affairs, despite the multiplicity of his wives. Since respectable Macedonian matrons and girls were kept in as rigid seclusion as Athenian ones, they were hard to get at; nor did all women welcome his advances. It was one such who, in an effort to get him to direct his attentions elsewhere, made the memorable remark that "all women look alike in the dark." Philip also pursued affairs with men. Homosexuality was an accepted practice in Macedonian circles, and if we believe his enemies, Philip's appetite was insatiable. A Macedonian king was surrounded by a chosen group of nobles who formed his court, who were constantly with him, serving as his generals in war and his administrators in peace. They were called the *hetairoi*, his "companions." Not hetairoi at all, smirked his enemies, but hetairai, his "courtesans" (not courtiers but courtesans comes near the pun). Philip took a particular interest in the so-called Royal Pages. These were a corps of boys in their teens recruited from noble families to wait on the king, to serve him at table, to taste his drinks (as a precaution against poison), to stand guard in the bedroom as he

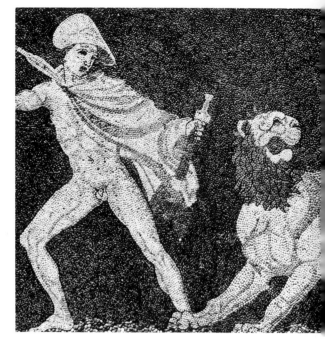

Two hunters close in on a lion in this 300-B.C. mosaic from a house at Pella, Macedon's capital under Philip. Courage in hunting was highly esteemed. At banquets only nobles who had speared a wild boar without the aid of a net could recline; the rest had to eat sitting up.

slept—and to share his bed when he wanted.

At the time Philip was born, in 383 or 382 B.C., Thebes had supplanted Athens as Greece's most powerful polis, thanks largely to a military genius in her midst, Epaminondas, who revolutionized the art of war by improving the phalanx. He organized his infantrymen into deep, dense units that had no trouble smashing through the thin lines Greek generals traditionally favored. In 368, when Philip was a boy of fourteen or fifteen, he was sent to Thebes, one of fifty hostages demanded by the city as guaranty of Macedon's continued good behavior. He spent three years there, and it was the best thing that could have happened to him, an unparalleled opportunity to observe at first hand a modern army being drilled by the master himself.

Five or six years after Philip's return, Macedon's king, Philip's older brother, was slain battling barbarian invaders from the north. As a possible successor to his brother, Philip was not the only candidate. What is more, it looked as if whoever inherited the throne would have to defend it against three of Macedon's neighbors, each attacking from a different quarter. And Athens, who ruled the seas just as she had in Pericles' time, was an ever-present danger along Macedon's coast. Appointed regent for his brother's young son, Philip disposed of the boy and by some quick and hard fighting and some adept diplomacy, nullified all the threats from outside. Then he set about the task that was to make his career possible, the transformation of the Macedonian peasantry, splendid material for soldiers but very raw, into an up-to-date army. A Greek polis relied upon a citizen militia called up whenever the need arose. Philip created a force whose basic units were permanent; he had, at least in part, a standing army of well-trained professionals. Its hard core were infantry brigades organized in phalanxes, as at Thebes—dense squares sixteen men across and sixteen deep. These he equipped with a new weapon, the *sarissa,* an eighteen-foot lance, which was much longer than that used by the Greek armies—so long it had to be gripped by both hands.

TEXT CONTINUED ON PAGE 84

MACEDONIAN AGAINST GREEK

Philip II knew he faced a formidable adversary when he prepared to attack the Greek city-states. From the seventh century B.C. onward, the mainstay of any Greek army had been the hoplites, a heavily armed infantry of citizens who fought as a solid body, or phalanx, in ranks usually eight deep. The aim of a battle was to smash the enemy line with a charge–a powerful but difficult maneuver, since slight

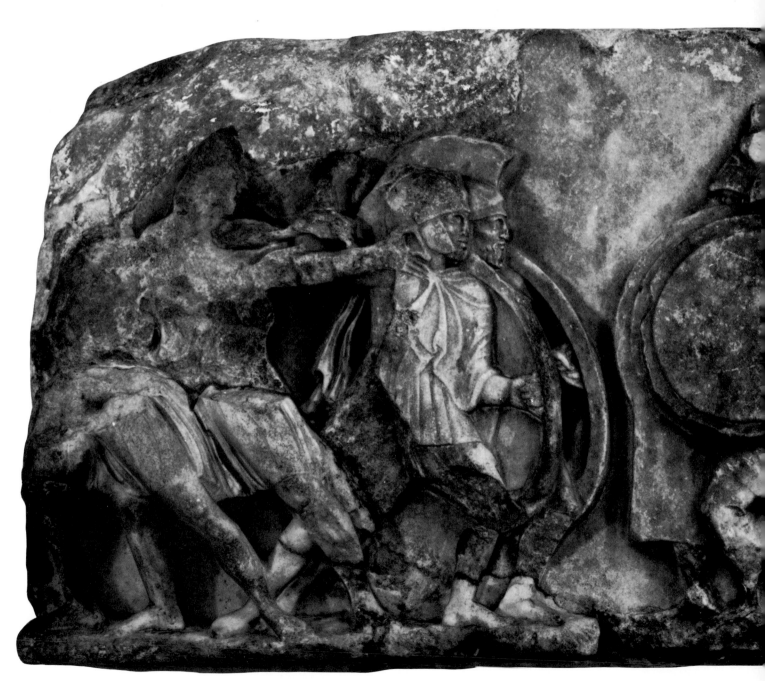

Carrying large shields, Greek hoplites supported by archers, at left, advance on a heavily manned foreign

gaps in either line could be fatal. Besides sheer numbers, the basis of the hoplites' strength was their armor, consisting of spear, shield, helmet, greaves, and breastplate. Made largely from bronze, it provided efficient protection in a manner that, as the pieces on pages 80–83 show, combined function with superb form.

The Macedonian infantry, composed of peasants drilled into professional regiments, could not afford the panoply of the prosperous hoplites. Instead, Philip armed them with eighteen-foot pikes and had his phalanx sections of sixteen deep pave the way for charges by heavy cavalry—a vital striking force, flexible and not easily outflanked. The hoplite armies, who rarely used cavalry, toppled before such tactics and their treasured armor was left to be seized as battle trophies by the victors.

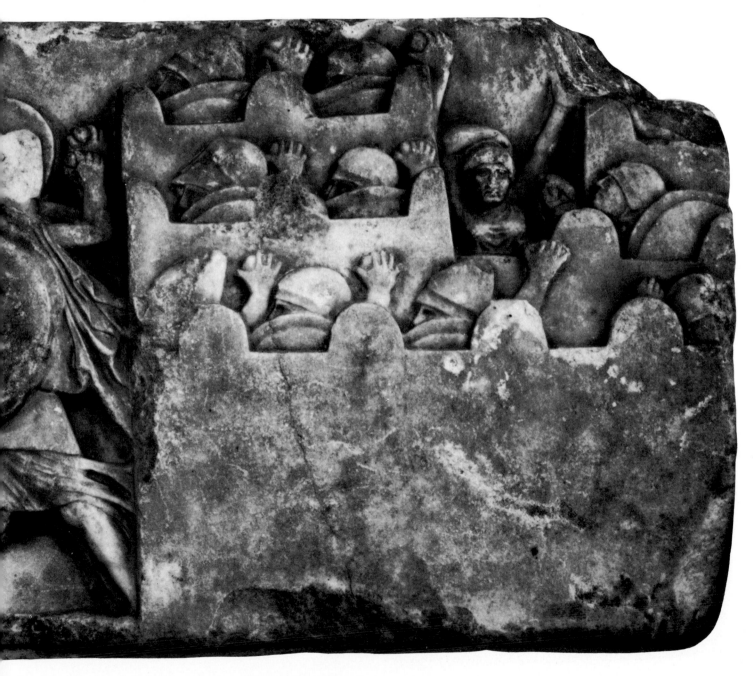

citadel in this fourth-century-B.C. frieze. The defending soldiers are wearing Persian-style helmets.

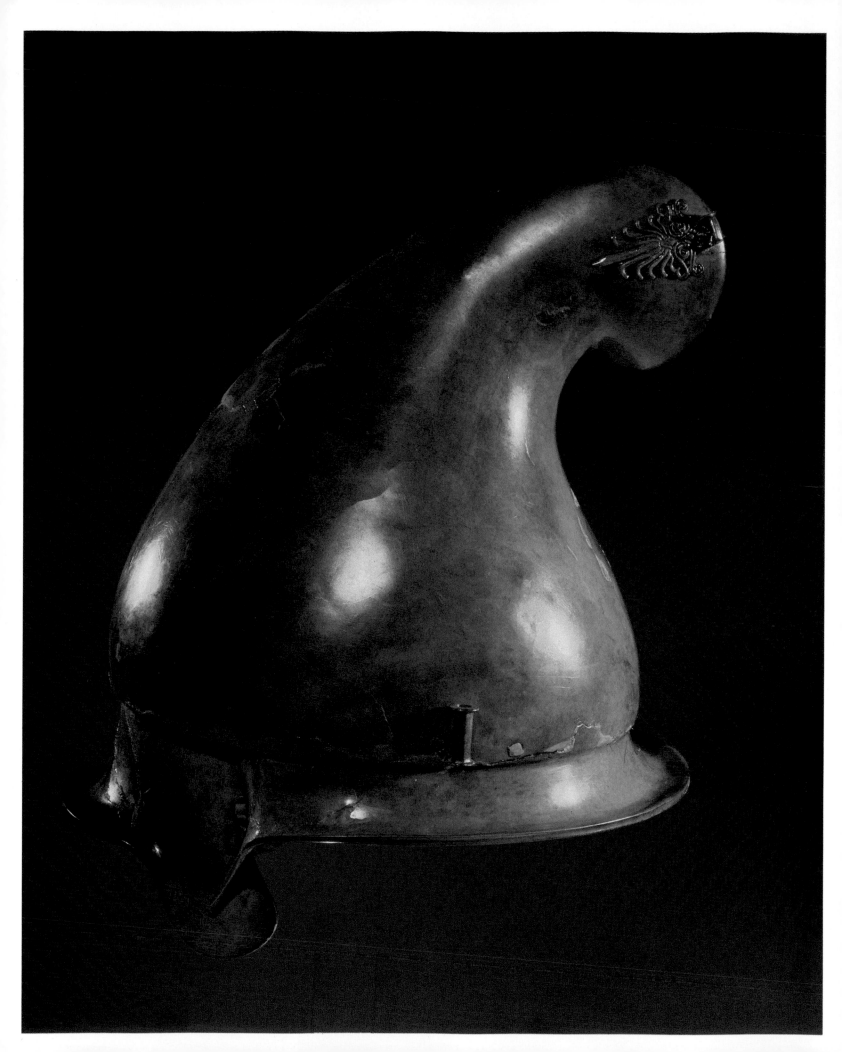

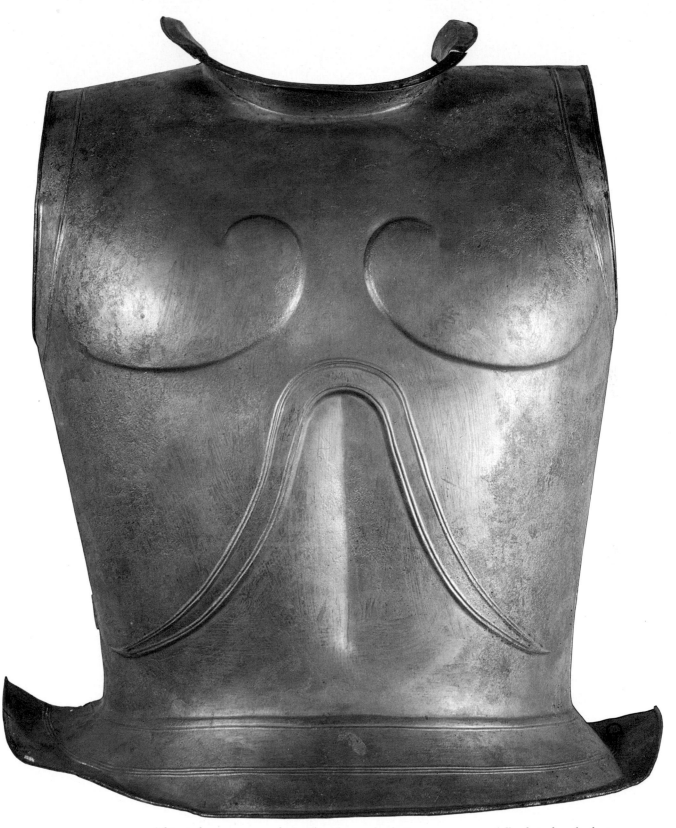

This sixth-century-B.C. breastplate from a hoplite's armor was carefully shaped to fit the torso.

Now missing its cheekpieces, this bronze helmet is a type worn by both Greek and Macedonian infantry. At the peak and temple are small spools for attaching adornments such as a crest.

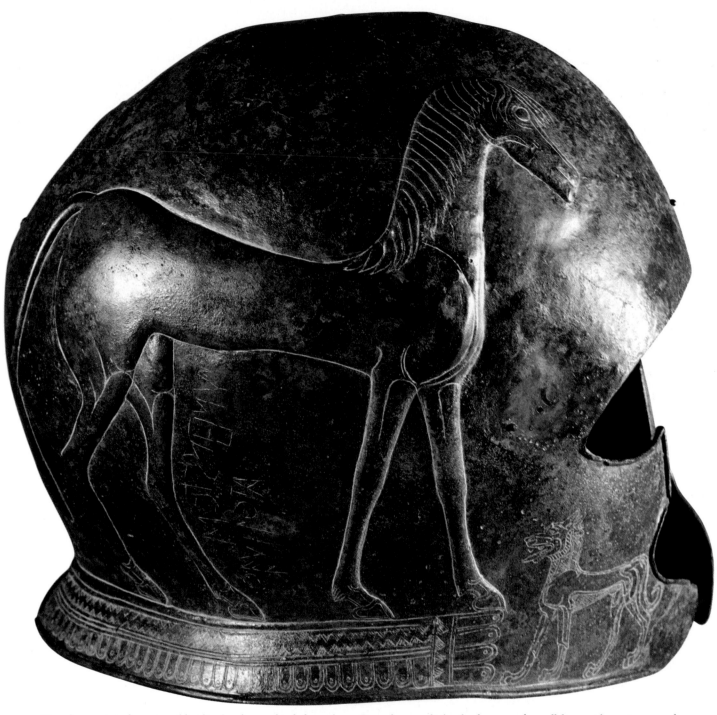

Based on a popular type of hoplite headgear, this helmet from Crete bears reliefs of a horse and small lion with canine muzzle.

A Greek warrior battles an Amazon on this shoulder flap from a fourth-century-B.C. bronze breastplate. A masterpiece of relief work, the armor probably belonged to a high-ranking officer.

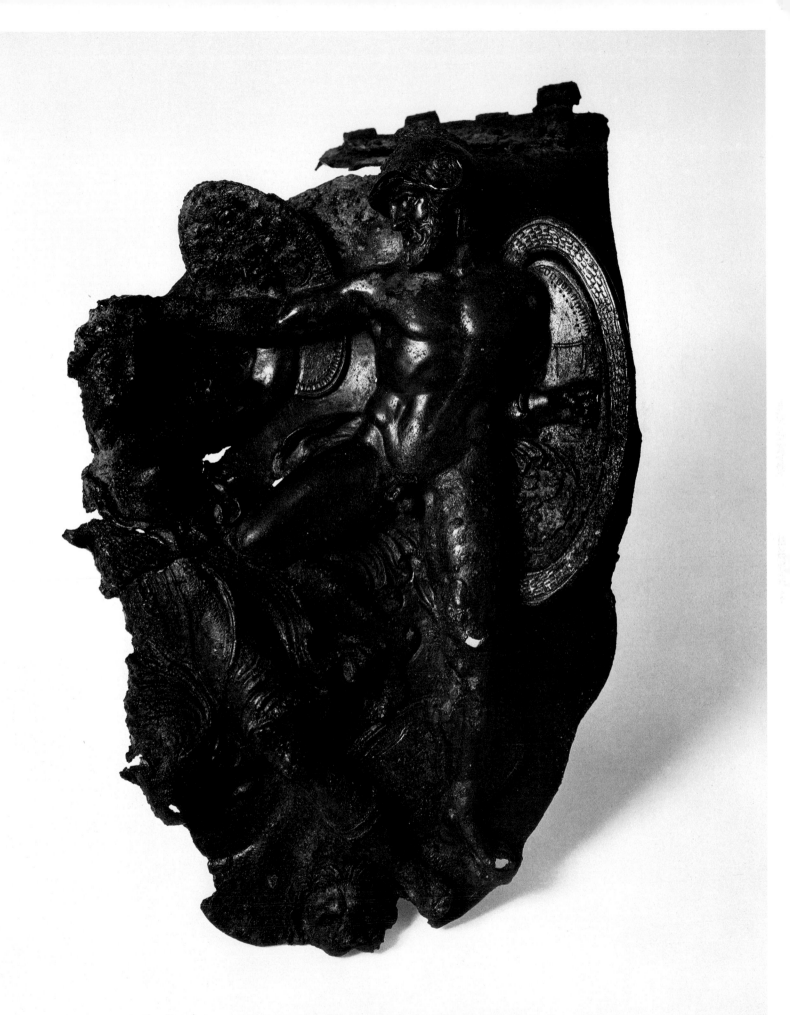

TEXT CONTINUED FROM PAGE 77

An army has to be fed and paid, a standing army fed and paid all year round—and Macedon's resources were slender. But then a bonanza came Philip's way: about 360 B.C., the year before he ascended the throne, men struck gold at Mount Pangaeus, about a hundred miles east of his capital. Within the next four years Philip had taken over the area, partly by using force, partly by intriguing with the local city-states, and mostly by hoodwinking the Athenians who claimed vital interests in the region and whose massive navy could have given him real trouble. The little mining town that had sprung up he refounded as Philippi—the first city in the Greek world to be named after a person. It later became famous as the site of the battle where Brutus and Cassius made their last-ditch stand against Mark Anthony and Octavian after the assassination of Julius Caesar.

With his army in order, his financing assured, and his borders secure, Philip was ready to adventure south into the world of the Greek city-states. Here his major weapon was guile: he inserted himself into the squabbles that raged among them, masterfully playing one off against the other. If he had to, he fought, and usually with success; even the finest polis armies were no match for his highly trained professionals. Whenever he could, he advanced and conquered through flattery, diplomacy, bribery. He did not even have to fight for the impregnable Pass of Thermopylae, in the north of Greece, where the city-states could easily have made a stout stand; he was able to buy it from the Greek commander stationed there. In 346 B.C. the great festival held every four years at Delphi in honor of Apollo was celebrated with Philip ensconced in the presidential chair. The Macedonian barbarian had come a long way.

One politician Philip had never been able to win over either by flattery, gold, or guile was Athens' renowned orator Demosthenes. The farther Macedon advanced, the shriller were Demosthenes' pleas to his countrymen to do something about it. But the Athenians found it more comfortable, and cheaper, to take on faith Philip's assurances that he was acting legally and

properly, that he was in no wise trespassing upon Athens' rights, and that he certainly meant no harm to her. Now that Philip had swallowed up all the city-states right down to the borders of Thebes, it was grimly clear to those left that they would be his next mouthfuls. Only an alliance of the two most powerful states, Athens and Thebes, stood a chance of stopping him—but Athens and Thebes hated each other more than they hated Philip. The clear and present danger, reinforced by Demosthenes' calls for concerted action, at last convinced them to try to avert disaster. In 338 their combined armies squared off against Philip's forces at Chaeronea, some twenty-five miles northwest of Thebes. Philip's victory was complete. Athens and Thebes were his; he was master of all Greece. Alexander, now eighteen, distinguished himself in command of the cavalry. With hardly a break in his stride Philip moved on to what he hoped was to be the grand climax: the conquest of Persia.

Greek culture had long been prized at Pella, the Macedonian capital. Philip's predecessors, who ruled when Athens was enjoying her great half-century, were generous patrons of the arts and maintained numbers of well-known poets and artists and musicians in residence. (The playwright Euripides spent his last years there.) Philip himself was a master of Greek oratorical style and to tutor his son selected no less a savant than Aristotle. But now that he ruled an empire, rich and powerful, his rise in fortune was appropriately reflected in his style of life.

Though the nobility of Macedon had traditionally looked to the Greek city-states for tutoring in the fine arts, how to spend wealth and live grandiosely were not in the curriculum. Macedon in any case had had little to spend, and the city-states, with their inhibitions about extravagance and personal display, had little to teach. But now, when Macedon was in a position to profit from guidance in this area, the city-states were in a position to offer it; for the polis mentality had changed radically. The attitude toward service in the army reveals dramatically how far the pendulum had swung: in the fifth century B.C., the cit-

A crown and earrings adorn the head of this woman, probably a queen at the court of Aegae (today called Vergina), the first Macedonian capital. Her portrait is part of a floor mosaic from a palace built there in the third century B.C.

izens considered service a glorious duty; in the fourth, they voted to hire mercenaries to do their fighting for them; well-off citizens had better things to do with their time. For example, it was now perfectly respectable to devote time to making money. And, once the money was made, it was perfectly respectable to parade its effects: live in a mansion, adorn oneself with jewelry, wear fine clothes, serve elegant dinners prepared by skilled cooks. In the days of Pericles people had been content with the beautiful but inexpensive Athenian pottery; now they went in more and more for costly metal vessels, pitchers and cups of bronze, even of silver and gold.

Macedonians followed the Greek lead in the new taste for display as they had in art, music, and literature. And Philip, with the tribute of his newly conquered cities at his disposal as well as the yield from the gold mines of Mount Pangaeus, was able to indulge himself on a scale that no citizen of a polis could afford. At his court parties, drinks were served the way they had been a thousand years earlier in the sumptuous days of the Mycenaeans, in silver pitchers and golden goblets. Macedonian notables were able to afford armor so finely worked it challenged comparison with that worn by Homer's heroes. Royal tombs were filled with treasure as prodigally as those of the kings of Mycenae had been. A royal tomb was found recently at Vergina (formerly Aegae) in Macedonia. Some think it was Philip's—if not his, it surely belonged to a member of his family. The ashes of the deceased were enclosed in a box made out of just under twenty-four pounds of gold. Croesus, possessor of proverbial riches, might well have envied Philip's wealth.

Philip, however, did not enjoy it for very long. His end came soon, an unhappy end that he brought upon himself. The sure judgment that he had exercised for so long began to weaken. A year after the monumental victory at Chaeronea, when the path to far greater glory seemed so well marked, he took a wrong turning: he decided to marry for the seventh time. Had it been a marriage like all the others, it would have had scant effect

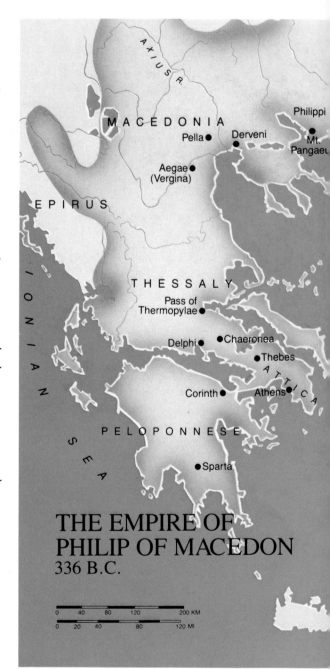

THE EMPIRE OF
PHILIP OF MACEDON
336 B.C.

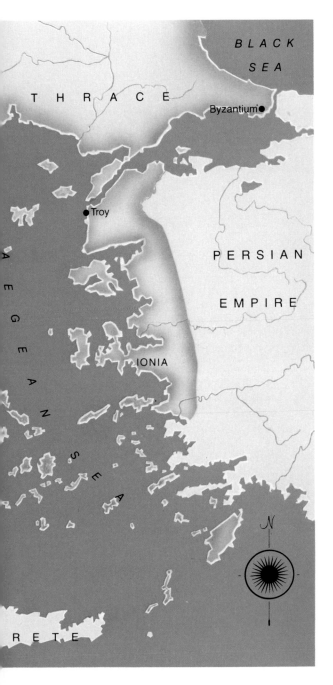

beyond perhaps raising the level of chatter and intrigue in the women's part of the palace. It was not: Cleopatra, as the young bride was called, was the daughter of a high-ranking Macedonian nobleman; the others, Alexander's mother, Olympias, included, were of foreign extraction. Up to now there had never been any question that Alexander was the designated successor. Philip had trained him for the post. But what would happen if Cleopatra had a son—which was no remote possibility since she had years of potential childbearing ahead? Alexander was only half-Macedonian; a half-brother would be Macedonian on both sides—an issue that Cleopatra's powerful relatives would be sure to raise. Why did the astute Philip enter a marriage that could produce so dangerous a problem? Plutarch explains that it was love, and he adds regretfully that it came at a time when Philip was "past the age for such things."

The wedding party was a wild affair with more than usual hard drinking. At one point the bride's uncle, a certain Attalus, who had downed far too much wine, spoke aloud what must have been in the thoughts of everyone in the room: he proposed that they all pray for his niece to give Philip a "legitimate successor." Alexander was on his feet in a flash. "You filth!" he shouted, "What do I look like to you? a bastard?" and grabbing a cup—very likely a heavy gold one—he hurled it at Attalus. In a rage Philip staggered up from his couch and, pulling at his sword, made for his son. Luckily he was so drunk he fell flat on his face. "Look at him," jeered Alexander, "the man who was going to cross from Europe to Asia goes head over heels crossing from one couch to another." Alexander and his mother forthwith packed up and left for her home in Epirus. Eventually Alexander let himself be talked into returning, but not Olympias.

A year later another celebration took place when Philip married off one of his daughters. He was a skilled hand at putting on impressive public pageants, and this time he decided to go all out. The guest list included practically everyone of importance from inside and outside Greece. And the program included not

only endless banqueting but also an all-day Festival of the Arts to be held in the theater at Aegae. By sunrise the house was packed. Shortly thereafter, Philip made his appearance, his bodyguard following a good distance behind; it was his way of showing how confident he was of everybody's good will. At that precise moment a courtier named Pausanias darted out and put a knife through him.

Pausanias' act had ugly roots. Partly it was the jealousy of a man scorned: he had been Philip's lover until Philip discarded him for another. Partly it was the doing of Attalus, the same who had broken up Philip's wedding party. Attalus had held a grudge against Pausanias which he had settled in a particularly vicious way: he got Pausanias blind drunk and then turned him over to the stable boys to have what sexual fun they wanted with him. When Pausanias came to, he rushed up to Philip in a white heat and publicly demanded redress. But Attalus, after all, was Philip's in-law as well as a powerful noble. Philip hedged, making Pausanias mad enough to murder him.

Or did it? Philip's death was unquestionably a great boon to a number of interested parties, notably Olympias and Alexander. Olympias was a prime suspect, and wagging tongues were quick to accuse her of taking advantage of Pausanias' resentment to make a tool of him. But Alexander had more to gain—enough, some believed, to tempt him to parricide.

It was a sordid final curtain for what had been, up to the last scene, a fine show. Philip, however, had written much of the script for what was to come next. He had created a wealthy empire, under the control of an absolute monarchy, that embraced the whole of Greece as well as some lands to the north. He had built up the finest army of the age, which could not only handily defend his empire but expand it as well. And he had already set such expansion in motion: his forces were poised for a crossing into Asia to attack mighty Persia.

But the leading man had just been murdered. The understudy stepped in—and proved to be a greater star than even his father.

MACEDONIAN
SPLENDORS

Embossed with a sunburst, emblem of the Macedonian
dynasty, this gold chest held the bones of a fourth-century-
B.C. noble, possibly King Philip II himself.

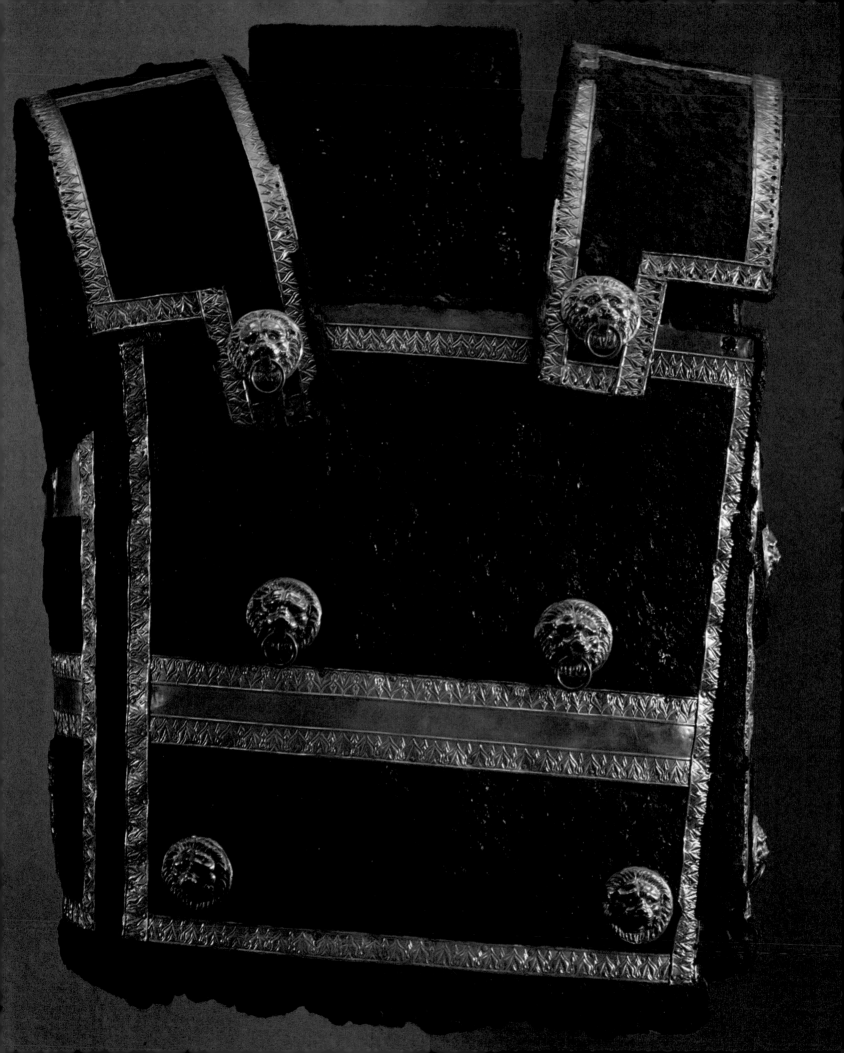

By the mid-fourth century B.C., Philip II's successful leadership had ushered in a new age of ostentation. An abundance of newly mined metals, initially tapped to pay an army, allowed Macedonian nobles to adorn themselves and their homes with objects of silver, bronze, and gold. In working the precious metals, local artisans mastered a variety of innovative decorative techniques such as plating bronze with gold and fashioning vessels with relief portraits of mythical beings. Such finery was sure to impress visitors from cultured Greek centers to the south. The most beautiful objects were also enshrined in tombs, in the belief that their owners would be displaying them in the company of the gods.

An unusually large tomb, perhaps Philip's, discovered in the village of Vergina, yielded the treasures here and on pages 92–97. The Vergina site has been identified as Aegae, burial place of Macedonian kings, and the opulence of the contents suggests a royal burial. Moreover, everything in the tomb was put there between 350 and 325 B.C., during which time only one king, Philip, was buried in Macedon. But whoever the man was, these splendid possessions, with others from a great tomb at nearby Derveni (pages 98–105), demonstrate the rise in fortune and taste of Greece's new overlords.

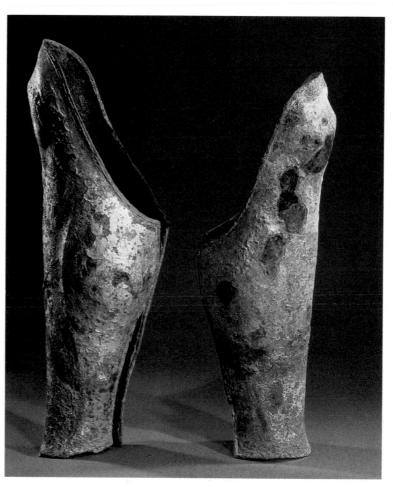

Royal leg armor, these gilded bronze greaves—one of them shorter than the other—could have been worn by Philip, who was lame.

The ornate cuirass, or breastplate, opposite, from the Vergina tomb is made of iron plates bordered with decorated gold bands. On the front are six golden lion heads, which held leather thongs for binding the sides and shoulder pieces.

OVERLEAF: *Bristling with thirty-two branches, this golden wreath of paper-thin oak leaves and acorns was found in the casket thought to be Philip's. The oak was the sacred tree of Zeus, whose image Philip favored on his coinage.*

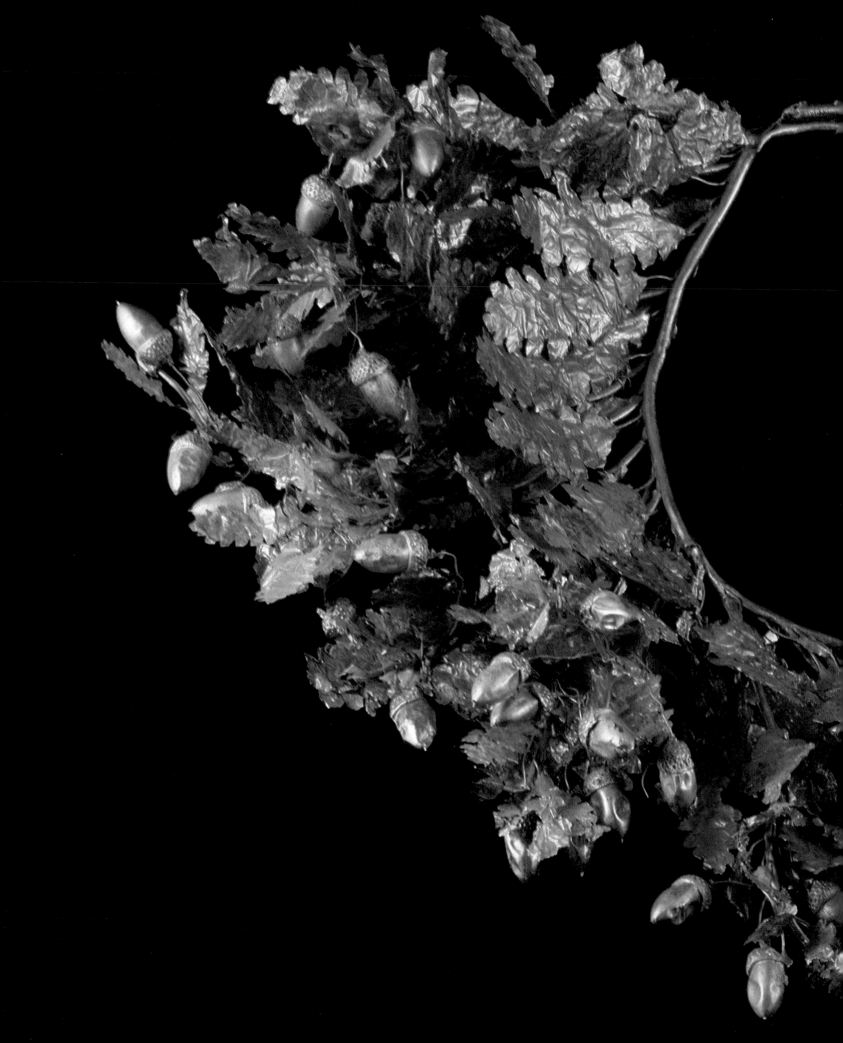

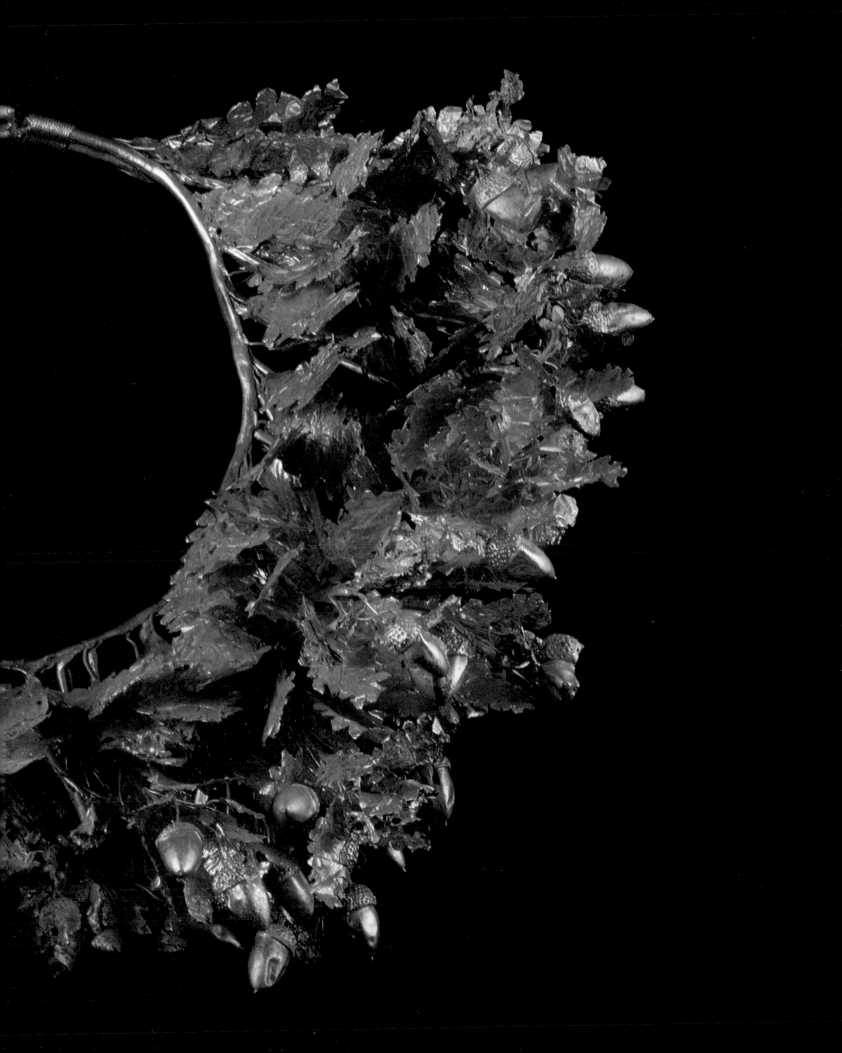

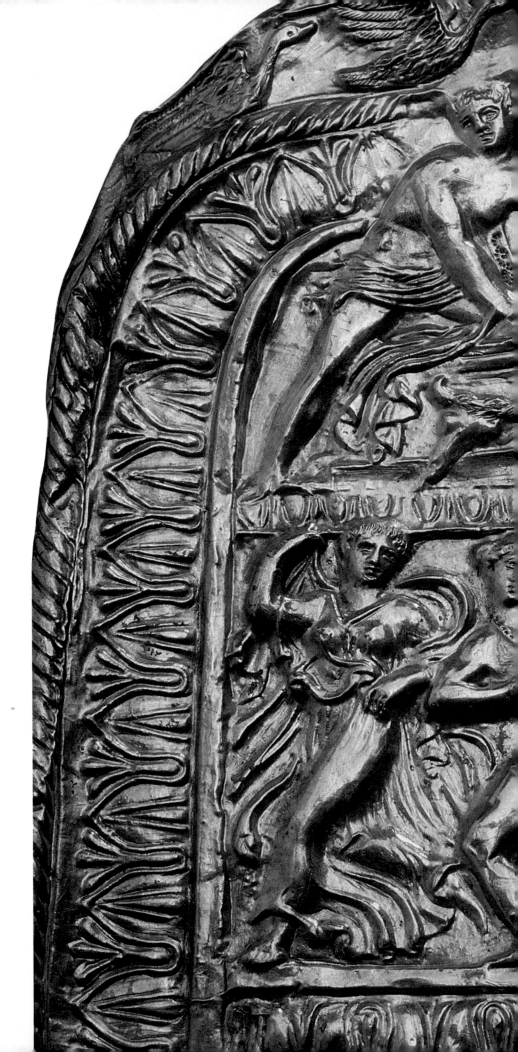

An intricate relief of infantry storming a city, in detail at right, covers most of the gilded plaque above. Made to sheathe a leather quiver, the plaque resembles those favored by the Scythians, nomadic tribesmen of the steppe of southern Russia who often commissioned these ornaments from Greek goldsmiths. This piece, from the tomb at Vergina, may have been part of the plunder that Philip took in a campaign against the Scythians in 339 B.C.

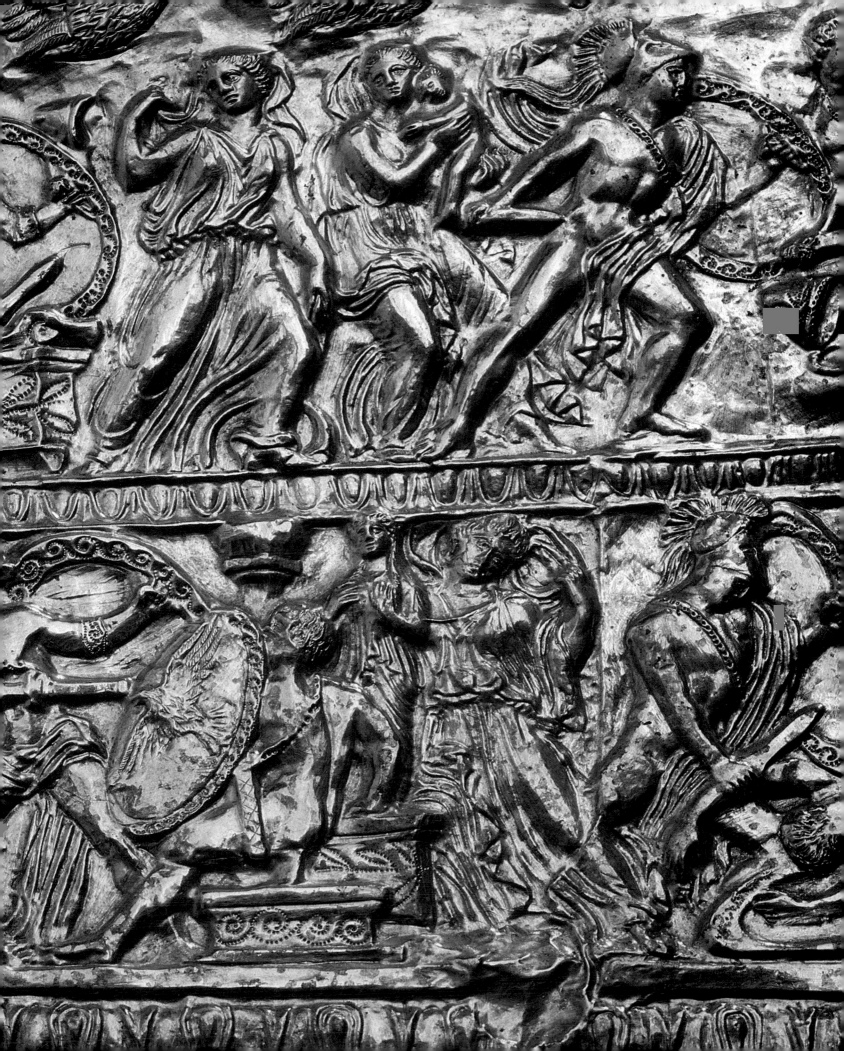

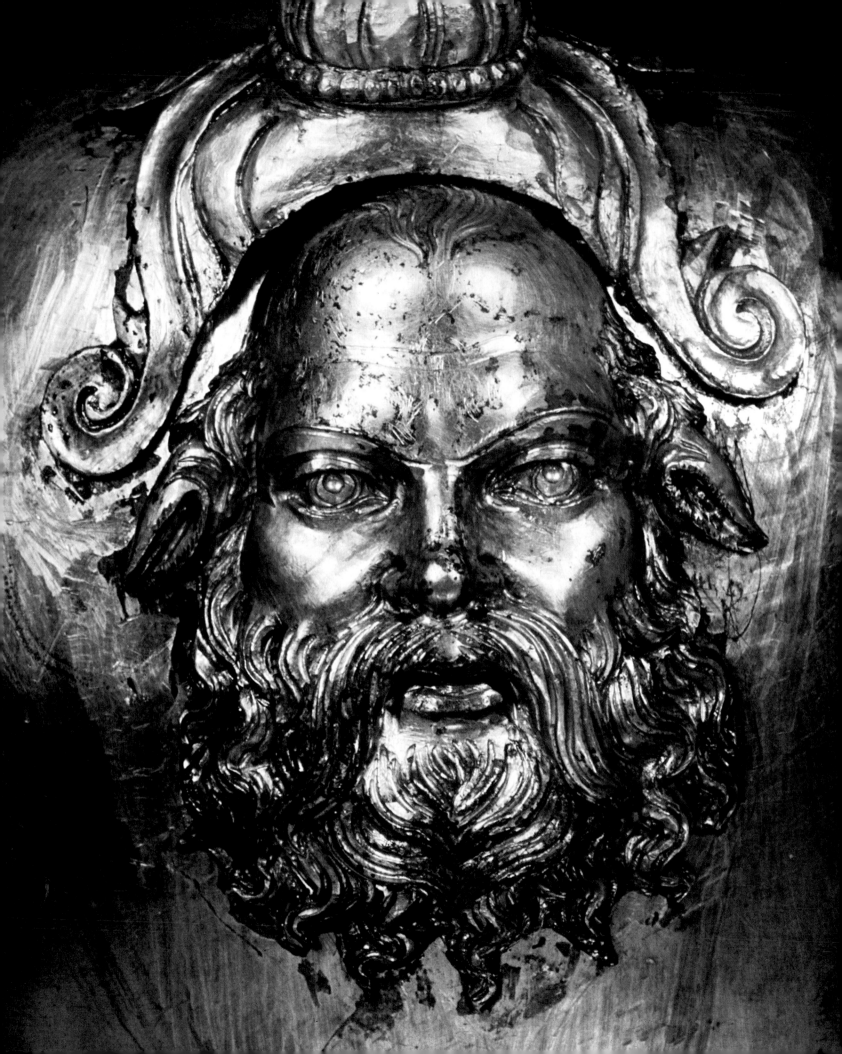

A silenus with gilded wreath and beard smiles up from the center of this silver cup. The expressive portrait was executed on a medallion soldered to the bottom of the vessel.

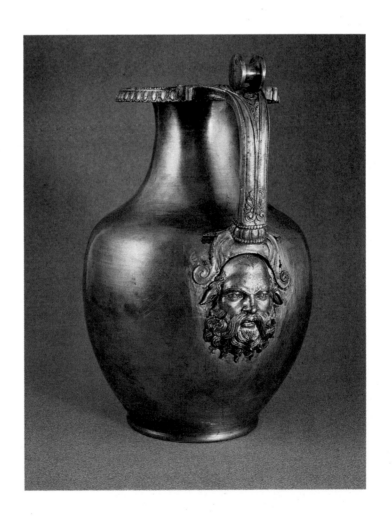

This silver oinochoe, or wine pitcher, from the burial chamber at Vergina has a gently swelling body and a handle ending in the finely sculpted head of a mythical creature (detail, opposite). The figure is a silenus, a woodland deity and attendant to Dionysus, god of wine, whose cult was widespread during Philip's reign.

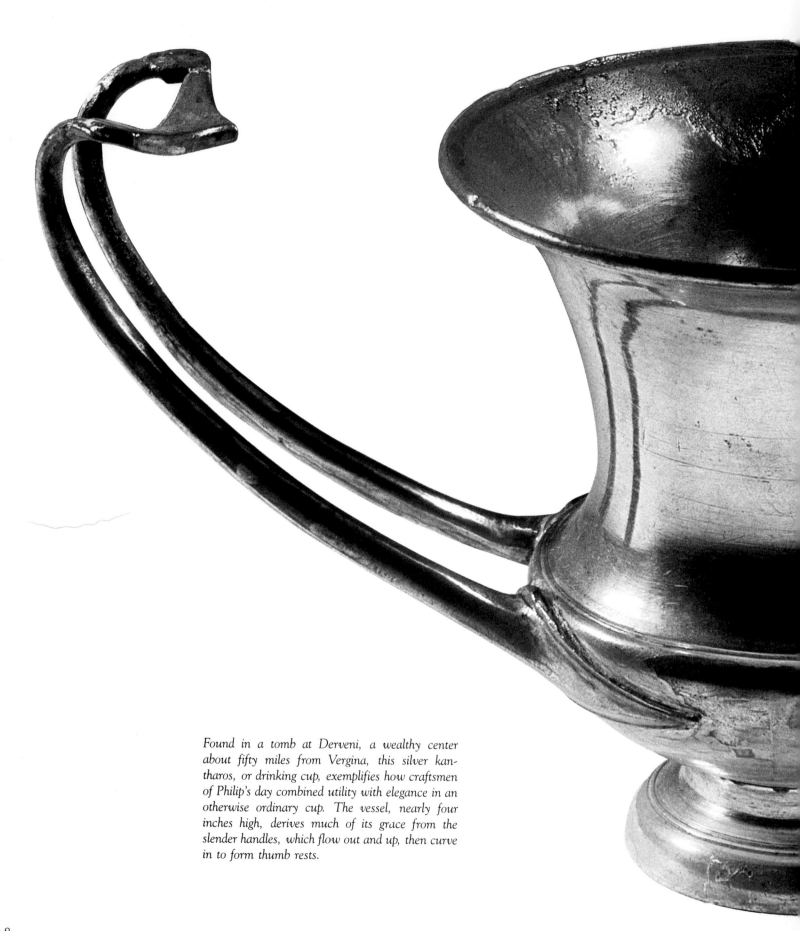

Found in a tomb at Derveni, a wealthy center about fifty miles from Vergina, this silver kantharos, or drinking cup, exemplifies how craftsmen of Philip's day combined utility with elegance in an otherwise ordinary cup. The vessel, nearly four inches high, derives much of its grace from the slender handles, which flow out and up, then curve in to form thumb rests.

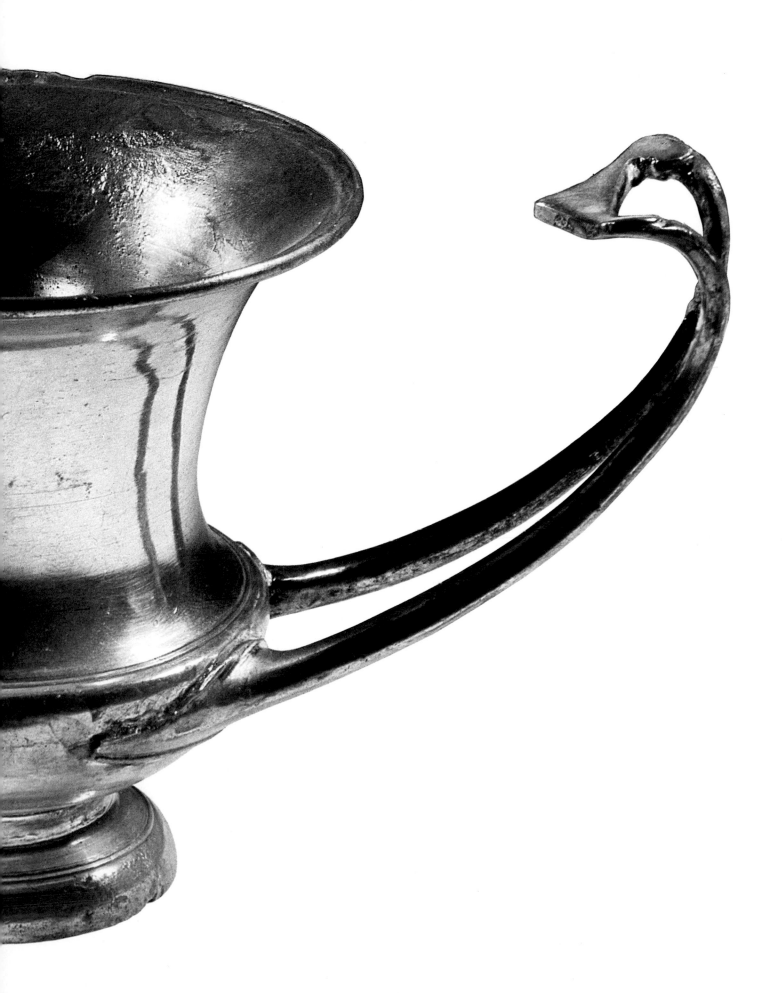

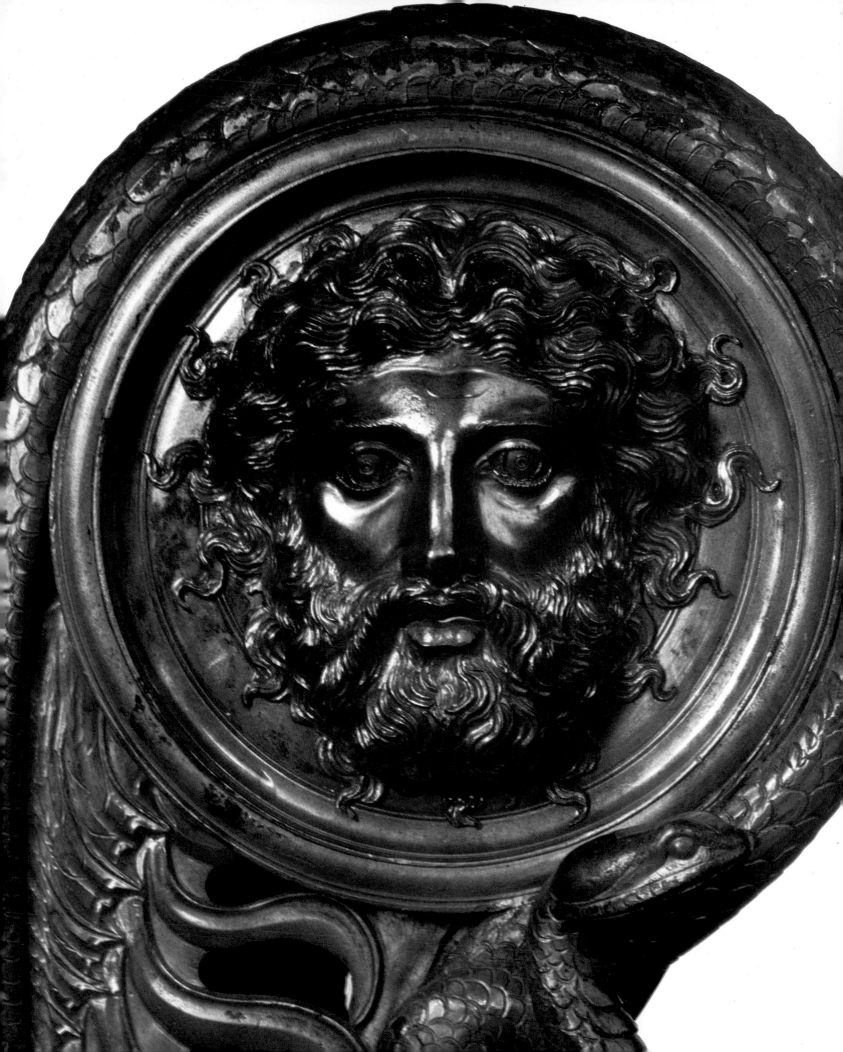

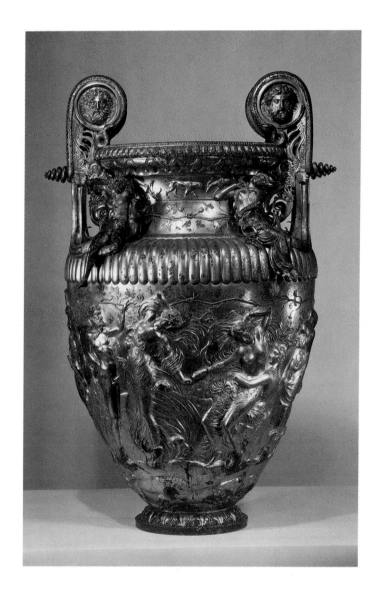

Unique among the treasures from the age of Philip, this massive gilded bronze vase—a yard high and weighing nearly ninety pounds—was uncovered at Derveni. Known as the Derveni krater, it was used for mixing wine and water, and ultimately served as a burial urn for the remains of a noble. The krater is decorated with a riot of animal and mythical figures (in detail opposite and on pages 102–105). In the embossed relief around the krater's body revelers attend Dionysus. Above this exuberant scene, soldered to the shoulder of the vessel, perch additional Dionysiac characters masterfully sculptured in the round. And each handle bears miniature visages of deities: in the detail opposite, a snake encircles a mask of Hades, god of the underworld.

OVERLEAF: *Dionysus gestures toward a sleeping maenad, one of the god's female followers, in this detail from the Derveni krater. Behind the two statuettes, ivy in silver appliqué and animals in relief decorate the neck.*

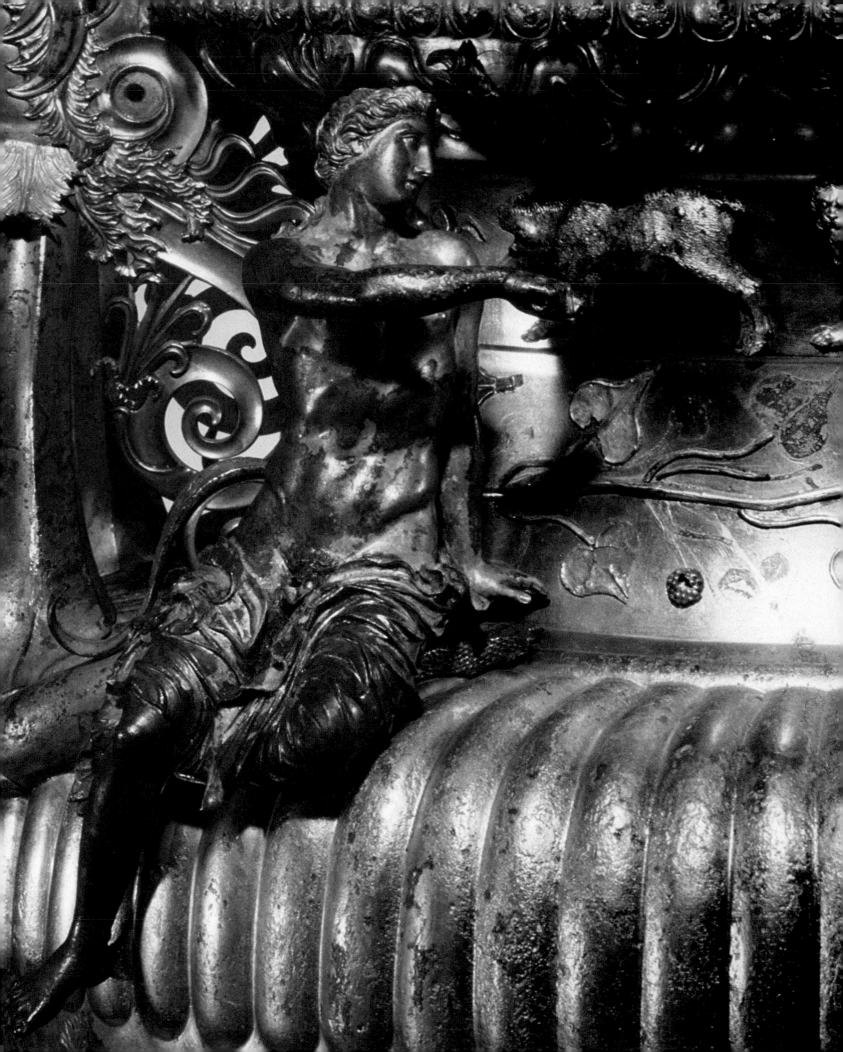

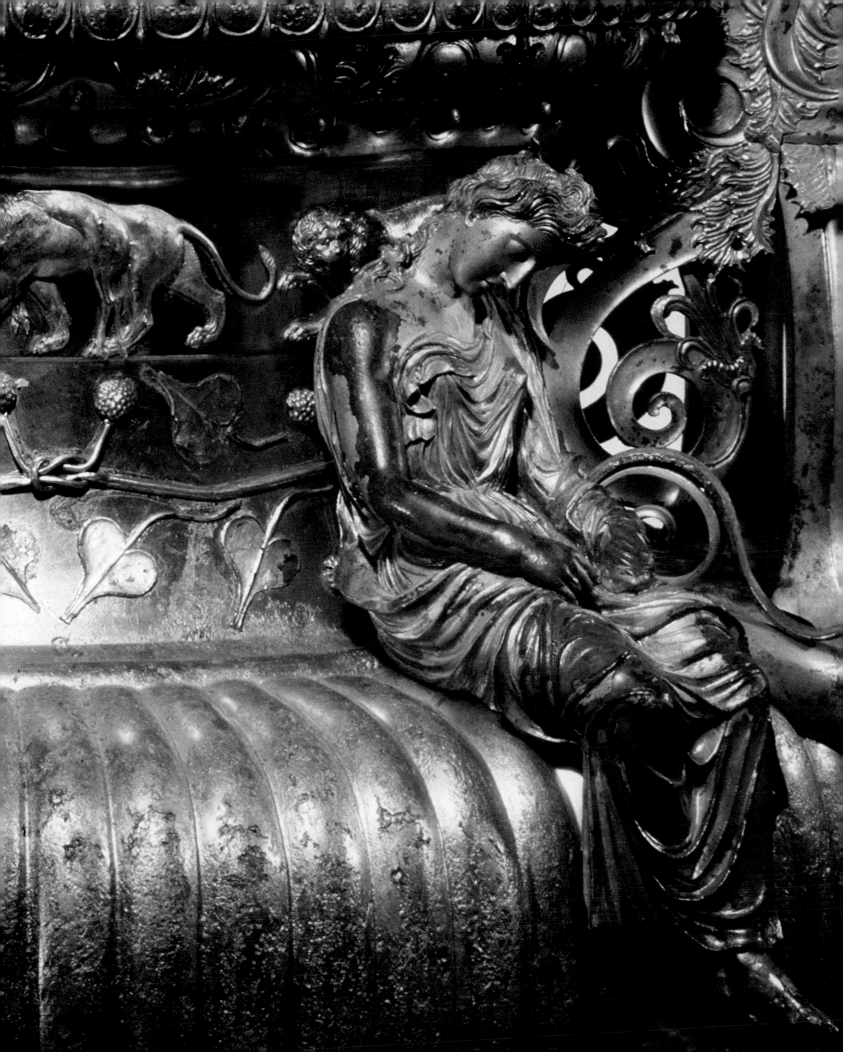

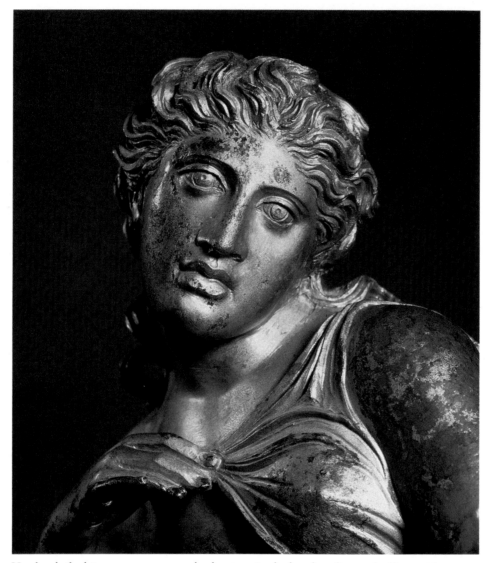

Her head tilted in ecstasy, a maenad takes part in the bacchanalia on the Derveni krater.

Beautifully proportioned, the wine god Dionysus affects an indolent pose in this relief from the krater. The silver band of ivy running above his head signifies he was also the god of vegetation.

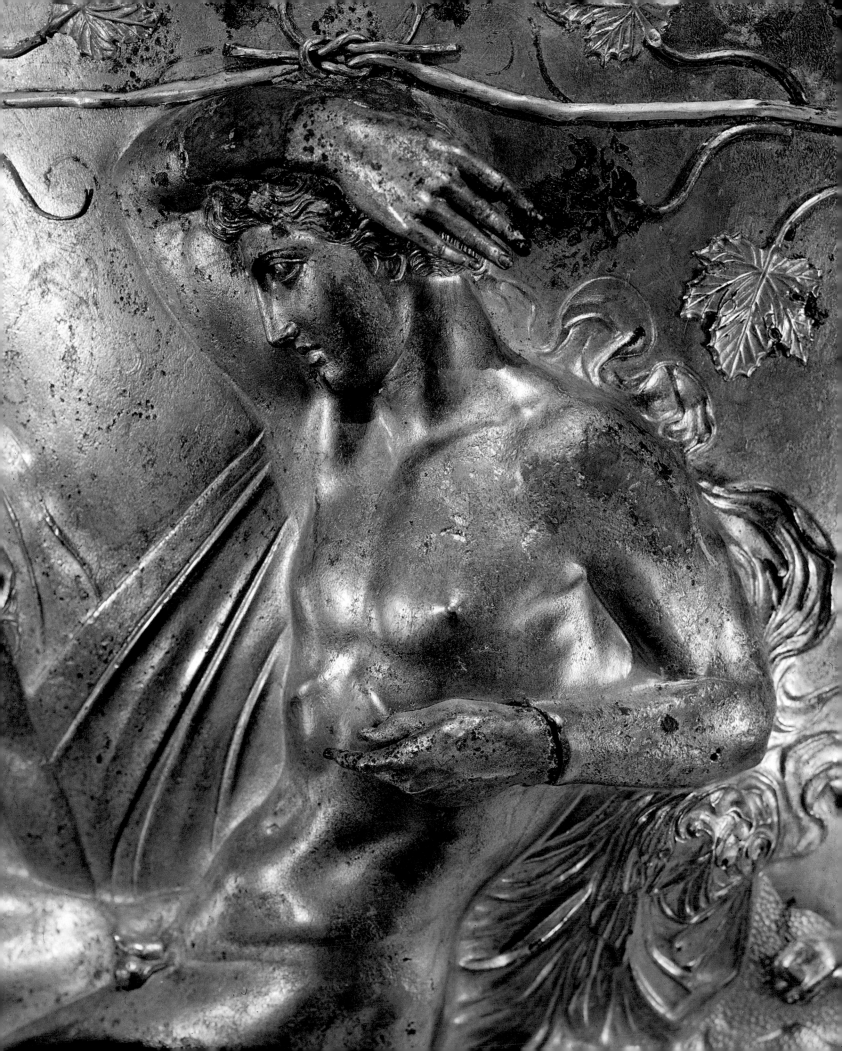

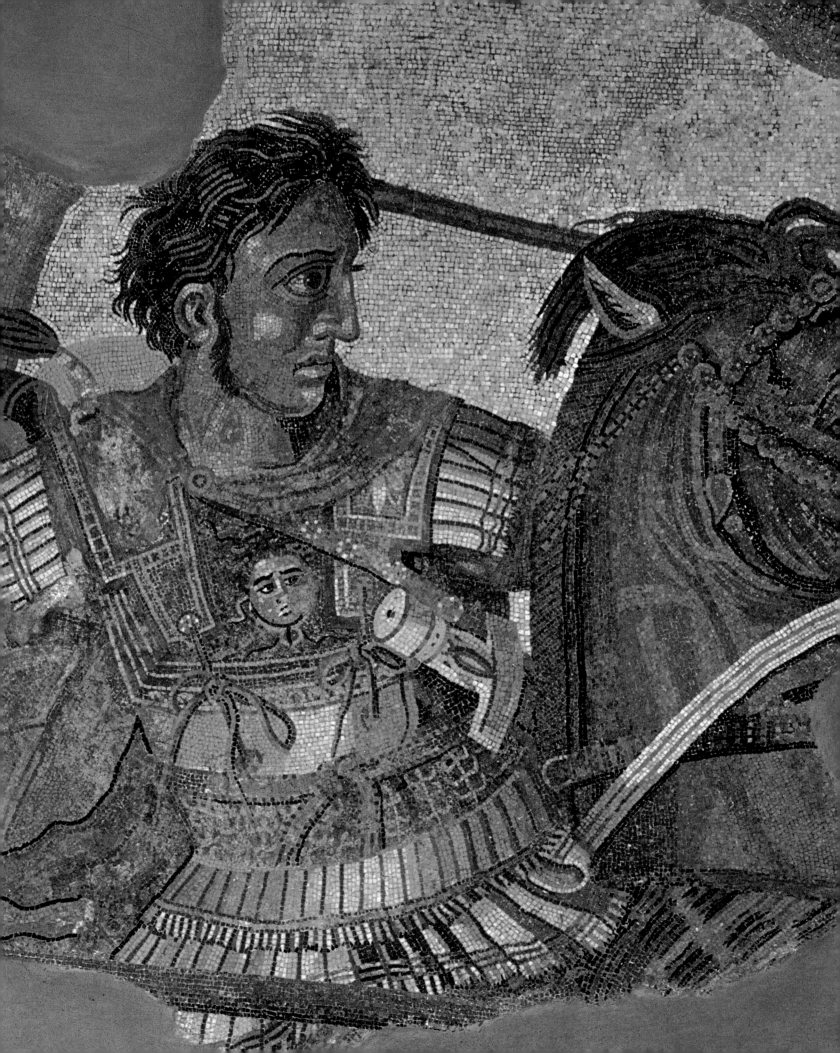

IV

ALEXANDER THE GREAT

AND THE WEALTH OF EMPIRE

Philip's body was hardly cold when Alexander swung into action. He was twenty years old, a seasoned commander, and his claim to the throne was clear. He rounded up a batch of suspects, convicted them of collusion with the assassin, and summarily executed them; the victims conveniently included all who had any possible claim to the throne. Philip's young wife had just given birth to a son, as her relatives had hoped she would; Alexander allowed his mother, Olympias, the satisfaction of personally killing off mother and infant.

The wild tribes to the north of Macedon took Philip's death as an invitation to revolt; what had they to fear from this fledgling king? They found out soon enough. With a small but mobile force Alexander raced northward and, in a series of dramatic strikes, brought them to heel. During his absence a rumor spread that he had been killed, and with Thebes as ringleader, the Greek city-states joyfully declared their independence. After a forced march of three hundred miles in thirteen days, Alexander

*Alexander the Great spearheads a charge against Persian ranks at the battle of Issus, in the first-century-*A.D.* Pompeian mosaic at left.*

A third-century-B.C. onyx cameo joins Alexander and his mother, Olympias, who advanced her son's cause by hinting that his real father was not Philip but Zeus, and by slaying with her own hand an infant rival for Alexander's throne.

turned up, not only alive but at the gates of Thebes. He flung his troops upon the city, broke down its desperate resistance, and then made it plain that he was no Philip: he sold into slavery almost all the survivors—some thirty thousand—and razed the walls and buildings to the ground.

In the spring of 334 B.C. Alexander crossed the Dardanelles from Europe into Asia Minor to carry out Philip's dream of conquering Persia. As time went on this became but a first step, a prelude to a far more grandiose scheme: the conquest of the lands to the east as far as they were known to stretch. When he was a young boy, Alexander had worriedly told his playmates that his father, "won't leave me any great and brilliant deed to show the world." He solved the problem by conceiving of great and brilliant deeds that had never crossed Philip's mind.

He was uniquely equipped to accomplish such deeds. Like Philip, he was a born leader and soldier, but, unlike him, he had a breadth of vision unhindered by traditional thinking or ways. The father had founded only one city to name after himself, Philippi; the son founded at least sixteen Alexandrias. Philip had followed time-honored methods for treating the places he conquered—agreements, treaties, garrisons. Alexander broke fresh ground: he used the ruling class of his newly acquired subjects as civilian administrators and he incorporated these new subjects into his army. His freewheeling ways owed much to the unique combination of his being a Macedonian who had been brought up as a Greek. His upbringing spared him the rough, nonintellectual stance of his countrymen, while birth and residence in Macedon spared him the narrowness that being raised in a city-state of that time inevitably brought. To a Greek, it was always "we" and "they," "we Greeks" and "those barbarians"—barbarians being their inclusive term for all who were not Greek. Alexander was free of such prejudices—so much so that he was able to envisage a nation in which Greeks and barbarians formed an amalgam. Admittedly he sought this not for humanitarian reasons but for political ones; integrating his subjects

would make them easier to rule. Only an Alexander was capable of such an unorthodox idea.

Philip had gained his throne the hard way and in the process had learned useful lessons in flexibility, patience, self-discipline. Alexander was born to the purple and knew from childhood that he was destined to be the absolute monarch of a powerful kingdom. It is no surprise, then, that from an early age he was afflicted with the curse of arrogance. As a boy he was so fleet a runner that it was suggested he enter the Olympic Games; "Only," he replied, "if my competitors are all kings."

He seemed to do everything in extremes, for he could easily fly into an excess of gratitude, grief, or anger. On one occasion he gave a friend who had amused him a gift of no less than five talents—at the very least about three hundred thousand dollars. Another time he rewarded a philosopher he admired with a fortune of fifty talents. When his closest friend, Hephaestion, died, Alexander's reaction was almost manic. He had the doctor on the case executed, put the whole army into mourning, conducted a showy funeral, and erected a tomb that, it was said, cost ten thousand talents.

One area in which his high-strung nature did not lead him to excess was sex. He did not inherit the drive that so notoriously affected his father. Plutarch and Alexander's other biographers not only have no scandal to tell of him but, on the contrary, dwell on his continence. They give us, for example, a glowing account of his chivalrous treatment of the wife and daughters of Darius, the king of Persia, after he had captured them: he did not lay a finger on any of them, not even the wife, a renowned beauty. People looking for favors on occasion offered him temptingly handsome slave boys; he turned them down indignantly. With great deliberateness he chose the partner to whom he would lose his virginity, an older woman who, though Persian, was the widow of a Greek general and had had a Greek education. By her he fathered a son; later he fathered a legitimate heir. His two marriages to Asian princesses, including one of Darius'

A young Alexander tames his famed mount Bucephalas in a fourth-century-B.C. bronze. Experienced horsemen had failed to break Bucephalas, but Alexander noticed that the horse shied from its shadow and simply turned it toward the sun.

AN EPIC MARCH
OF CONQUEST

Eight years of fighting and a twenty-thousand-mile march awaited Alexander when he crossed the Dardanelles into Asia in 334 B.C. After first defeating a strong Persian force sent to throw him back into the sea and then driving the Persians out of the Greek cities in Asia Minor, Alexander came face to face with Darius himself at Issus. On a narrow coastal strip Alexander's cavalry broke the Persian formation and put the Great King to flight. In order to prevent the Phoenician navy, loyal to Persia, from harassing the homeland and his lines of communication, Alexander besieged the port of Tyre and demolished it. Egypt fell to him without a fight.

Having spurned a peace offer from Darius, Alexander marched north through Syria and Mesopotamia to a plain that Darius had prepared for a decisive battle. At the battle of Gaugamela, Alexander's hardened Macedonians and superb tactical planning overcame the massed might of the Persian Empire, including an elephant corps and a detachment of feared Scythian horsemen. After Babylon, Susa, and Persepolis surrendered, Alexander drove north in pursuit of Darius, who died at a traitor's hand.

In the next four years Alexander's soldiers fought ceaselessly in mountainous terrain through burning summers and icy winters to subdue the eastern regions of the old Persian Empire. Reaching India in 326, Alexander's army refused to go any farther, so Alexander returned to Babylon where he was laying plans for the conquest of Arabia when he died in 323 B.C.

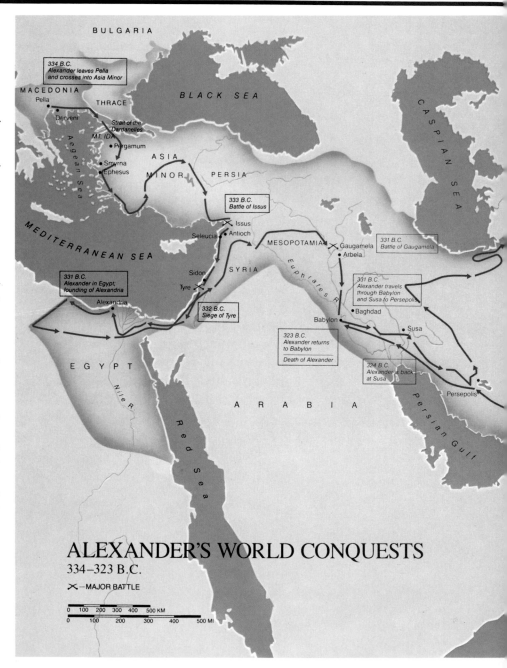

ALEXANDER'S WORLD CONQUESTS
334–323 B.C.

✕—MAJOR BATTLE

| 0 | 100 | 200 | 300 | 400 | 500 KM |
| 0 | 100 | 200 | 300 | 400 | 500 MI |

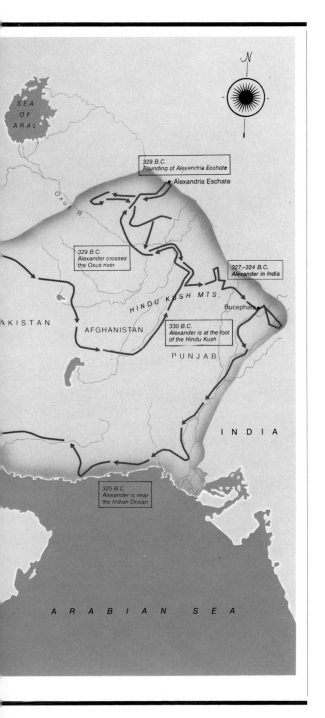

daughters, were purely political. So, to be sure, were Philip's marriages, but he enjoyed making love to his brides; it was doubtful that Alexander did.

When Alexander entered Asia in 334 B.C., he was never to see his native soil again. He was to spend the next eleven years moving deeper and deeper into the world of the East, subjugating its inhabitants by sword, and improvising a system for its administration. This was far from easy since he was acquiring an empire that embraced a miscellany of peoples—each with its own language and customs—and terrains that varied from the plains of Mesopotamia to the jagged mountains of Afghanistan, from the rainless valley of the Nile to the monsoon-drenched delta of the Indus River.

Alexander had crossed the Dardanelles at the head of an army of some forty thousand men, who were highly mobile and able to live off the land. Asia Minor belonged to Persia, whose Great King was Darius III, the last of his line and no match for the Macedonian conqueror. Darius' governors met Alexander with an equal force not far from where he had landed; the intent was to stop him at the very outset. Alexander routed the enemy in a sharp battle and then went on to conquer all of western Asia Minor within a year. He was preparing to march south when at Issus, the right-angled bend in the coast where Asia Minor ends and the Levant begins, he was met by a second Persian army, a huge aggregation commanded by Darius in person. The defeat this time was so complete that Darius fled the battlefield leaving not only much treasure but his whole family too—mother, wife, and daughters—to fall into the victor's hands.

Alexander then moved south through what is today Lebanon and Israel. En route he was held up for seven months laying siege to Tyre, the first of a number of places reputed to be absolutely impregnable but which yielded to the stubbornness and ferocity of his attacks. Then he continued on to Egypt, where he was welcomed as a liberator and where he founded, on the site of an Egyptian coastal village, the first and greatest of his many Alex-

andrias. From Egypt he marched back northeast into Mesopotamia. Here Darius faced him once more with all the fighting men he could scrape together, only to suffer a third, shattering, defeat. This might have been enough for Philip but it was not for Alexander. He followed on the heels of the remnants still under arms, driving farther and farther, right into the wilds of Afghanistan where neither the bitter winter nor the trackless mountains kept him from running down all opposition and stamping it out. Darius, a fugitive in his own realm, was murdered by one of his own followers.

At selected points as he moved east, Alexander dropped off contingents of his soldiers, men disabled or otherwise unfit for the rigorous demands he made of them, to found new settlements, new Alexandrias. He even planted a colony in what is now Russian Turkestan, not far from Samarkand; it was called, appropriately, Alexandria Eschate, "Farthest Alexandria." One can imagine the feelings of those Greeks and Macedonians who were suddenly told to remain there at this primitive spot in the middle of nowhere for the rest of their lives. There was nothing to be done about it; orders from Alexander were orders.

From Afghanistan he went over the Hindu Kush mountains into the Punjab in northwest India. Here a dangerous situation developed when a rajah named Porus, a giant of a man (at least he seemed so to the short-statured Greeks; he was six feet three), took the field against him with a powerful army stiffened by a corps of 130 or more war elephants. Alexander, resourceful as ever on the battlefield, discovered a way to combat even this unusual foe: his bowmen were able to kill the elephants' drivers one by one, leaving the animals without guidance. One last leg of the eastward journey remained: a march along the Ganges to its mouth. The Greek geographers, totally ignorant of China's vast bulk, believed that the river emptied into the ocean which bounded the world on the east. This was the boundary Alexander wanted to reach.

But in 326 B.C., on the threshold of that last crucial step, the

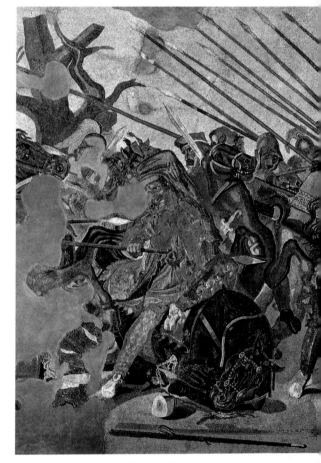

At the battle of Issus, Darius III, panic-stricken, flees Alexander in a chariot drawn by black stallions, which trample the Persian wounded in the confusion of battle. Darius' valiant bodyguards, wielding long spears, steadfastly face the Macedonian charge in this mosaic (another detail is on pages 106–107) believed to be a copy of a painting made soon after Alexander died.

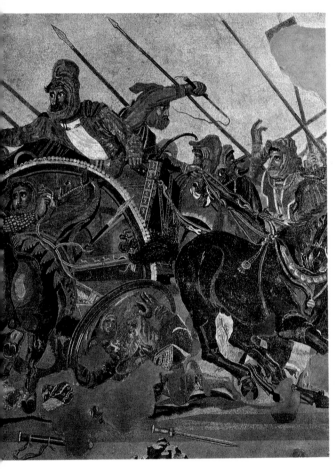

step that would crown his great enterprise, his men called a halt. They had been through eight years of incessant fighting and hardship; they had had enough. Alexander tried every-thing—rage, scorn, icy disdain—but they were adamant. So, having set his characteristic mark on India—the founding of several new settlements, including one named after his horse Bucephalas, which had died en route—he began the return. Part of his forces he put aboard ships and ordered them to coast westward to the Persian Gulf so that they could determine the suitability of the route for maritime trade; Alexander was concerned with the economy of his new empire as well as with its administration. The rest had much hardship still ahead of them: he marched them through the parched deserts of lower Pakistan and Persia, where thousands perished of heat and thirst.

By 323 he was back in Babylon with even greater plans in mind. Some said Alexander was planning to conquer the West as he had the East, and then to unite the whole by laying down a road from Egypt to Morocco. But none of it was to be. A dozen years of driving himself without letup had undermined even his incredibly durable constitution. Nor did it help that the days at Babylon were spent in feverish partying as well as planning. One night in June of 323, after a bout of particularly hard drinking, he came down with a fever. It grew steadily worse. Eleven days later he was dead, thirty-three years old.

His death was the signal for the group of strong and able men who had been his generals to close in like vultures and pick at the corpse of the great empire Alexander had put together. Two made off with big chunks—Ptolemy with Egypt, Seleucus with Syria and Mesopotamia and whatever lands farther east he could hold on to. A number of others ended up with smaller pieces. There followed decades of fighting in which the more powerful tried to swallow up the others or at least take bites out of their territory, but the division of the spoils remained roughly the same. Ptolemy's descendants held on to Egypt and the lower part of the Levant; Seleucus' to the upper part and to Syria and Meso-

TEXT CONTINUED ON PAGE 118

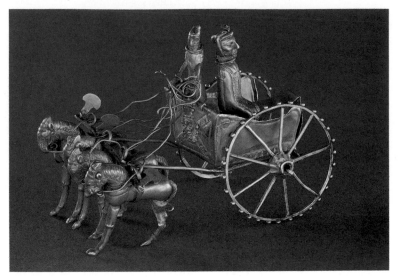

This chariot model, less than four inches long and fashioned of gold, holds a driver and a Persian nobleman or high official.

TREASURE FROM AN ALIEN LAND

The Oxus Treasure is an intriguing footnote to the history of Alexander's conquest of central Asia. Found in 1877 near the Oxus River (now the Amu Darya) the treasure includes 177 gold and silver drinking vessels, ornaments, and votive objects, as well as roughly 1,500 coins. Much of the hoard dates to the fourth and fifth centuries B.C. and was fashioned in the artistic style of the Persian Empire. The origin of the treasure and its connection, if any, to Alexander have been debated for a century. Some of the objects are religious offerings, which supports the theory that the hoard was a temple treasure buried when Alexander's army swept into the Oxus region in 330. A portion of the treasure may have been booty carried off by one of Alexander's officers from the Persian coffers of Susa or Persepolis. The most tantalizing conjecture is that the treasure belonged to Alexander's own family. A ring from the hoard bears a four-letter inscription that may spell out the name Oxyartes—the father of Alexander's Persian wife Roxana. Thus, by a stretch of the imagination, some of the Oxus gold could be the conqueror's personal gift to his new in-laws.

 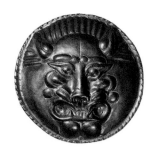

The gold ornaments above, with loops for attaching them to clothing, show a mythical winged griffin (left), a man's face surrounded by Greek-style dolphins (center), and the face of a roaring lion (right).

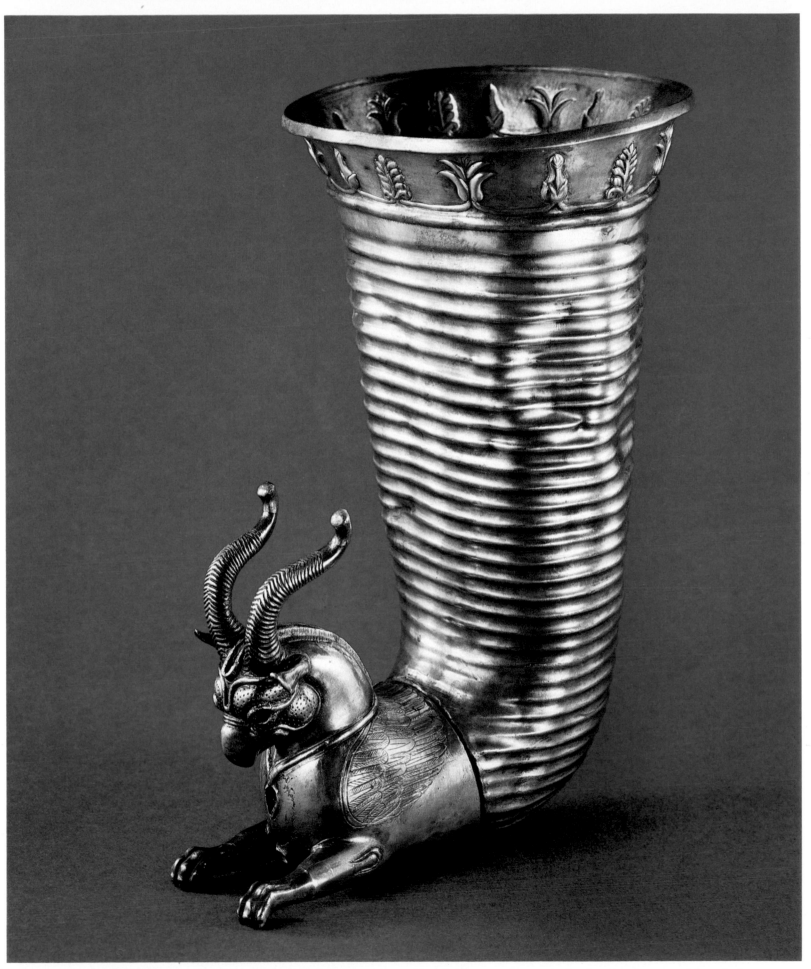

A horned griffin forms the base of this ten-inch-high silver rhyton with a fluted cup and a rim bordered with palmettes and lotus buds.

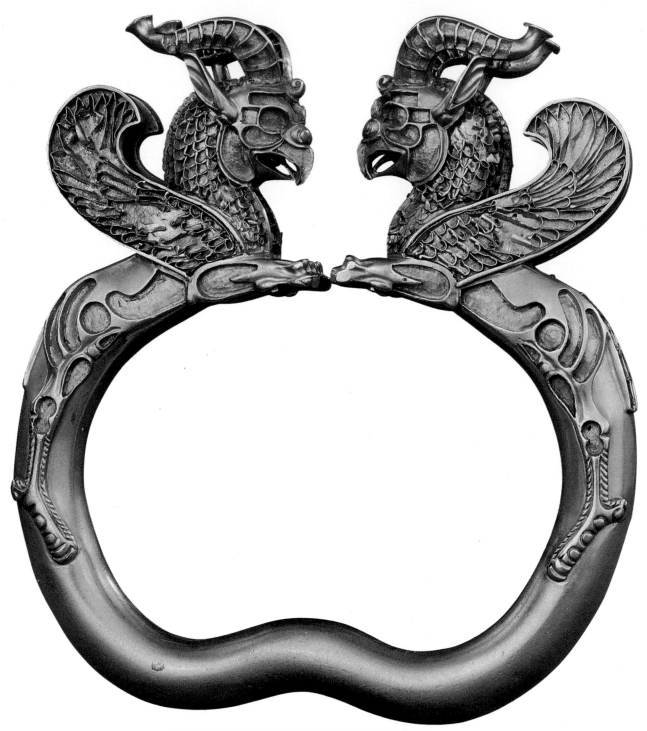

A FOOT-HIGH GOLD ARMLET WITH WINGED GRIFFINS

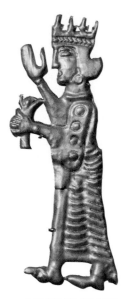

A PERSIAN PRINCE

A HIGHLY STYLIZED GRIFFIN

GOLD PLAQUE SHOWING A PRIEST

"So this is what it is to be a king?" was the famous remark of Alexander upon seeing the glittering booty he had won from Darius in battle. These objects from the Oxus Treasure may be an example of the sumptuous spoils taken in Asia, where aristocrats sported massive armlets (opposite page) and adorned their clothes with images of a prince (above) or a monster (right). The rectangular plaques showing a priest holding a bundle of rods (left) and a hammer-wielding warrior (right) were a rich man's temple offerings. The golden head (below) has holes in its ears and may have been the cap for a flask of perfume.

WARRIOR WITH HAMMER AND SPEAR

GOLD LION RING

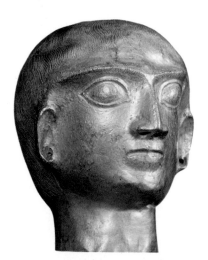

GOLD HEAD OF A MAN

TEXT CONTINUED FROM PAGE 113

potamia; the descendants of Antigonus, another one of Alexander's generals, to the homeland of Macedon.

Alexander's dramatic sweep through Asia and his annexations triggered a profoundly important movement in the course of history: the opening up of the East to the Greeks and the integrating of Greeks and Asians into one world. It was a movement unaffected by the breakup of his empire at the hands of his successors, for he had let loose currents of social and economic change that flowed as strongly as ever after his death.

His new settlements were joined by others founded by Ptolemy and Seleucus. The nuclei of settlers that Alexander had dropped off along his route, or that Ptolemy and Seleucus planted, were swelled by a tide of Greek immigrants drawn by opportunities that were nonexistent in the small and stagnating city-states back home.

"Go east, young man!" could have been the motto of the late fourth century B.C. Circumstances had created a demand for skills that only Greeks could supply. Oriental towns had narrow labyrinthine streets, like those in Arab casbahs today, and public buildings that presented a solid wall along the front and sides. The new settlers, however, wanted the latest in Greek urban planning: a strict checkerboard system of streets, broad main avenue, spacious main square, and those structures that Greeks, no matter where they lived, could not do without—temples, gymnasium, theater, council hall—all usually of stone and garnished with columns. Greek architects were needed to plan them, Greek masons to put them up, Greek artists to adorn them.

In addition to these technicians and craftsmen, Alexander's successors required thousands of mercenaries to fill the ranks of their regiments or man the benches of their war galleys, and husky young Greeks were among their preferred choices. They were everywhere—at the new port of Antioch, erected by Seleucus on his western border; at Seleucia, the new capital named after himself that he built some forty miles north of Babylon; at Alexandria in Egypt, which Ptolemy was making into the hand-

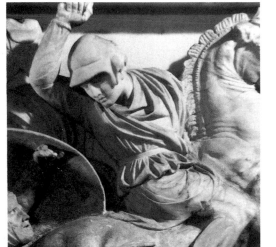

Hephaestion, the lifelong friend of Alexander, strikes a Persian in an engagement that may be the battle of Issus. A cavalry commander and member of Alexander's elite bodyguard, Hephaestion also led the army's bridge-building engineer corps.

somest city of the age; at the remote Alexandrias deep in Asia. In the course of time the immigrants picked up a smattering of the local tongue, began worshiping Baal or Isis or Ishtar or whatever the local god was, married local women, raised children.

The result was, after the passing of enough generations, the emergence of a Greco-Asian amalgam. It shows itself in language. The various Greek dialects spoken by the original settlers—Macedonian or Athenian or Spartan, depending upon the man's hometown—died out with the first generation, and their Greco-Asian posterity came to speak a common Greek. It was actually called that, the *koine*, the "common language," for it was the same from Greece clean across Asia to India. It is the Greek, for example, in which Matthew, Mark, Luke, and John, inhabitants of Palestine, wrote the Gospels.

We can see the Greco-Asian amalgam even more dramatically in art. At Gandhara in Pakistan near the Indian border, thousands of miles east of Greece, by the beginning of the Christian era sculptors working under Buddhist patronage were turning out Buddhas dressed in Greek clothing or set in Greek poses. The design of jewelry coming from what is today Afghanistan bore the imprint either of Greek craftsmen or native craftsmen trained by Greeks. Greek influence was not confined by the boundaries of the new empires; it spilled far over them. The type of jewelry just described has also been found in tombs in Siberia and southern Russia, having been worn by chieftains of the nomadic tribes that ranged the lands beyond the periphery of Greek and Persian civilization.

Asia gave to the Mediterranean as good as it got. As the influence of Western art, architecture, and language flowed toward it, the East sent forth influences in the other direction, above all in religion. Eastern religions have always offered their own brand of benefits—ways of achieving release from the world around one, ways of satisfying deeply personal needs, various forms of mystic experience. Then as now, these had an irresistible appeal for many Westerners. From Asia Minor came the cult of the goddess

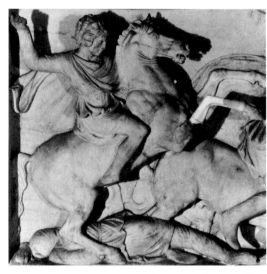

Alexander, astride Bucephalas, runs down a Persian horseman. This scene and the one opposite are from the so-called Alexander Sarcophagus—the lavishly sculpted marble coffin of a fourth-century king who knew and admired Alexander.

Cybele, which involved a rite so wild it might end in a frenzied ecstasy at the climax of which neophytes would carry out self-castration. From Egypt came a pair of deities of a far different nature, Isis and Horus, tender mother and beloved child; they gained favor among women in particular and left their imprint upon the Christian "Virgin and Child." From Persia came Mithra, a god who stood for unswerving devotion to duty and hence was popular among army men. And out of Babylon came astrology. Its spell has hardly weakened from Alexander's day to our own.

Alexander is responsible for yet one more all-important change: he made the world richer than ever before, and spread wealth far wider than ever before. Persia provided its kings a fabulous income, so much so that Darius and his predecessors, though they lived in the traditionally gorgeous oriental luxury, still had enough left over to fill capacious treasuries. Thus, when Alexander seized Susa, another Persian capital, he came upon a fortune of forty thousand talents and the same amount when he took Persepolis, altogether no less than five billion dollars. And these were only the biggest of his strikes.

He immediately began dispensing the money–to his soldiers, to the artisans working on the new settlements, to the contractors supplying provisions for his armies, and for the generous gifts he handed out in his impulsive way. His successors continued the process, paying out a steady flow of funds on mercenaries for their armies, on ships and men for their navies, on the handsome buildings they put up to adorn their new capitals. In the late fourth century B.C. the ready money of a new world to be built drew men to Egypt, Syria, and Mesopotamia, just as it does today to the oil states of Arabia and the Persian Gulf. And a good deal of the wealth traveled back west as soldiers and sailors returned loaded with booty and pay.

The money did not all go for utilitarian purposes. Plenty was spent to enable Alexander and his successors to live in the style befitting all-powerful monarchs. History is full of rulers who

Alexander the Great battles a horned and winged monster

ALEXANDER LIVES ON

Poets and writers carried the name of Alexander farther than Macedonian arms ever did. For more than a millennium after Alexander's death, talespinners from Iceland to China told of his exploits, adding their own fantastic exaggerations and inventions until Alexander became a figure of myth to rival Homer's Odysseus. The mythmaking process began with a fanciful biography of the conqueror written sometime before the third century A.D. A tenth-century Latin translation of the biography spawned some eighty local versions, which tell of Alexander carrying off a treasure from a Valley of Diamonds guarded by snakes; visiting a cave where the gods of the Greeks are confined; and sojourning in a paradise where the descendants of Heracles dwell,

in a fourteenth-century Persian miniature.

subsisting on vegetables and scholarly wisdom. In one tale Alexander is said to have built an immense wall to hold back barbarian tribes, and a credulous caliph of Baghdad actually sent an expedition to find it. Two of the most popular Alexander legends describe his exploration of the ocean depths in a glass barrel (right) and his attempt to reach heaven in a basket drawn by birds. In a tale with a modern echo, Alexander gives a container of magical water to his sister but she spills it and, in her grief, jumps into the sea where she turns into a monster. According to sailors' yarns the sister now and then pops up from the waves to hail passing vessels and ask if her brother is alive. If told he is dead, the sister stirs up a storm; but if told that he lives and rules the world then the monster goes away happy. To this day Greek sailors call out the name of Alexander in storms to calm the spirit of the hero's unfortunate sister.

In this sixteenth-century miniature, Alexander explores the sea in a glass barrel.

spent fortunes on themselves and indulged in every luxury. What distinguishes the age of Alexander is the way the money spread not only to kings but also to people all along the social ladder. A tomb unearthed in Bulgaria, rich in Greek-crafted gold treasure, held the remains of some Thracian who died about 300 B.C. Thracians were among Alexander's favorite troops, particularly the members of a tribe called the Agrianians, whom he invariably included in the units he led in person. The tomb was found at Panagyurishte, at the eastern edge of the homeland of the tribe. Could it not have been pay and loot gained under Alexander that enabled the deceased to buy the vessels of pure gold, weighing over thirteen pounds and fashioned by master Greek craftsmen, that were found in the tomb? In the Greek comedies of the age one of the standard plots involves a young fellow who is desperately in love with a beautiful slave girl but who does not have the money to buy her. To complicate his problem, along comes some strutting veteran of the army of Alexander or one of his successors with his money bags bulging, ready to offer the owner whatever price he puts on her in spot cash. And more often than not, the father of the young fellow is a businessman who has made his fortune in trade with the East.

No figure in history has a better claim to the title "the Great" than Alexander. The effects of what he did lasted to the end of ancient times and in some cases even beyond. Before him, for example, India had been a semilegendary land of marvels. After him geographers were to write soberly and accurately about its terrain, peoples, and customs. Alexander's capture of Babylon made available to the West centuries of precise celestial observations that had been amassed there. Greek astronomers used this information to work out the astronomy that served the world until the coming of Copernicus. Alexander opened the Western world to Eastern religions and loosed a flood of Persian gold upon it. The first gave Greeks and Romans the craving, and the second the means, to erect shrines for Cybele, temples for Isis, chapels for Mithra, and finally, churches for Christ.

FINE ART IN ROUGH HANDS

The sinewy, full-bearded creature above is a centaur—one of its hooves is at lower right. This wine-loving beast forms a handle of the vessel on page 137.

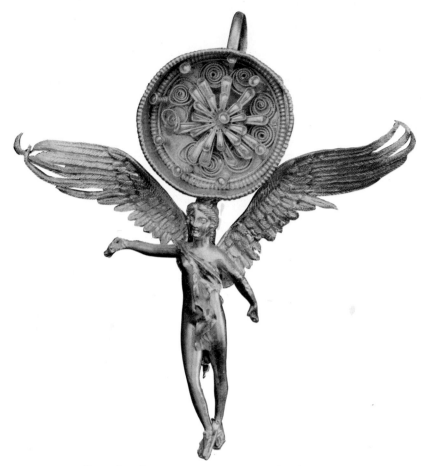

On a fourth-century earring, two inches long, a demigoddess swings from a stylized flower.

Some of the finest gold objects ever wrought by Greek artisans adorned the tents and banquet tables of two northern peoples–the Thracians, a bellicose group of tribes who lived in what is now Bulgaria, and the nomadic Scythians. These so-called barbarians had a taste for gold and the money to indulge it. The Scythians derived much of their wealth from a lucrative livestock and grain trade–so lucrative that one scholar puts them into the millionaire class of the fourth century. The Thracian warlords for their part extracted huge tribute payments from conquered tribes and Greek cities along their coast. These rough-and-ready fighters of the forest and steppe, who skinned dead enemies and offered human sacrifices, had an entirely civilized appreciation for sophisticated Greek goldwork. Aristocrats of both cultures proclaimed their status by dressing themselves and their many wives in elaborately worked

chest ornaments, bracelets, earrings, and pendants. At ceremonies the chief and his entourage glittered with gold helmets, greaves, scabbards, and weapons skillfully embossed with floral designs and scenes from Greek myth and history. At feasts the tables groaned under imposing gold drinking vessels of various shapes, some sculpted into vivid likenesses of animals. The gold that betokened a man's status in Scythian and Thracian society went to his grave with him to ensure his prestige in the afterlife. Excavations of tombs such as the Kul Oba and Chertomlyk mounds in the Soviet Union and the Vratsa and Panagyurishte tombs in Bulgaria have yielded spectacular treasures such as the Scythian pectoral on page 128 and the Thracian greave on pages 138 and 139–evidence of the fertile mingling of two robust warrior cultures with the refined grace of Greek craftsmen.

Two golden snakes (opposite) twine into a symbolic Heracles knot, thought to ward off evil. The fourth-century bracelet, over four inches high and inlaid with a garnet, was found on an Aegean island.

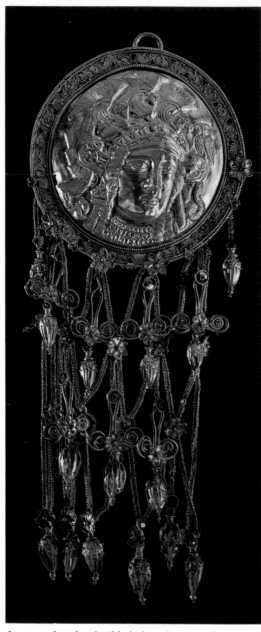

Intricate braids of gold, linking beads and rosettes, swing from a pendant (above) with a portrait of a goddess that may have been modeled on Phidias' statue of Athena in the Parthenon.

Artemis, the huntress, carrying a quiver and clad in animal skin, is portrayed on the hair ornament at right. The central medallion is of a lighter gold alloy than the setting, and may have come originally from another piece.

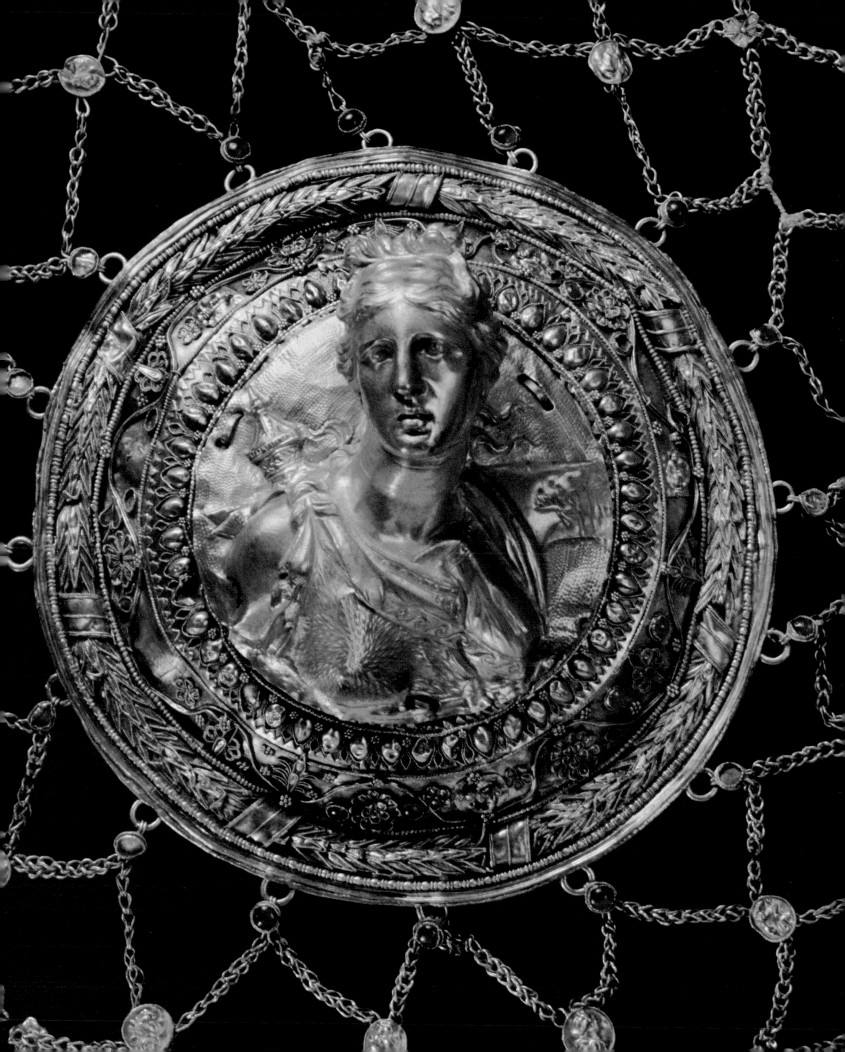

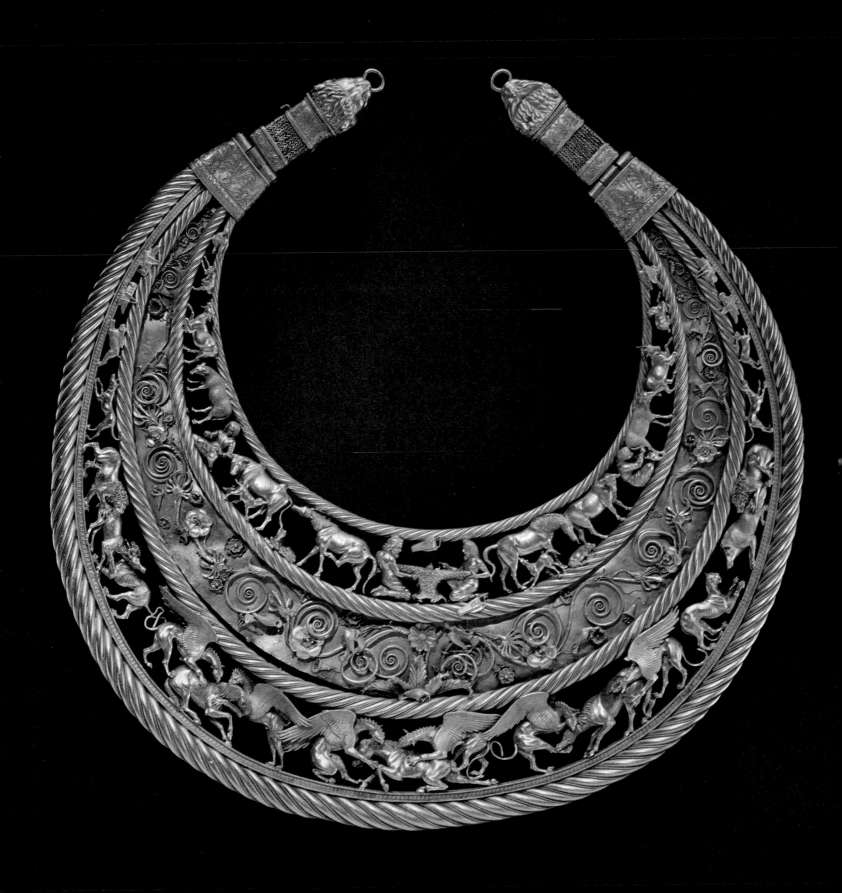

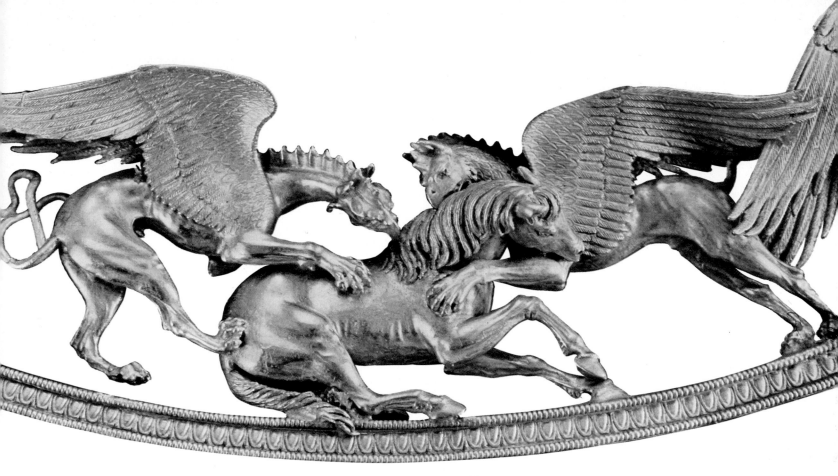

TWO GRIFFINS ATTACKING A HORSE

A Greek goldsmith produced the chest ornament opposite, found in a royal Scythian tomb near the Black Sea. The unknown master soldered forty-eight tiny human and animal figures into two bands along with a decorative strip of flowers and spirals. In the top band three vignettes of Scythians at work—milking a ewe (detail, right), sewing a shirt, and capping an amphora—vibrate with life. In the lowest band griffins attack horses (detail, above); lions and panthers fall upon a deer and a boar; dogs chase hares; and even grasshoppers are set against each other in a panorama of nature's violence.

A SCYTHIAN YOUTH MILKING A EWE

A FOURTH-CENTURY PECTORAL, OPPOSITE

A Scythian horseman, wearing Greek-style armor, prepares to thrust his lance at an attacker who has lost his mount. This miniature battle is a two-inch decoration atop a three-inch comb. Greek goldsmiths were adept at small-scale work; by skillful composition the maker of this comb created a dramatic scene with only three figures.

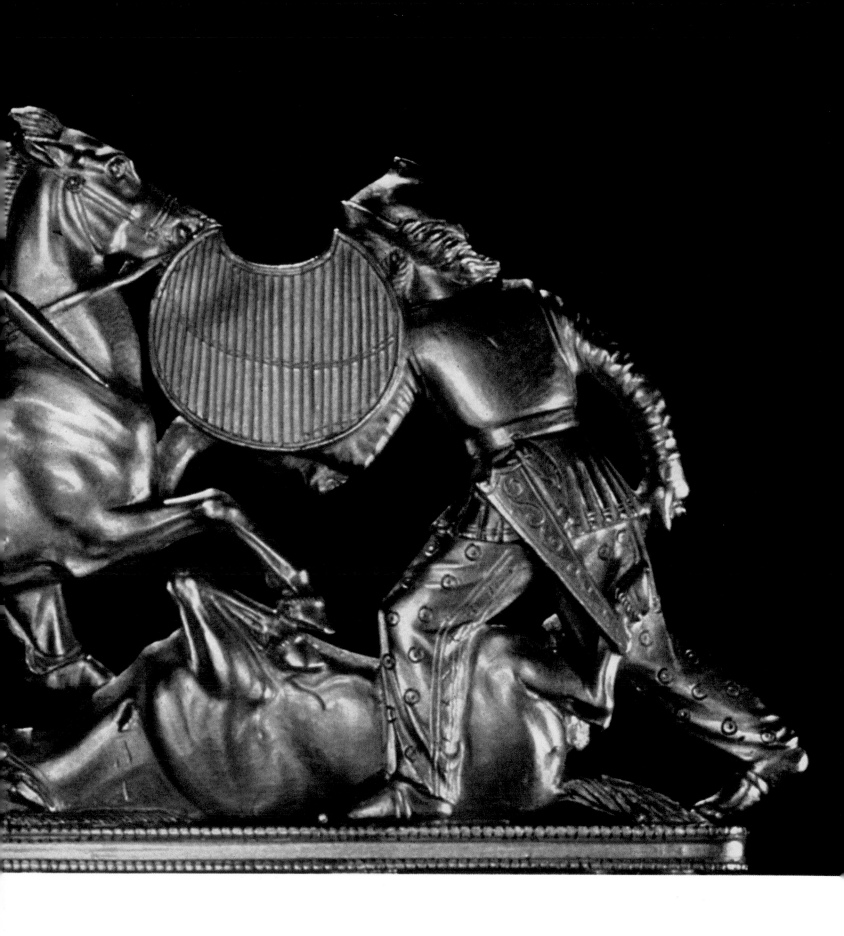

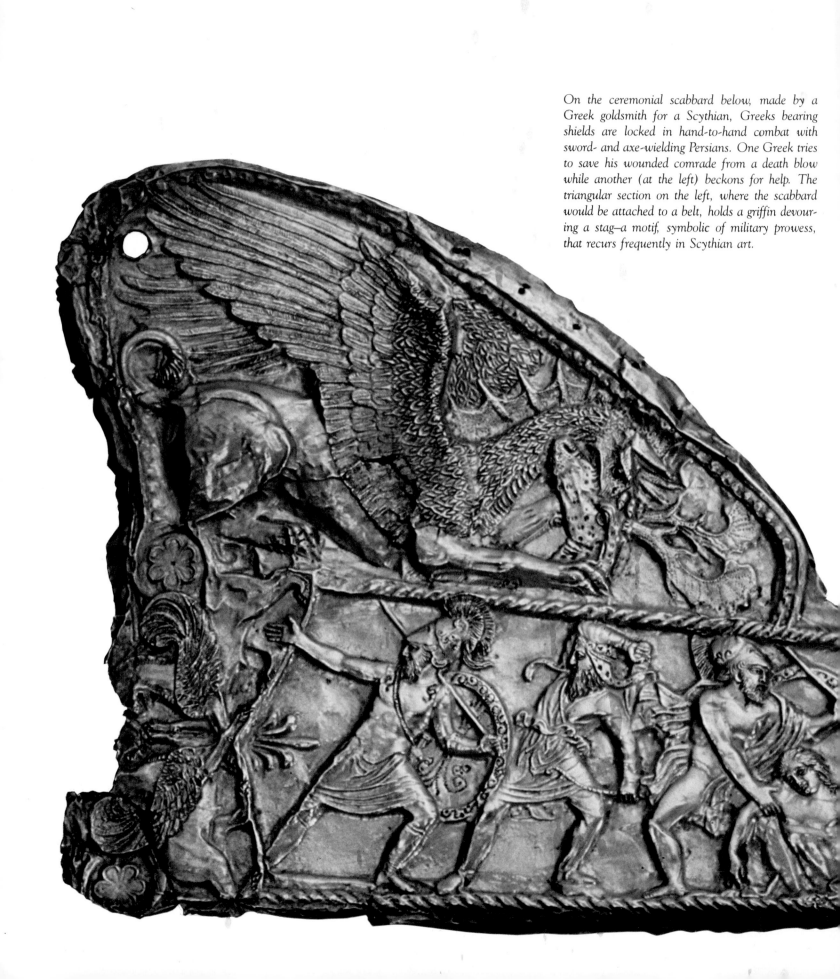

On the ceremonial scabbard below, made by a Greek goldsmith for a Scythian, Greeks bearing shields are locked in hand-to-hand combat with sword- and axe-wielding Persians. One Greek tries to save his wounded comrade from a death blow while another (at the left) beckons for help. The triangular section on the left, where the scabbard would be attached to a belt, holds a griffin devouring a stag—a motif, symbolic of military prowess, that recurs frequently in Scythian art.

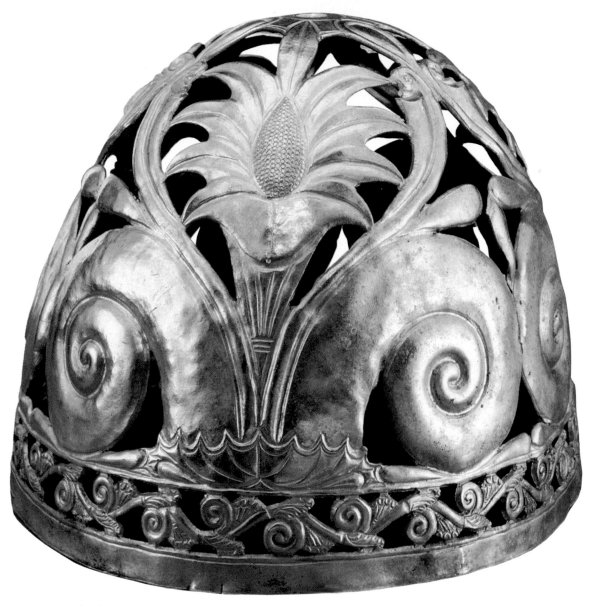

A Scythian warrior commissioned a Greek artisan to make this gold, openwork helmet, which would have been a splendid sight when it was worn over a colorful lining of felt or fur. The acanthus leaf in the center is a common decorative device in Greek art of all types.

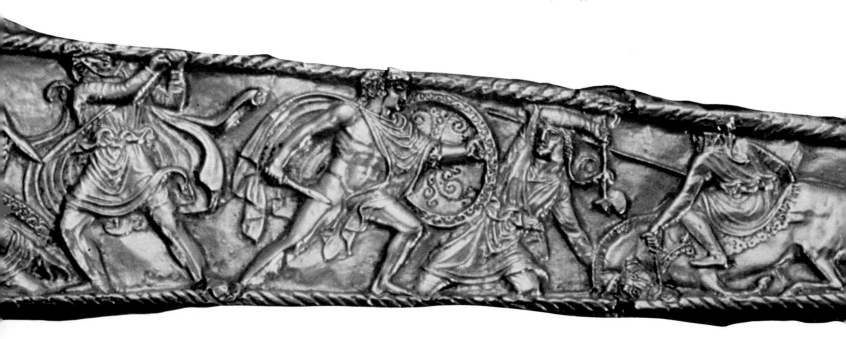

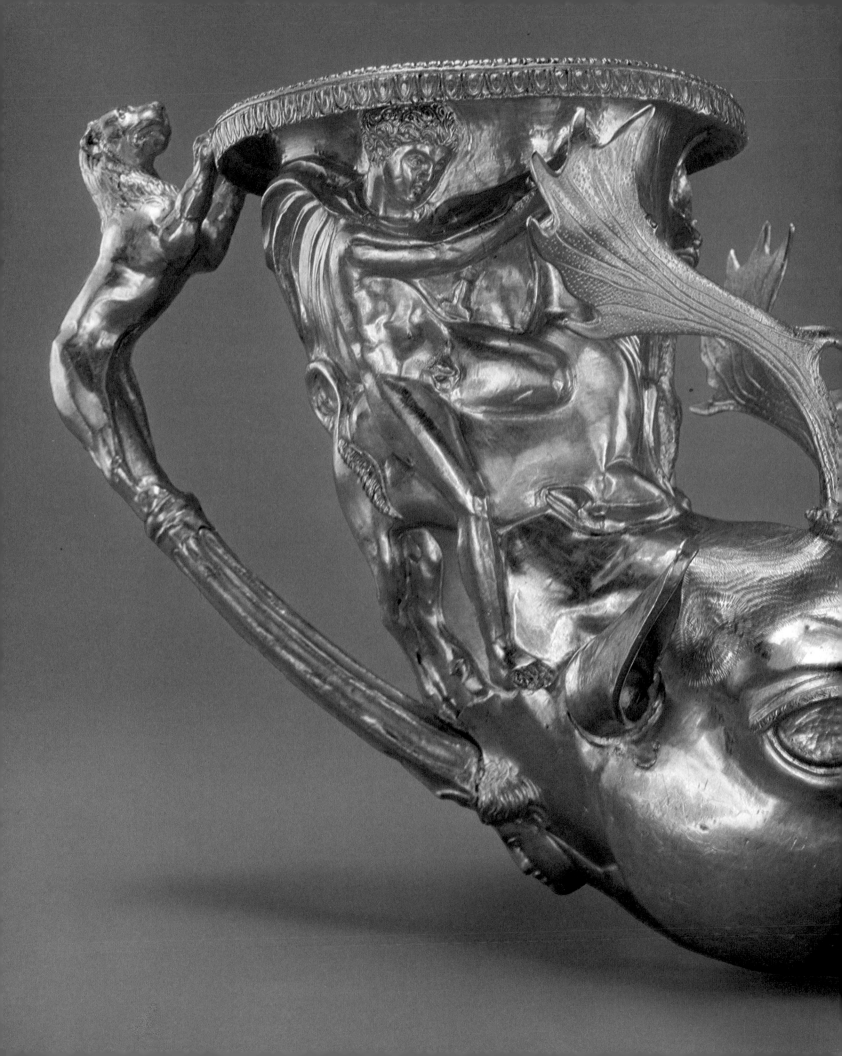

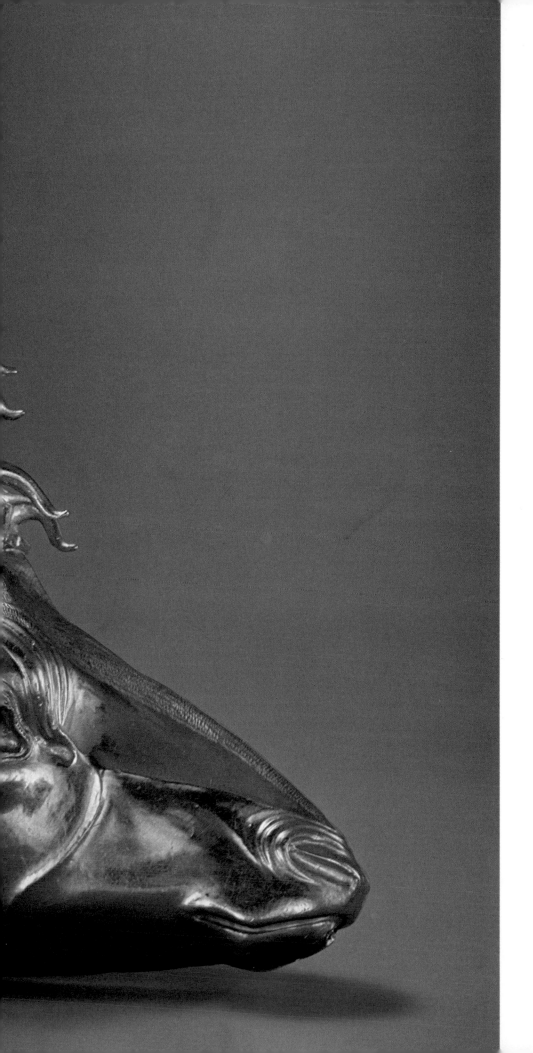

The gold rhyton, or drinking vessel, at left was recovered from the tomb of a warrior-king of Thrace. Created by a Greek goldsmith around 300 B.C., the rhyton is cast in a traditional shape—that of a horn—ending in a splendid stag's head. On the sides of the cup are two heroic scenes from Greek myth: Theseus battling the bull of Marathon and Heracles wrestling with a mighty stag. The tomb where the rhyton was buried in Panagyurishte, Bulgaria, held no fewer than eight such pieces, as well as a bowl, all together a treasure containing nearly thirteen and a half pounds of gold.

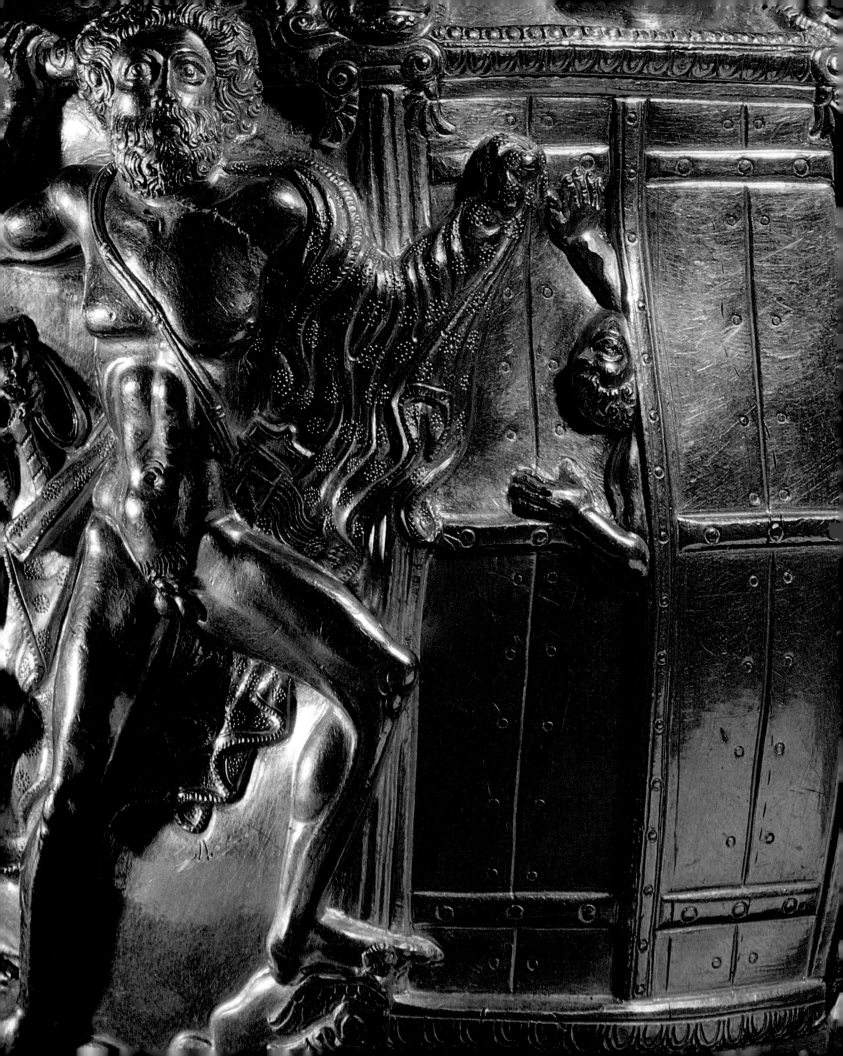

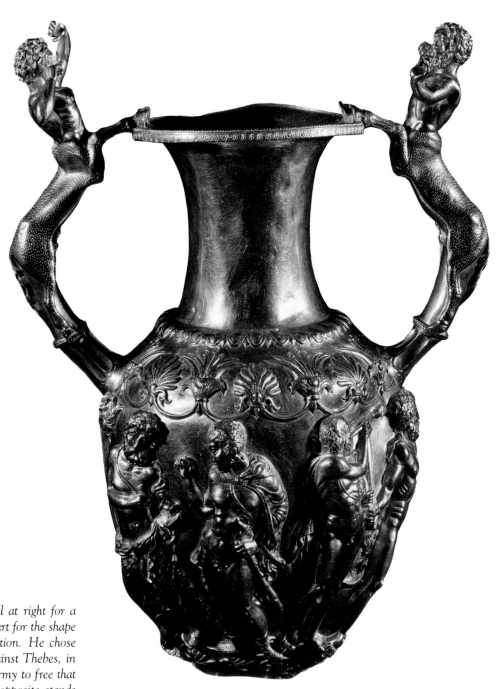

A Greek goldsmith made the vessel at right for a Thracian lord, drawing on Persian art for the shape and on Greek myth for the decoration. He chose the mythical battle of the Seven Against Thebes, in which seven famous heroes led an army to free that city from a usurper. In the detail opposite stands one of the heroes, naked, poised to slash at a palace gate where an old man cowers and cries out.

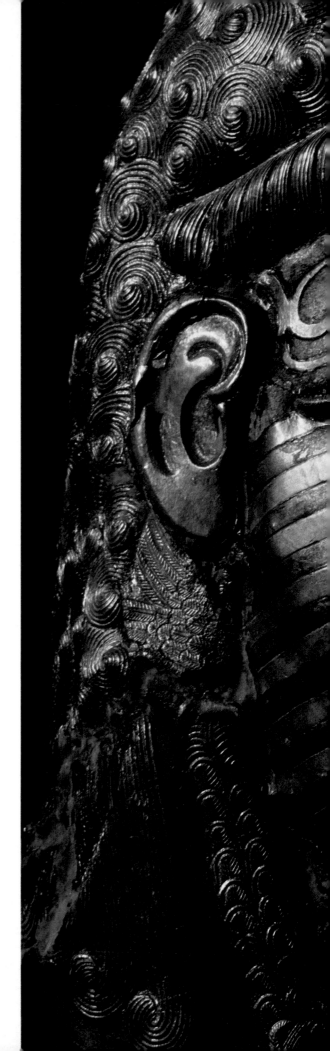

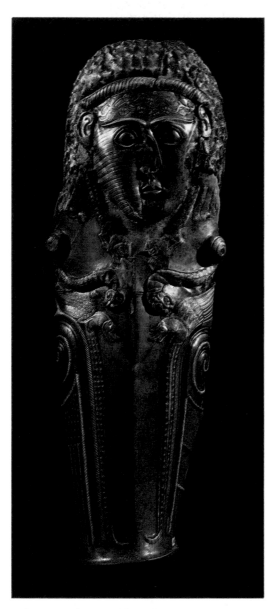

The magnificent gold and silver greave above, found in the grave of a Thracian prince, portrays a fearsome goddess, her collarbone formed of snakes and her strands of hair turning into snarling lions. The face of the goddess (detail, right) is powerfully expressive, with bold stripes on one cheek representing tattoo marks—a sign of high rank in Thracian society according to Herodotus.

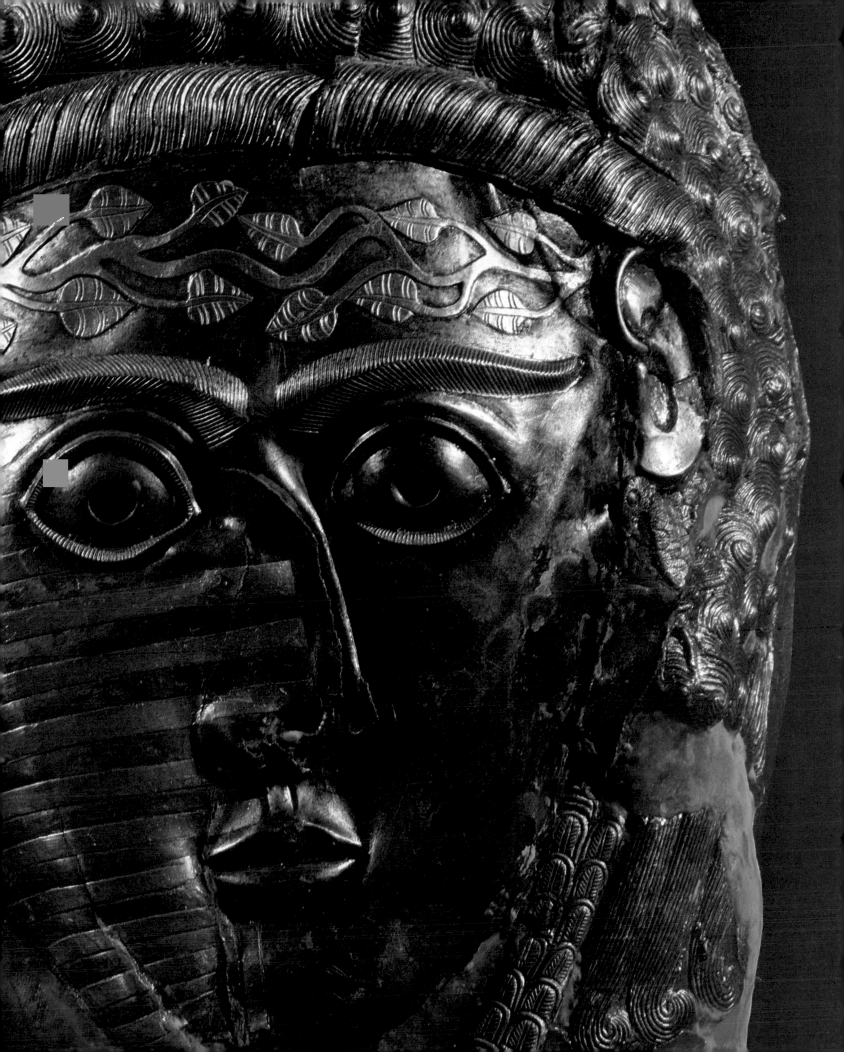

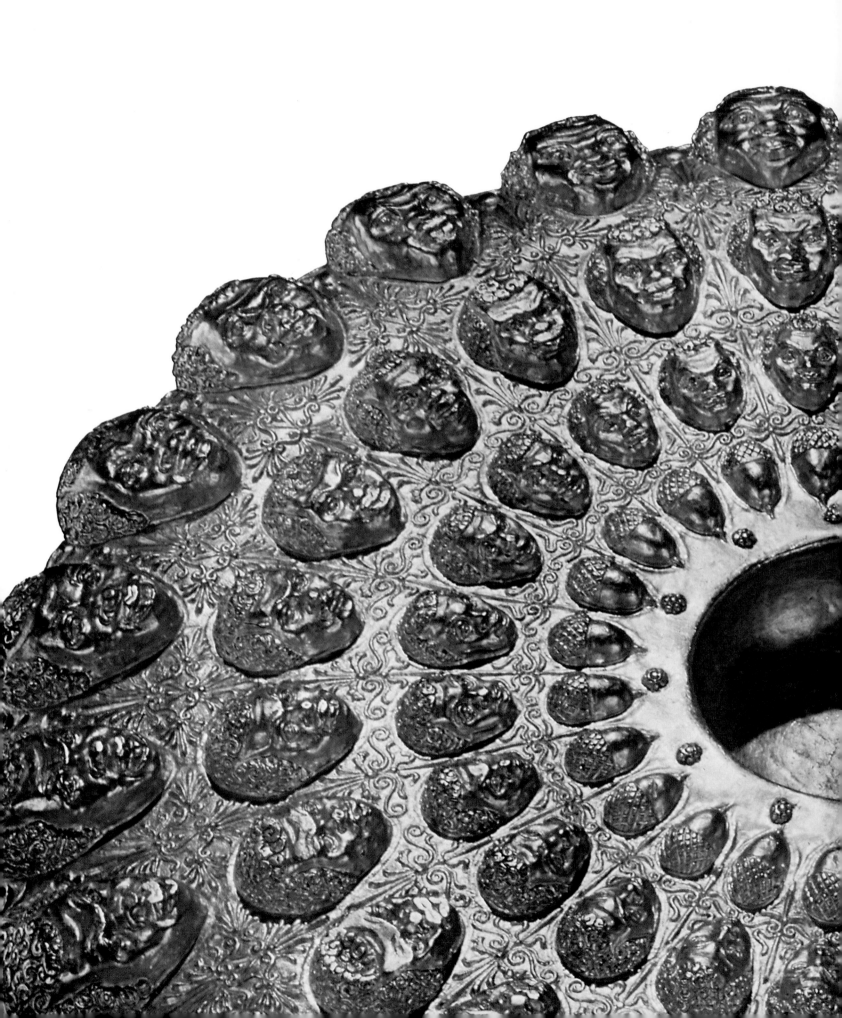

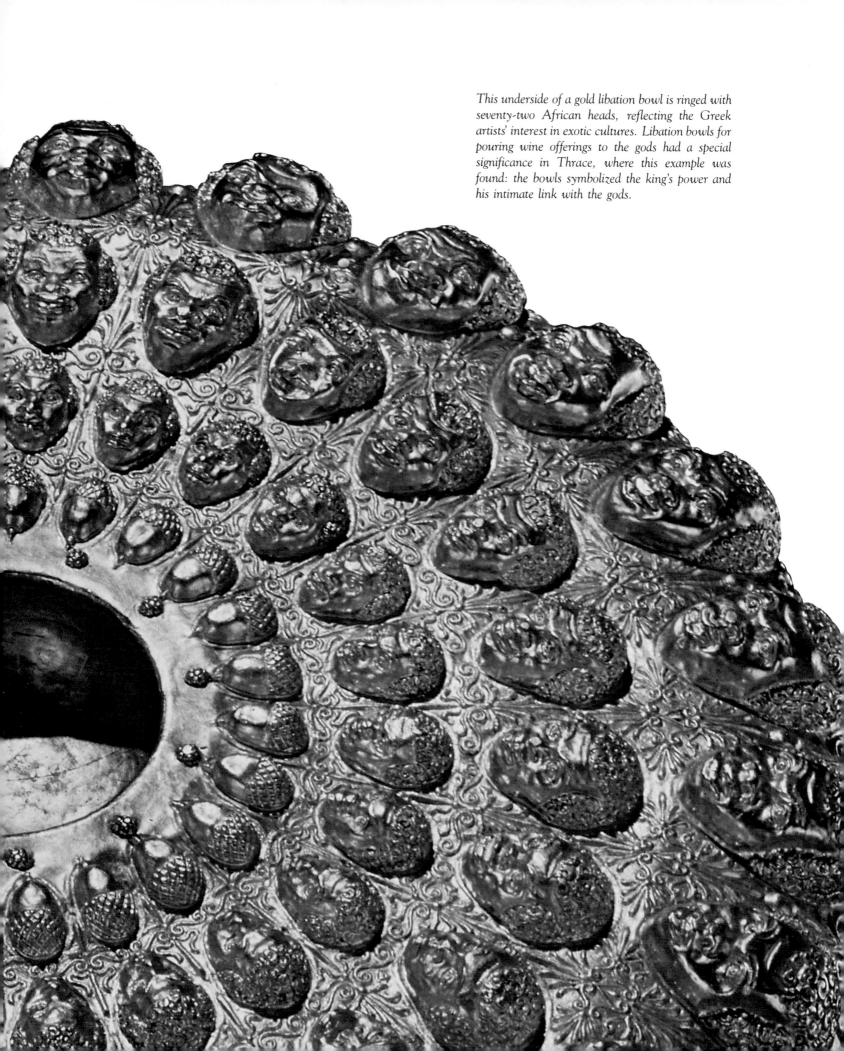

This underside of a gold libation bowl is ringed with seventy-two African heads, reflecting the Greek artists' interest in exotic cultures. Libation bowls for pouring wine offerings to the gods had a special significance in Thrace, where this example was found: the bowls symbolized the king's power and his intimate link with the gods.

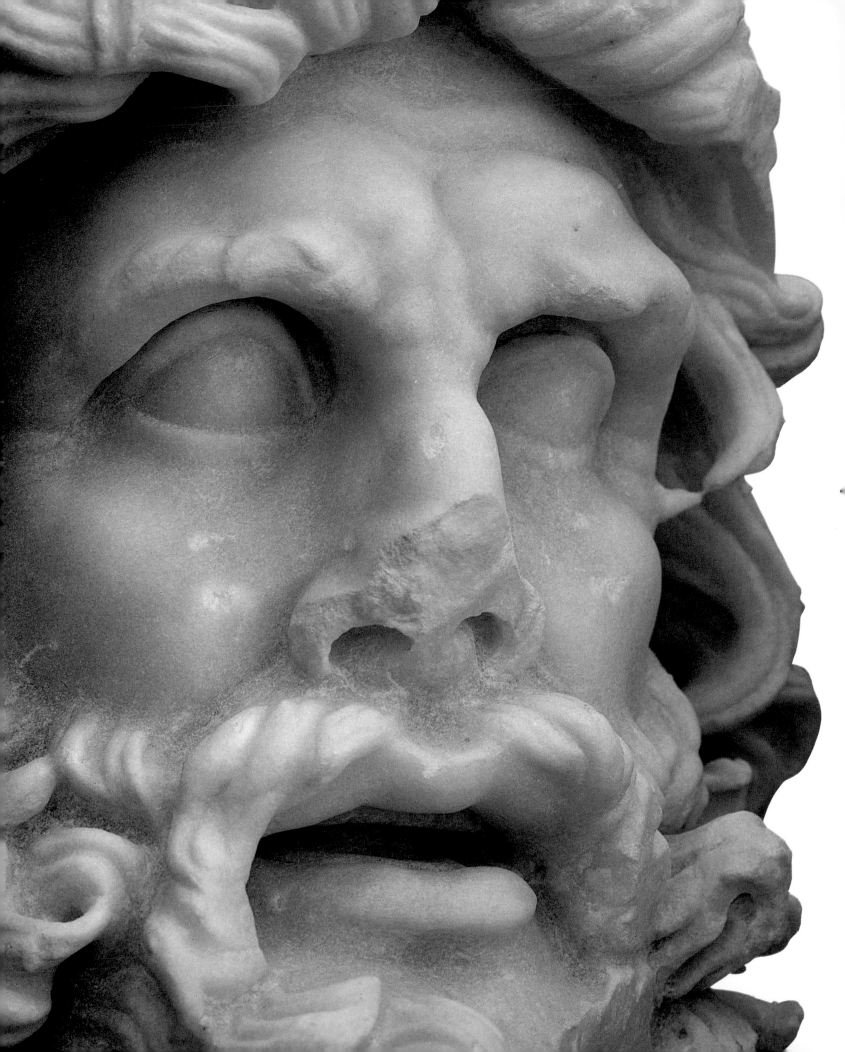

V

THE FIRST COLLECTORS

AND THEIR PRIVATE TREASURES

When Alexander took off on his campaign into the wilds of the East, he carefully picked a safe spot to leave his Persian mistress and the son she had borne him. He chose Pergamum, and so brought an obscure little town to the notice of history. Pergamum, in the northwestern part of Asia Minor, was no different from dozens of other small towns except for one thing: perched on the top of a steep conical hill, it was well-nigh impregnable.

Here the child and his mother lived undisturbed during Alexander's campaigns and the savage wars that followed Alexander's death as his former generals fought each other for control of his empire. But there came a time when the struggle reached even the quiet backwater of Pergamum: in 308 B.C. one of the contending factions lured the child out of his aerie in the hope of using him as a pawn. He turned out to be more a hindrance than a help, and so they murdered him. He was forgotten and so too was Pergamum.

As the Greek empire dissolved after Alexander, some collectors wanted works romanticizing past glories—such as this second-century-B.C. head of Odysseus.

An aged shepherdess, portrayed in marble about 180 B.C., carries a lamb to market. Despite nostalgia for the past, in the three centuries or so after Alexander many artists for the first time chose such everyday figures as their subjects.

But eight years later Pergamum made a second entrance on the stage of history, this time to play a leading role. One of Alexander's generals who had ended up with a modest share of the spoils was Lysimachus. He held Thrace—what is today Bulgaria and European Turkey—and hungrily eyed the realm to the south. In 302-301 B.C. Lysimachus, with the aid of three other Macedonian generals, struck across the Dardanelles and took over the western part of Asia Minor. Now he held the territory in which Pergamum lay, and it recommended itself as it had to Alexander. He made it his safe-deposit site, storing there a treasure of gold and silver vessels and coin worth no less than nine thousand talents, at least half a billion dollars. Lysimachus appointed a certain Philetaerus as administrator.

Philetaerus was not a noble, not even a Macedonian. He was a native of Asia Minor, born in a small town on the Black Sea, the son—so scandalmongers claimed—of a prostitute. As for his father, the most that can be said is that he may have come from Macedon since his name was Attalus, a uniquely Macedonian name. What is more, Philetaerus suffered from a humiliating disability: he was a eunuch as a result of an accident he had when an infant. He was, however, liberally endowed with brains and ambition, and was already an experienced bureaucrat when Lysimachus made him treasurer at Pergamum. After fifteen years of performing his duties faultlessly, he took the daring step of abandoning Lysimachus in favor of Seleucus, who held the eastern part of Asia Minor. It turned out to be the right move at the right time, for when war erupted between the two kings, Lysimachus lost not only the battle but his life. Philetaerus emerged as king of Pergamum along with its surrounding countryside and, on his death, became founder of a new dynasty, the line of Attalids.

Philetaerus, to be sure, was childless, but he had two nephews who succeeded him, the first as Eumenes I, the second as Attalus I. The line was neither numerous nor long: only three more were to follow, a second Eumenes and two more Attaluses,

to make a total of six kings who reigned exactly a century and a half, from 283 to 133 B.C. Yet the dynasty spanned almost the entire Hellenistic age–from the death of Alexander to Roman times, and it played an important role in Near Eastern history as well as a vital role in the history of art.

Attalus I, whose long rule extended from 241 to 197, had his uncle's talent for joining the right side at the right time. Toward the end of his reign he spotted Rome as the political rising star, and from then on the Romans could count on the unswerving loyalty of the kings of Pergamum, and the Pergamenes on the steady rewards and support from this mighty nation that was eventually to swallow up the whole of the Near East.

But it was in the realm of art that the Attalids truly made their mark. They were the first to look upon sculptures and paintings as private treasures to be systematically sought after, the way others sought gold and silver and gems; the first to be willing to pay whatever it cost to land the object of their search. They were the distant forerunners of all the millionaire founders of great art collections: Andrew Mellon, Henry Clay Frick, J. P. Morgan. These later collectors, however, had to depend upon outside experts to tell them what to buy; the Attalids needed no such help, for they were connoisseurs as well as collectors.

The Attalids had no problem finding the money for their acquisitions. We say "rich as Croesus"; the ancients said "rich as the Attalids." Philetaerus, of course, gave them an auspicious start, the nest egg of nine thousand talents of Lysimachus' money. They were able to build this up in gratifying style, thanks to the abundant natural resources of the country they ruled.

To begin with, it had gold mines. At their height the Attalids controlled most of western Asia Minor, the lands where Croesus once had reigned, as well as the lands of Midas, whose holdings of gold were legendary. Then there was agriculture. The rich soil yielded grain, wine, and olive oil, all three of which were commodities everywhere in demand, especially grain; an ancient nation that had grain to sell was in the position of an oil exporter

TEXT CONTINUED ON PAGE 152

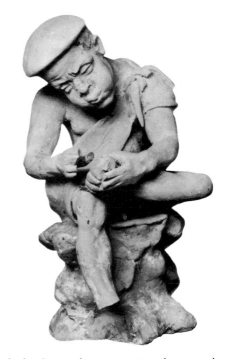

A look of pained concentration distorting his features, a scruffy street urchin removes a thorn from his foot. This terra-cotta statuette was created about 100 B.C. in Priene, a bustling town near the west coast of Asia Minor.

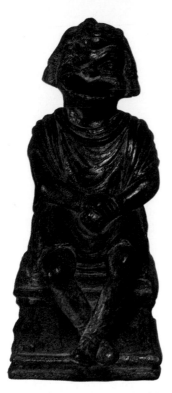

This seated figure with its widemouthed leer is an actor wearing the mask of a slave, one of the favorite stock characters in comedies of this period.

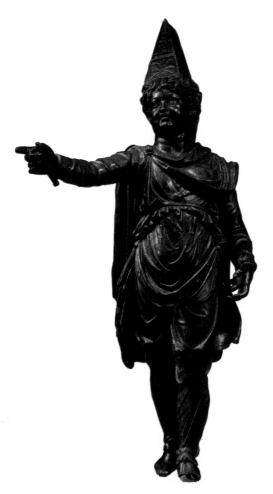

Cherubic in countenance, this plump youth wears the generalized costume of a non-Greek barbarian, distinguished by trousers and long-sleeved tunic.

A young Negro musician bends gracefully to sing and play his instrument, now missing, perhaps a harp. His eyes are inlaid with silver.

PRIVATE, PORTABLE LUXURIES

In the tumultuous age from the late fourth century through the first century B.C., known as the Hellenistic era, affluent citizens developed an unprecedented taste for small objects to brighten their homes. Especially popular were bronze statuettes, cast in workshops all over the Hellenistic world. Like the ones here and overleaf, which range in height from seven to twenty-five inches, these gleaming figurines were made to be held or displayed close at hand on tripods. Subject matter encompassed both the noble and ordinary, with artists increasingly drawn to familiar characters from daily life. Typically modeled in a realistic vein, and lacking the nobility of classical sculpture, such figures were intended to amuse and delight, not inspire. Yet the insistence on lofty themes and ideal beauty never disappeared, as particularly evidenced in a sumptuous cameo on pages 150–151.

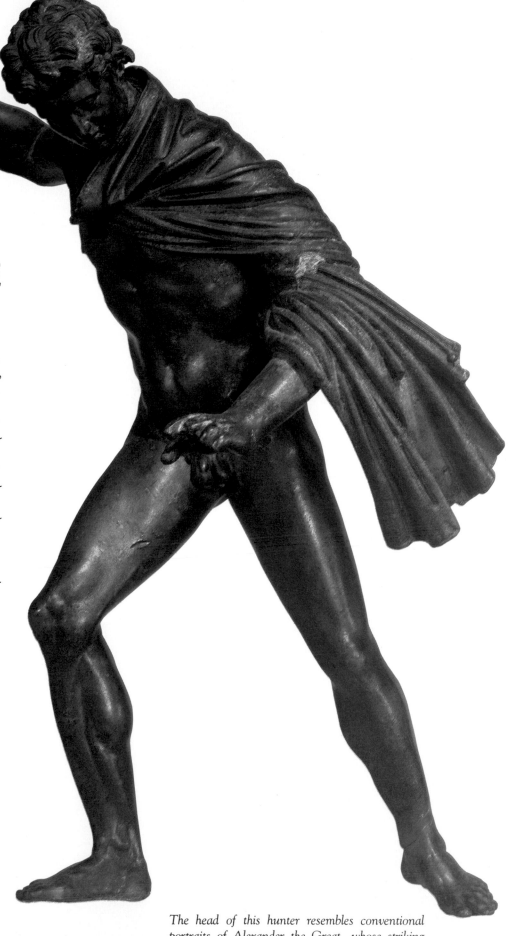

The head of this hunter resembles conventional portraits of Alexander the Great, whose striking visage was often adapted to idealize a real subject.

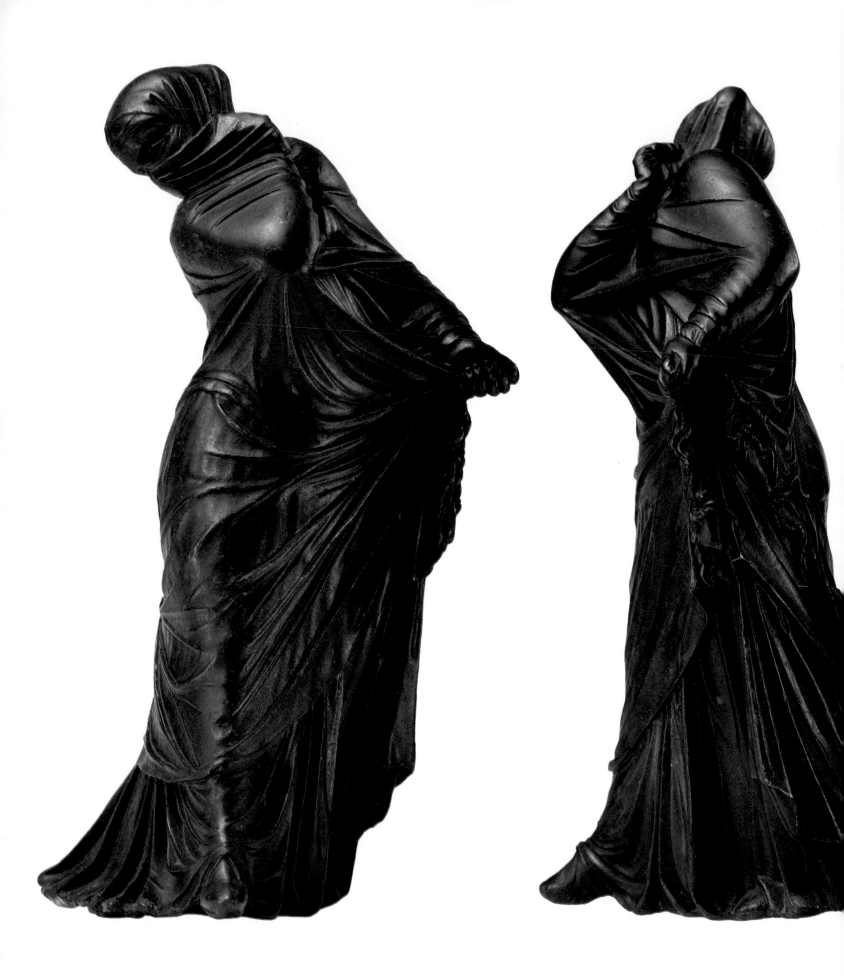

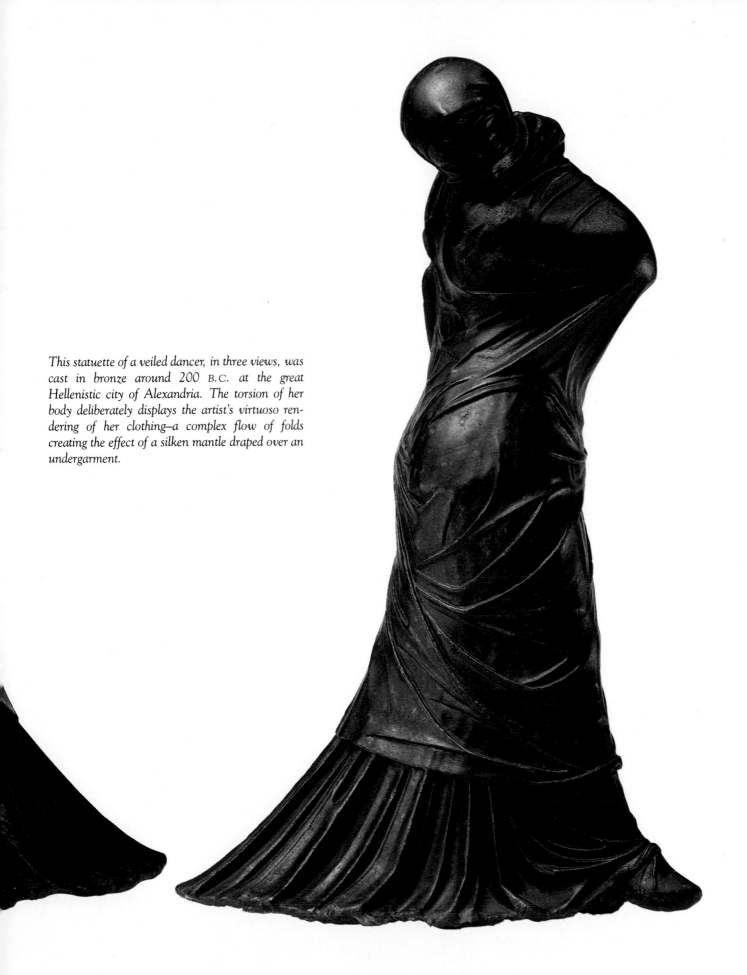

This statuette of a veiled dancer, in three views, was cast in bronze around 200 B.C. at the great Hellenistic city of Alexandria. The torsion of her body deliberately displays the artist's virtuoso rendering of her clothing—a complex flow of folds creating the effect of a silken mantle draped over an undergarment.

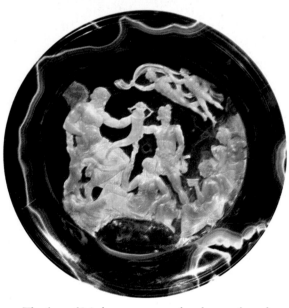

The face of Medusa, at top, and a cluster of pearly figures, above and in detail at right, decorate the outside and interior of an eight-inch-wide cameo from Alexandria. Probably made for a second-century Ptolemaic queen, it was cut in the shape of a shallow dish from sardonyx, a semiprecious stone with bands of alternating colors. The interior scene symbolizes the agricultural bounty of the Nile River: on the left in the enlargement, the god Nile holds out the "horn of plenty" to a chorus of Greek and Egyptian divinities. A marvel of fine carving, the cameo is called the Farnese Cup, after the Italian family that acquired it in the fifteenth century.

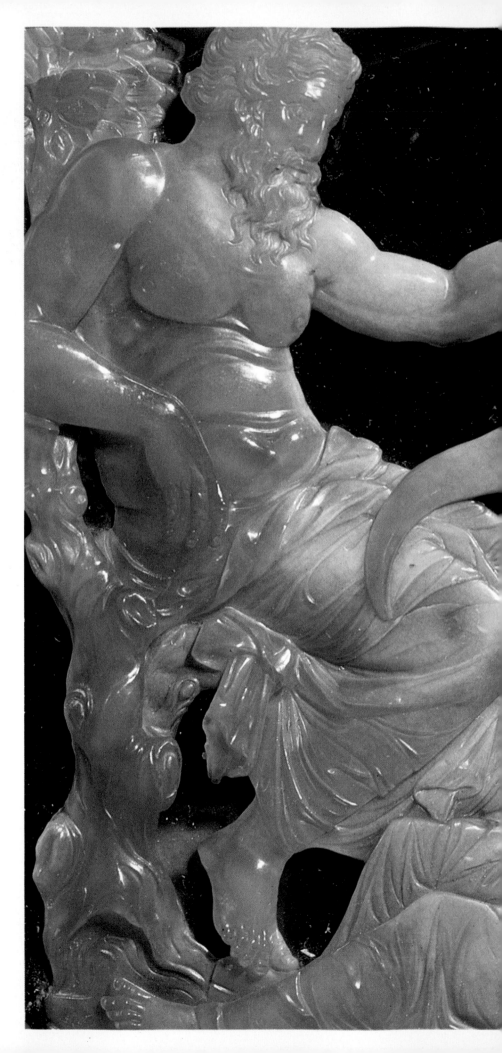

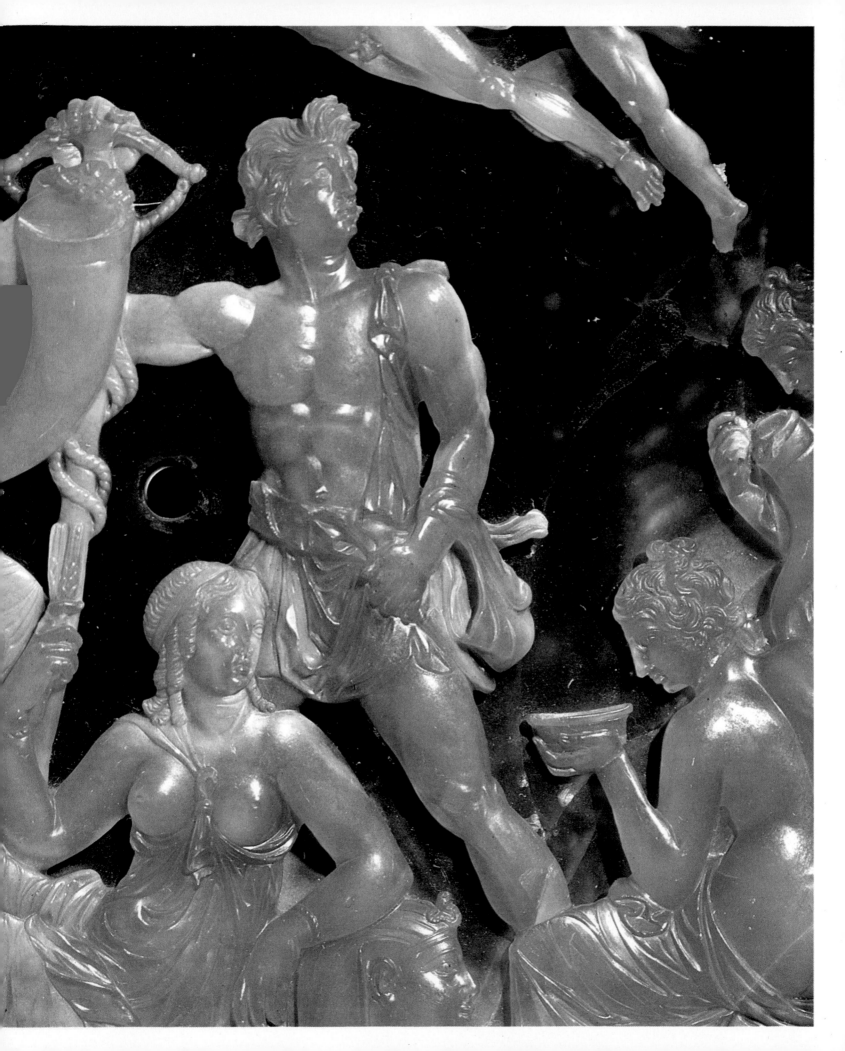

TEXT CONTINUED FROM PAGE 145

today. There was also the fine timber from the slopes of Mount Ida between Pergamum and Troy, which could be traded to Egypt or Greece or other countries that were barren of trees. And in the fields around Pergamum flocks of sheep grazed that bore a fine grade of wool.

The Attalids further increased their revenues by the creation of royal industries, such as workshops for the manufacture of fine textiles and parchment, the writing material made from sheepskin. The word "parchment" goes back to Pergamum: what the Attalids produced was called *charta pergamena*, "paper of Pergamum"; *pergamena*, in medieval French became *parchemin*; English borrowed this word, transforming it to "parchment."

Like other monarchs of the time, the Attalids spent a lot of their income on their capital city. With the economy flourishing, the Attalid bureaucracy grew; Pergamum swiftly changed from a modest town to a full-fledged metropolis. The hilltop became a showcase of public works—temples, gymnasiums, palaces, stoas (covered walks)—which were set upon broad terraces that climbed, one above the other, to the summit. The Attalids could even afford to put up buildings for their friends. At Athens, for example, they erected the famous Stoa of Attalus, the splendid covered walk along one side of the agora that has recently been completely restored and is now one of the city's prime tourist attractions. It was a way of promoting their image as cultivated, disinterested benefactors, an Attalid version of today's foreign aid.

But it was as collectors more than as builders that the Attalids shone. It was they who commissioned the great masterpieces of the period. One of the most renowned artistic treasures of antiquity was the monument Attalus I raised to commemorate his victory over the Gauls. For more than a century hordes of these bellicose, half-savage tribesmen had been migrating from their homeland in France toward the southeast, looting and slaughtering as far as Italy and Greece. One branch went into Asia Minor and settled down to make a living by pillaging their neighbors.

Three women assist a girl, second from right, with her toilette. Each wears a linen gown draped with translucent fabric, the customary dress of well-to-do women in Hellenistic Greece.

About 241 B.C. Attalus smashed them in a major battle, and to celebrate his triumph set up a cluster of statues at Pergamum, larger than life, of his enemies going down in defeat. The originals, in bronze, have been lost, but they were so famous that stone replicas were on display in many places and some of these have survived.

And about 180 B.C. Attalus' successor Eumenes II commissioned a mammoth altar to Zeus. It was shaped like an enormous U, 120 feet along the sides and 112 across the back. On the outside walls ran a frieze of huge figures of the Greek gods overthrowing the giants and monsters who had ruled the world till then, a subject chosen to symbolize the victory of the civilized Pergamenes over the Gallic barbarians. Parts of this masterwork have fortunately survived. Battered and incomplete as they are, they have the power of some of Michelangelo's mightiest creations, such as his statute of Moses or his pictures of the prophets in the Sistine Chapel.

It was Attalus I who took a step of crucial importance for the history of art: he started a collection of masterpieces of Greek sculpture and painting. Art collections of a haphazard kind were nothing new to the Greeks. Many a temple, for example, was filled with miscellaneous fine works deposited as votive offerings. But Attalus and his successors collected carefully chosen works, famous pieces by recognized artists of all periods, and used them to adorn the splendid new buildings on the hilltop. "Old" art from the sixth century B.C. and the opening decades of the fifth was easy to buy: it was out of favor, and the temples or city-states that owned it were willing to sell it. Nor was contemporary art a problem; the Attalids simply commissioned pieces from the acknowledged masters.

The period in between, however, caused trouble. The sculptures, say, of Polyclitus and Phidias and Praxiteles were famous and the owners would no sooner part with them than the Louvre today would with the *Venus de Milo*. The Attalids had to content themselves with ordering copies. This is what they did, for exam-

ple, for Phidias' masterpiece, the almost forty-foot-high figure of Athena in gold and ivory that stood in the Parthenon at Athens. They had a replica made in stone of reduced size—a mere twelve feet high.

Paintings could be harder to acquire, since many of the best known were frescoes on the walls of temples or stoas. Again the only solution was to have them copied. Panel paintings done on wood (Greek painters rarely used canvas) were another matter. The Attalids went to great lengths to get hold of originals. When the Roman army sacked the rich Greek city of Corinth in 146 B.C. and auctioned off the loot, artistic and otherwise, Attalus II bid the astronomical sum of one hundred talents, at the least about six million dollars, for a celebrated painting of the god of wine, Dionysus. The price was high enough to attract the attention of the Roman general, Lucius Mummius, who had taken the city and held the sale. He knew nothing about art; the story is told that he warned the teams in charge of packing up the masterpieces that any damaged pieces would have to be replaced with new ones. But on the assumption that anything worth one hundred talents was worth taking back to Rome, Mummius made the stricken Attalus return the painting.

It was a minor setback. Once they hit their stride, the Attalids collected omnivorously. In addition to large-scale sculptures and paintings, they bought or commissioned gold and silver vessels, cameos, and, above all, manuscripts. The library at Pergamum was second only to the one at Alexandria, which was the richest in the Greek world. The building that housed it has almost totally disappeared, but it must have been as elegant as all the others the Attalids put up, of marble with a columned front. Inside there would have been a series of rooms lined with shelves that held the leather boxes in which scrolls were placed. Like many libraries today, it had portrait statues of great writers, such as Homer and Herodotus, and in the central reading room stood the Attalids' copy of Phidias' *Athena*, goddess of wisdom.

Unlike his predecessors, who concentrated on collecting art

Soldiers carouse in front of a pavilion along the Nile in this detail from a mosaic executed about 80 B.C. Last outpost of the Greek empire, Egypt would shortly succumb, as had the rest of the Hellenistic world, to the new power of Rome.

and books, the last of the line, Attalus III, was a veritable Leonardo da Vinci. He was a sculptor who worked in bronze. He wrote on learned subjects such as agriculture, animals, and insects. He did medical research, perfecting a plaster for skin wounds, working out a diet for digestive disorders, investigating therapeutic uses for animal secretions, and experimenting with antidotes to poisons. The last was a favored pursuit: he grew his own hemlock, aconite, and henbane, and tested antidotes on condemned criminals. So adept was he in the manipulation of numbers that by the Middle Ages he had become legendary: he was even acclaimed—erroneously—to be the inventor of chess. Chaucer, in the *Book of the Duchess*, tells of a woman so adept that

> Ful craftier to playe she was
> Than Athalus that made the game
> First of the ches.

Attalus III reigned for only five years, from 138 to 133 B.C., in the course of which he managed to acquire as great a reputation for cruelty as for learning. He had a pathological fear of treachery and brutally killed off close friends and relatives who fell under suspicion. Eventually he opted never to leave the palace grounds, going about there in rags, his hair and beard filthy and unkempt. He died, supposedly from overexposure to the sun, as he worked away sculpting a monument to honor his mother.

When his will was opened it contained the startling news that, instead of appointing a successor, he had left his kingdom to the Roman people. Why? Some historians speculate that he hated all Pergamenes and wanted to see them in Rome's viciously exploitative grasp. Others, on the contrary, insist he loved the rank and file and used this way of getting them into Rome's protective embrace. Perhaps he was merely bowing to the inevitable. A century and a half earlier, the Attalids and the Romans had been respected allies. As the Roman presence bulked larger and larger in the Near East, Pergamum sank to the level of a

satellite. Attalus may cynically have anticipated the next step. For Rome it was a windfall, not only in natural resources that would produce a steady income but in actual treasures in hand. In 190 B.C. when the Romans had invaded Asia Minor and defeated the last reigning Seleucid king, they had come back with 1,450 pounds in silver objects and 1,500 in gold. When Attalus died, they got even more.

From this point on the spotlight is upon the Romans, who inherited not only the Attalids' fortune but their passion for collecting. The first century B.C., the age of Rome's great political leaders, Pompey and Caesar and Cicero, was also the age of her great private collectors. Rome's multimillionaires competed frantically to fill their mansions and villas with fine Greek sculptures, paintings, and vessels of gold, silver, and bronze. Some did it as the Attalids had done it—legitimately. Others simply stole or looted whatever they could lay hands on. The century—and the competition—ended when Octavian founded the Roman Empire. From then on amassing artistic treasures gradually came to be a royal prerogative. The emperors were now the Attalids' successors as the great collectors of the age.

But after the death of Constantine in A.D. 337, the Roman Empire entered upon its decline and fall, and Greek art was swept off to oblivion.

And in oblivion it remained until, after the passage of almost a thousand years, resurrection began under the savants of the Renaissance. They preserved for us not only treasures of Greek sculpture lying abandoned amid ancient ruins but also treasures of Greek literature lying forgotten amid the manuscripts in Christian monasteries. The resurrection is still going on under the archaeologists. They have rescued for us, along with so much else, the treasures of gold and silver and precious gems, the superbly crafted vessels and jewelry, that lay hidden away in tombs, from those of Mycenaean kings in the heart of Greece to those of Asiatic chieftains in remote lands outside the borders of ancient civilization.

DOWNFALL OF
THE GIANTS

A columned portico crowns a section of the frieze adorn-
ing the Great Altar of Zeus, the pride of Pergamum. The
Attalid king Eumenes II commissioned it about 180 B.C.

Created in the aftermath of Alexander the Great's empire, the grand-scale struggle between gods and giants from a marble frieze (shown in detail here and on the following pages) mirrors the turmoil and demise of the Greek world itself. This imposing work, nearly eight feet high and four hundred feet long, ran around the base of the marble altar dedicated to Zeus and Athena that stood atop Pergamum's royal acropolis. The battle scenes, sculpted in high relief on more than one hundred panels, were taken from a Greek myth of the gods vanquishing the giants, monstrous sons of the Earth who attacked Olympus. Eumenes II chose this theme in order to commemorate Pergamene victories over invading barbarians, and because it appeared on the Parthenon, a building much revered by the Attalids. But the Pergamum frieze (its surviving fragments and inscriptions are now reconstructed in East Berlin's Pergamum Museum) was like nothing else in Greek art. Enlisting scholars to dig up enough gods and giants to fill the immense space, the sculptors—at least a dozen—created figures of the greatest variety, including an abundance of startling animal imagery. Each figure, meticulously characterized, was carved practically in the round, in a style that combined classical harmony with unbridled emotional power. The combatants fight furiously, muscles knotted, their faces vibrant with ferocity or anguish. Such monumental intensity, emulated on later temples but never equaled, awed not only the Pergamenes but also the Romans. After occupying Pergamum in 133 B.C., they extolled the great altar and its frieze as one of the wonders of the world.

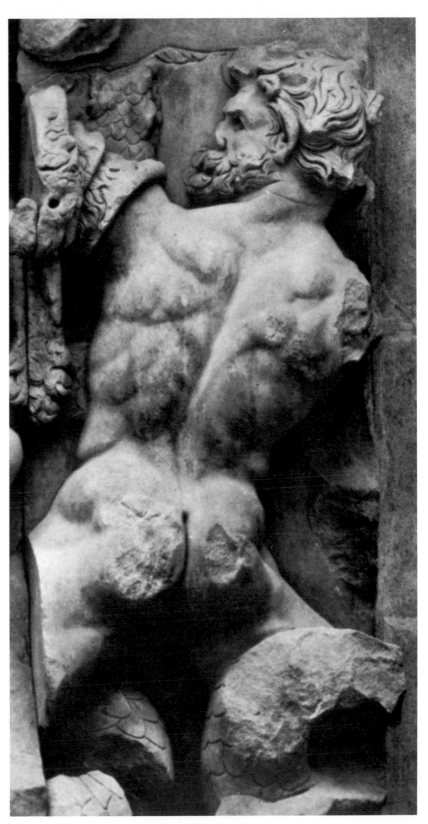

Arm raised, Porphyrion, the king of the giants, fends off Zeus' thunderbolts.

In the detail opposite, from the Pergamum frieze, a winged giant whose legs are scaly serpents prepares to hurl stones (now missing) at a god. Beside him lies a comrade slain by Aphrodite.

OVERLEAF: *A lion-headed giant pounces upon Aether, god of air, who grasps him by the neck; at far right, another deity contends with a foe, whose torso and leg are all that remain of the figure.*

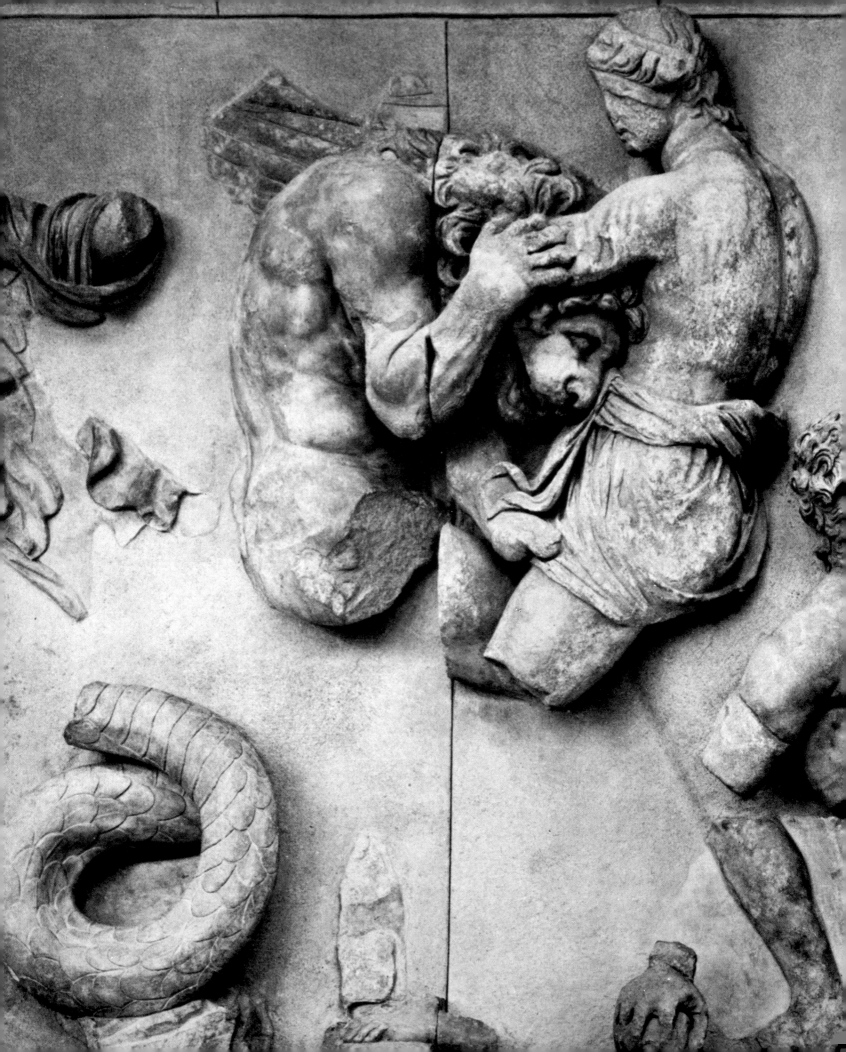

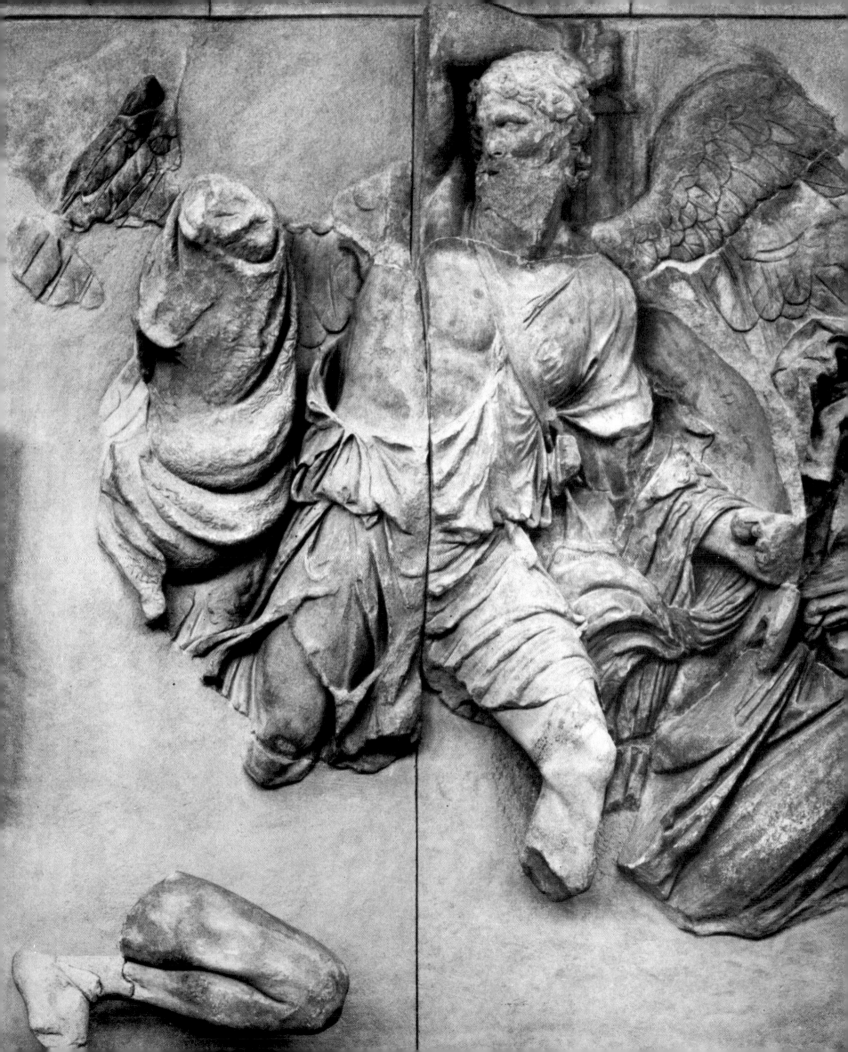

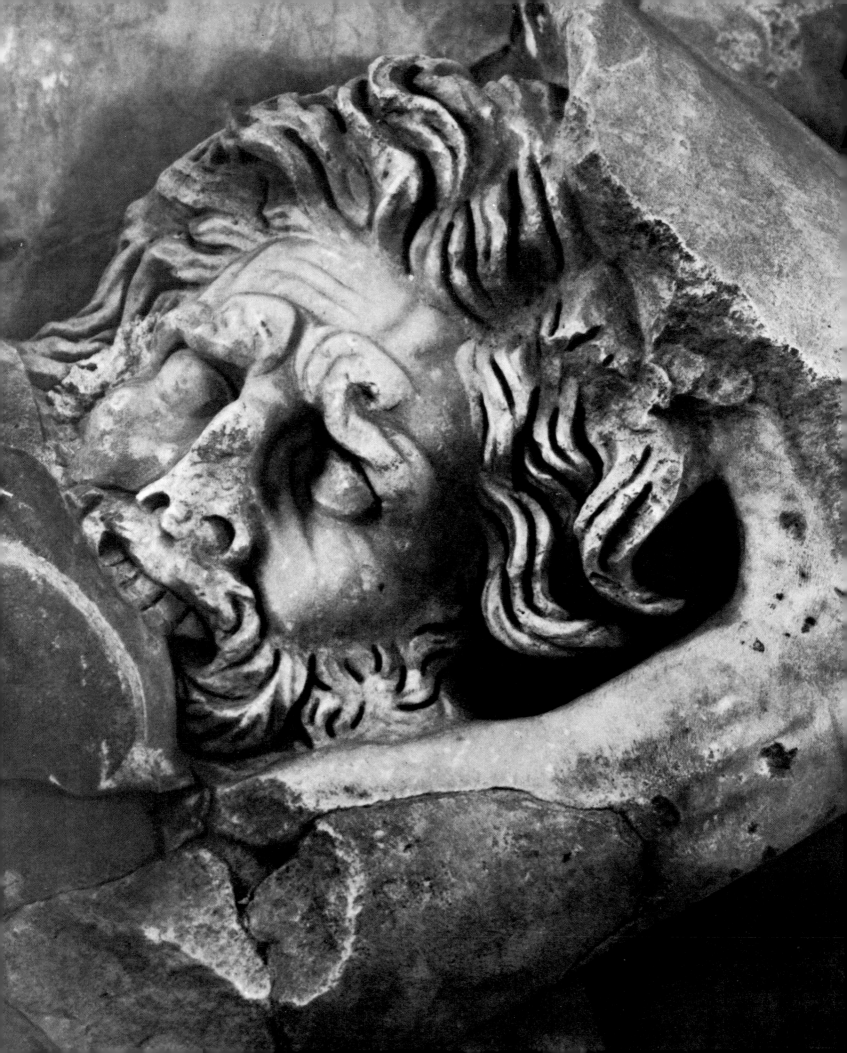

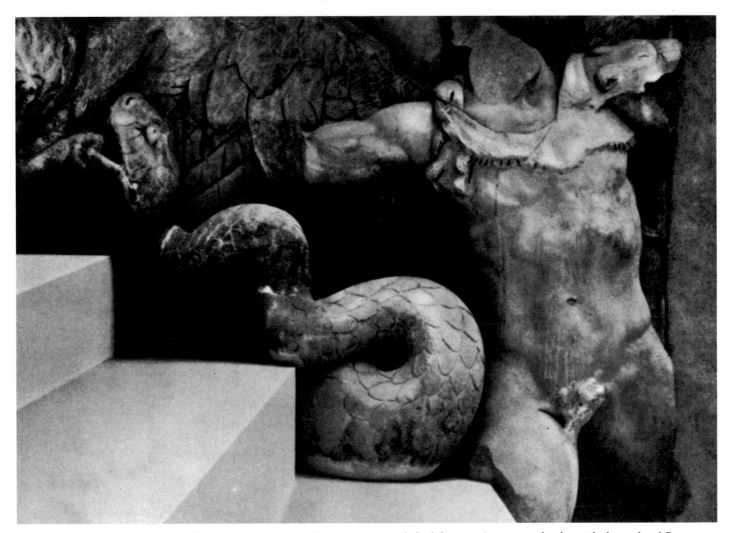

A giant, arms and head missing, flees from a goddess, while a serpent, symbol of the giants' savagery, battles with the eagle of Zeus.

Eyes blazing with malevolence, a giant, opposite, bites the arm of an enemy he has ambushed.

OVERLEAF: The bearded sea god Nereus, at far left, stands by his wife, Doris, who struggles to hold down a serpent-legged giant. To the right, Oceanus, father of water gods, pursues the shattered figures of two giants along the altar's staircase.

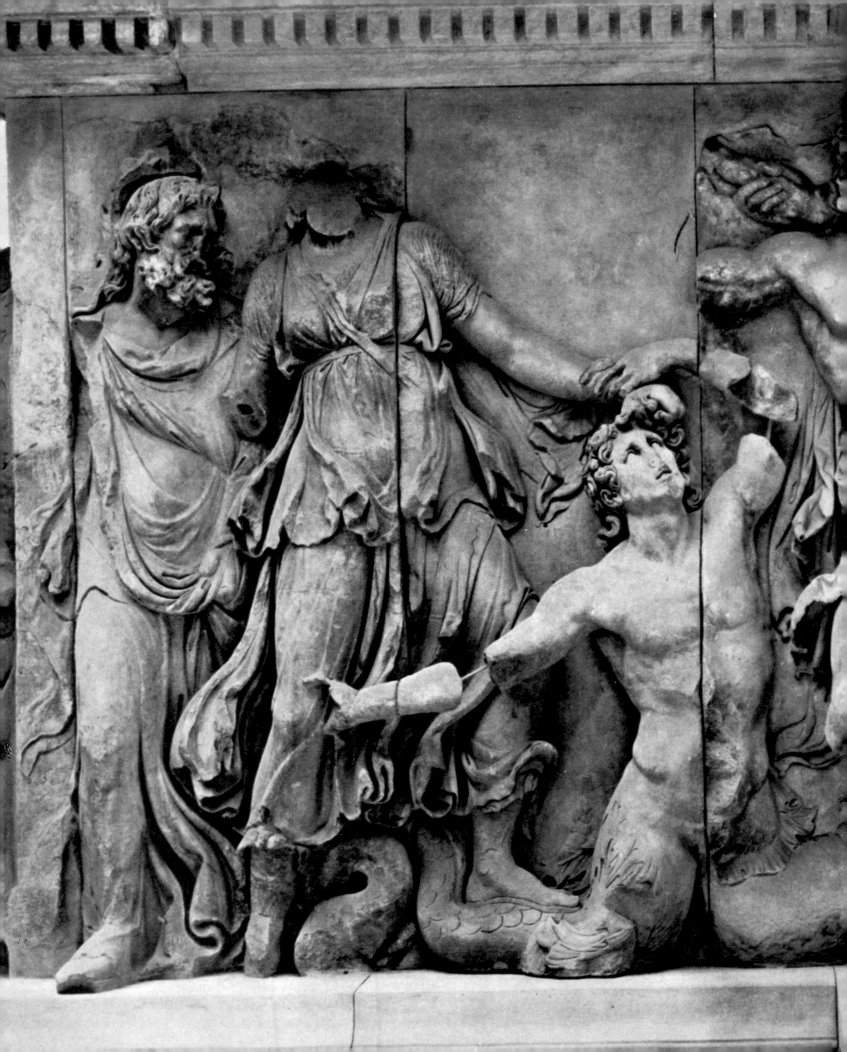

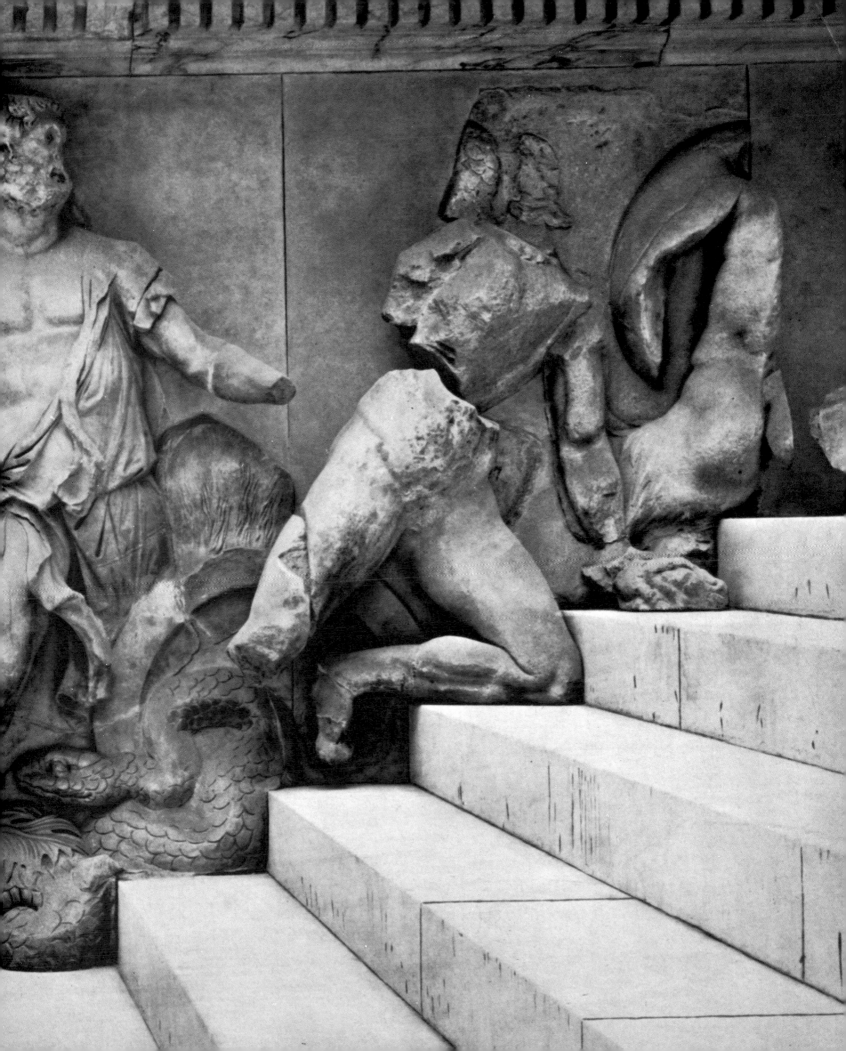

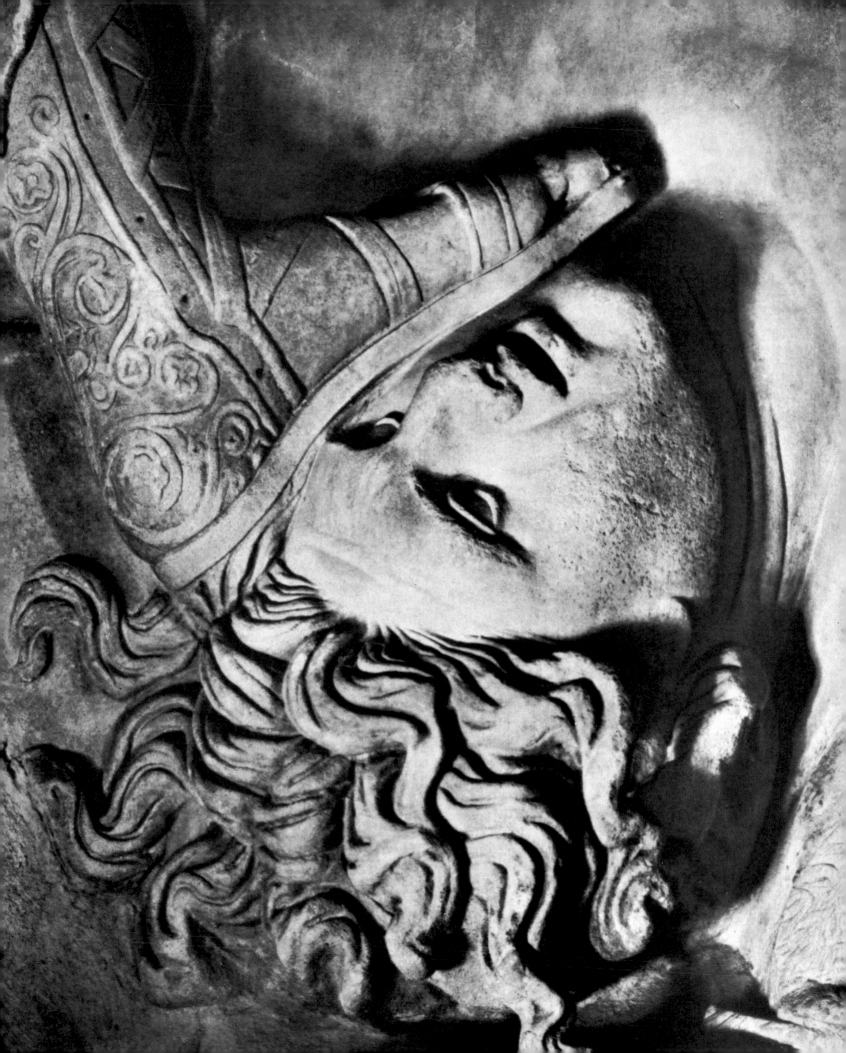

Springing out from behind a goddess, a lion with rippling mane crushes the arm of a giant.

A young giant, opposite, his handsome face frozen in death, lies pinned beneath the foot of Aphrodite, who has pierced him with a lance.

OVERLEAF: *Crying out in terrror, the giant Alcyoneus tears at the arm of Athena as she wrenches him from the protection of his mother, the Earth.*

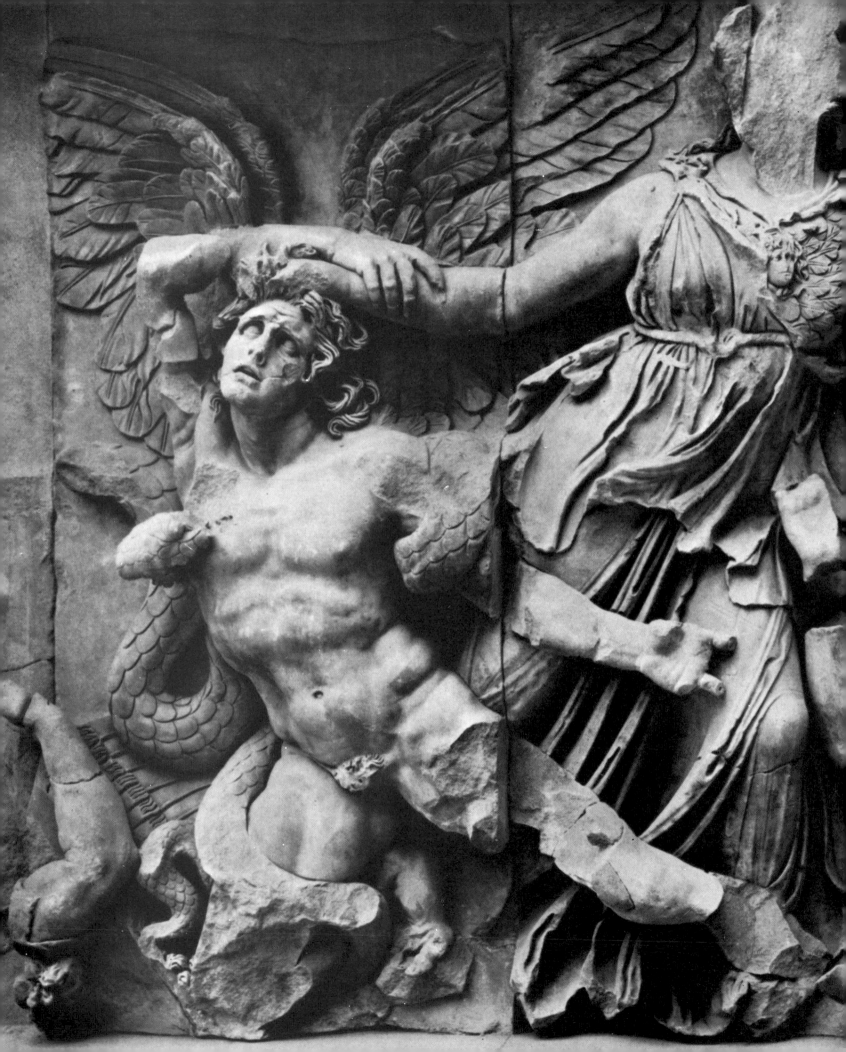

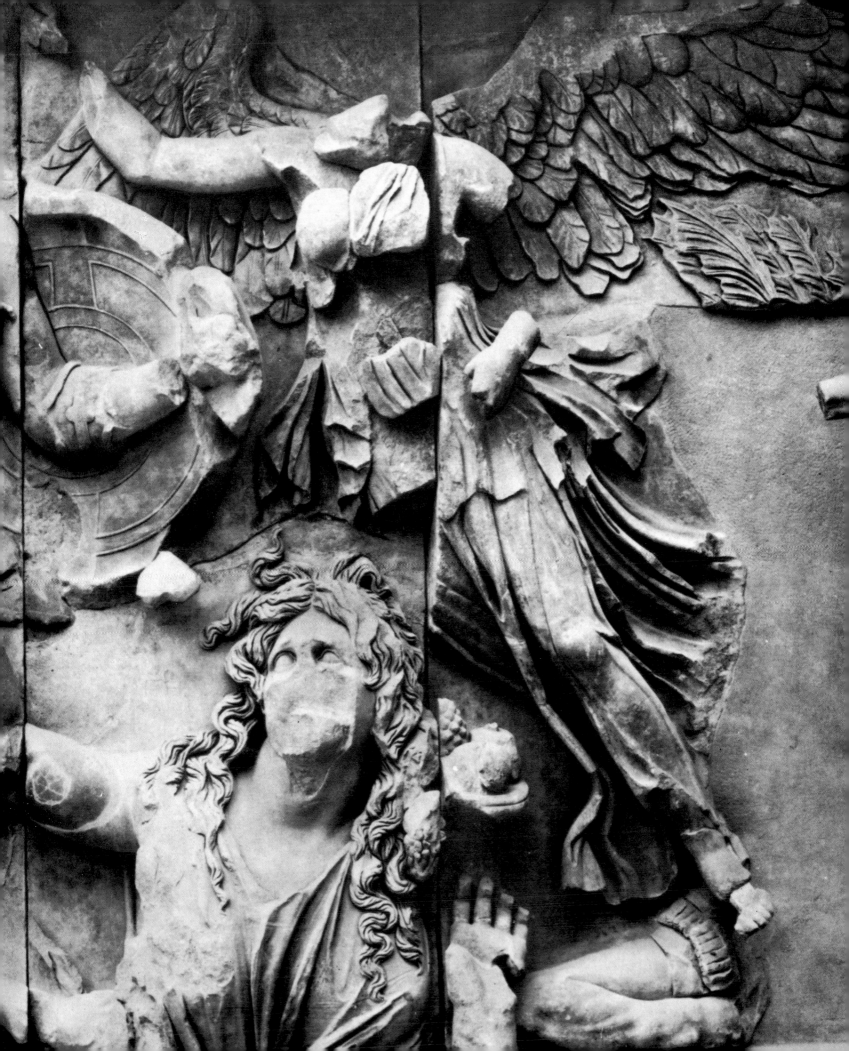

THE GREEKS: A CHRONOLOGY

EPOCH	EVENTS		ART AND ARCHITECTURE	
MYCENAEAN CIVILIZATION 2200–1100 B.C.	c. 2000	Rise of Minoan civilization on Crete		
			c. 1900	Building of palace at Knossos
	c. 1550	Rise of Mycenae	1550	First rich Minoan tombs
	c. 1450	Mycenaeans conquer Crete		
	1300–1100	Invasions by Sea Peoples and Dorians	1300–1200	Period of rich Mycenaean tombs, Greek mainland
	c. 1250	Trojan War		
	c. 1200	Collapse of Mycenaean civilization		
	1100	Greek occupation of the west coast of Asia Minor		
EARLY GREECE 900–500 B.C.	776	First Olympic Games		
	760–550	Greeks plant colonies from Spain to the Black Sea		
			c. 750	Homer's *Iliad* and *Odyssey*
			c. 700	Hesiod's pastoral poetry
			c. 650	Development of freestanding sculpture
			c. 600	Sappho's lyric poetry Black-figured pottery
			c. 550	Doric architecture is widespread Ionic influences appear
			c. 525	Red-figured pottery
CLASSICAL AGE 500–323 B.C.	500	Rise of Athens begins		
	490	First Persian War		
	480–479	Second Persian War		
			c. 465	Aeschylus' tragedies
			c. 456	Completion of the Temple of Zeus at Olympia
	450–429	Pericles, leader of Athens	c. 450	Sophocles' tragedies
			447–432	Erection of the Parthenon
			438	Dedication of the *Athena Parthenos* by Phidias
			c. 434	Herodotus' histories
	431–404	Peloponnesian War		
	431	Death of Phidias		
			c. 425	Euripides' tragedies
			c. 420	Thucydides' histories Aristophanes' comedies
			409–406	Erechtheum is completed on the Acropolis

EPOCH	EVENTS	ART AND ARCHITECTURE
	399 Death of Socrates	
	383 or 382 Birth of Philip of Macedon	
		c. 370 Plato's dialogues
	359–336 Philip, king of Macedon	
	356 Birth of Alexander	
		c. 350 Demosthenes' speeches
	338 Philip rises to supreme power in Greece	
		c. 337 Aristotle's treatises
	336 Murder of Philip	c. 335 "Philip's tomb" at Vergina
	334 Alexander crosses into Asia Minor	
	331 Founding of Alexandria Alexander at Babylon	
	330 Death of Darius	330 Derveni krater Erection of the statues of Aeschylus, Euripides, and Sophocles at the Theater of Dionysus in Athens
	327–324 Alexander in India	
	323 Alexander returns to Babylon Death of Alexander	
HELLENISTIC AGE 323–31 B.C.	311 Seleucus I founds dynasty of the Seleucids in Syria and Mesopotamia	
	305 Ptolemy I founds dynasty of the Ptolemies in Egypt	
		c. 300 Library founded, Alexandria Panagyurishte treasure
	283 Philetaerus founds dynasty of the Attalids at Pergamum	
	c. 241 Attalus I defeats the Gauls	
		240–230 Attalus I sets up monument celebrating defeat of Gauls
		c. 230 Library founded, Pergamum
	c. 200 Rome enters the politics of the East	c. 200 Oxus treasure buried
		180 Eumenes II sets up the Great Altar of Zeus
		150 Stoa of Attalus erected at Athens
	146 Rome sacks Corinth	
	133 Attalus III wills Pergamum to the Romans	

ACKNOWLEDGMENTS & CREDITS

Sources for the pictures in this book are shown below.
Abbreviations:
BM—British Museum, London
EA—Ekdotike Athenon
MFA—Museum of Fine Arts, Boston
MMA—Metropolitan Museum of Art, N.Y.

Treasures excavated at Vergina appear courtesy of the Greek Ministry of Culture and Sciences, Professor Manolis Andronicos, and the Commission on The Search for Alexander.
We would also like to thank the following for their assistance:
Don Anderson of the Walters Gallery, Baltimore; Dr. Maxwell Anderson, Classical Fellow, MMA; Deanna Cross, Photographic Services, MMA; Professor Edith Porada, Columbia University; Mrs. Edwin Smith, Saffron Walden, Essex; Janice Sorkow, Photographic Services, MFA; Christine Young of Harmer Johnson Books Ltd., N.Y.

All maps by Walter Hortens

Cover: Spyros Tsavdaroglou. 2: Erich Lessing/Magnum. 4,5: Giraudon. 6: EA. 10,11: EA. 12: BM. 13: EPA/Scala. 14: EA. 15: Dan J. McCoy/Black Star. 16: EA. 17: Dan J. McCoy/Black Star. 18-25: EA. 26: (top) EA. 26,27: (bottom) Photoresources. 27: (top, left) Spyros Tsavdaroglou; (top, right) Photoresources. 28,29: D.A. Harissiadis, Athens. 29: EA. 30,31: EPA/Scala. 32-37: EA. 38: Aldo Durazzi/Vatican. 40,41: EA. 42: Giraudon. 43: MFA. 44: C.H. Krüger-Moessner/Antikensammlungen, Munich. 45: (top, left to right) MMA, MMA, MFA, MMA, EPA/Scala; (bottom) MMA. 46: (top) Johns Hopkins Unversity; (bottom) Chip Vincent/Agora Excavations, Athens. 47: BM. 48,49: EPA/Scala. 50: (top) Giraudon. 50,51: Martin von Wagner Museum, University of Würzburg. 51: (top) National Museum, Copenhagen. 52: Soprintenza Archeologica della Lombardia, Milan. 53: National Museum, Copenhagen. 54: MMA. 55: EPA/Alinari. 57: George Holton/Photo Researchers. 58: John Veltri/Photo Researchers. 59,60: Roger-Viollet. 61: Nikos Kantos, Athens. 62: Edwin Smith. 63-66: Alison Frantz, Princeton, N.J. 67: Boudot-Lamotte. 68: Alison Frantz, Princeton, N.J. 69: D.A. Harissiadis. 70,71: Margot Granitsas/Photo Researchers. 73: Bibliothèque Nationale, Paris. 74: EA. 75: Spyros Tsavdaroglou. 76,77: EA. 78,79: BM. 80: Spyros Tsavdaroglou. 81: EA. 82: Norbert Schimmel, N.Y. 83: BM. 85: Spyros Tsavdaroglou. 89,90: Dmitri Kessel, Paris. 91-104: Spyros Tsavdaroglou. 105: EA. 106,107: EPA/Scala. 108: EPA/SEF. 109: EPA/Scala. 112,113: EPA/Scala. 114: (top) BM; (bottom) Photoresources. 115,116: BM. 117: (prince, warrior, head, priest) Photoresources; (griffin, ornament) BM. 118: Robert Harding Picture Library. 119: EPA/Scala. 120,121: MFA. 121: MMA. 123: Lee Boltin, Croton-on-Hudson, N.Y. 124: Johann Willsberger, Munich. 125: Virginia Museum of Fine Arts, Richmond. 126: Lee Boltin, Croton-on-Hudson, N.Y. 126,127: EA. 128-135: Lee Boltin, Croton-on-Hudson, N.Y. 136-139: Erich Lessing/Magnum. 140,141: Lee Boltin, Croton-on-Hudson, N.Y. 142: Erich Lessing/Magnum. 144: EPA/Alinari. 145: Ingrid Geske/Staatliche Museen, Berlin. 146: (top,left) Art Museum of Princeton University, N.J.; (bottom,left) MMA; (right) Bibliothèque Nationale, Paris. 147: BM. 148,149: MMA. 150: (top) Giraudon. 150 (bottom)-151: A. Dagli Orti/Archivio I.G.D.A., Milan. 152-155: EPA/Scala. 157: James Whitmore/Time Inc. 158-166: Staatliche Museen, Berlin. 167: James Whitmore/Time Inc. 168,169: Staatliche Museen, Berlin.

SUGGESTED READINGS

Brilliant, Richard, *Arts of the Ancient Greeks.* McGraw-Hill Book Co., 1973.

Bury, J.B. and Russell Meiggs, *A History of Greece.* St. Martin's Press, Inc., 1975.

Chadwick, John, *The Mycenaean World.* Cambridge University Press, 1976.

Charbonneaux, Jean et al., *Archaic Greek Art.* George Braziller, Inc., 1971.

———, *Classical Greek Art.* George Braziller, Inc., 1973.

———, *Hellenistic Art.* George Braziller, Inc., 1973.

Finley, M.I., *Ancient Greeks.* Penguin Books, Inc., 1977.

Hammond, N.G.L. and G.T. Griffith, *A History of Macedonia.* Oxford University Press, 1979.

Hood, Sinclair, *The Arts in Prehistoric Greece.* Penguin Books, Inc., 1979.

Richter, Gisela M.A., *A Handbook of Greek Art.* E.P. Dutton, 1974.

Scranton, R., *Greek Architecture.* George Braziller, Inc., 1979.

Vermeule, Emily, *Greece in the Bronze Age.* University of Chicago Press, 1972.

INDEX

Page numbers in **boldface type** refer to illustrations and captions.